Advances in Art & Urban Futures Volume 1
Locality, Regeneration & Divers[c]ities

intellect™

BRISTOL, ENGLAND
PORTLAND, OR, USA

Edited by Sarah Bennett and John Butler

First Published in Hardback in 2000 by
Intellect Books, PO Box 862, Bristol, BS99 1DE, UK

First Published in USA in 2000 by
Intellect Books, ISBS, 5824 Hassalo St, Portland, Oregon 97213-3644, USA

Consulting Editor: Masoud Yazdani
Book and Cover Design: Joshua Beadon
Copy Editor: Peter Young

Set in Joanna

A catalogue record for this book is available from the British Library

ISBN 1-84150-046-1

Printed and bound in Great Britain by Cromwell Press, Wiltshire

Contents

Section Three – On the Ground

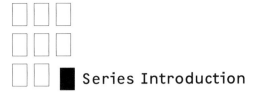

Series Introduction

This is the first volume in the series *Advances in Art & Urban Futures.* The series is a vehicle to disseminate research and discussion papers from seminars and symposia organised by the Art & Urban Futures Research Unit, in the School of Art & Design, University of Plymouth. It aims to contribute nationally and internationally to the advance of practical, critical and theoretical understandings of the relation of art to the development, regeneration and sustainability of cities.

The series will be multi-disciplinary in content, including, with a balance which varies from volume to volume, contributions from specialists in art and design, architecture, urban design, the social sciences and philosophy. Art and design will be represented by both practitioners and academics. This multi-disciplinarity, and the related theory, criticism and practice, reflects the complexities, and excitement, of current debates around the futures of cities as the primary form of human settlement and primary location of cultural production and reception.

The first volume, co-edited by Sarah Bennett and John Butler, includes papers from seminars during 1999 and 2000 at the University of Plymouth (Exeter School of Arts & Design), the University of Barcelona (through Public Art Observatory, a prject of the Thematic Network of the European League of Institutes of Art) and at Bath University. The volume includes entirely new writing, and makes a significant contribution to debate by problematising conventional categories and boundaries, as between public and private space, and conventional identifications, such as that of public space with a public realm of democracy. It includes papers with a contextual breadth, as well as those which investigate specific problems and practices.

Future volumes will reflect, in varying ways, the research questions of the Unit, on art's relation to urban futures, the commonalities and differences of relevant discourses and critical frameworks, the cultures of non-metropolitan cities, and the implications of research on these questions for pedagogy in relevant fields. Each volume will have two co-editors, changing each year, and will be published annually in December.

Finally, my thanks to Sarah Bennett and John Butler for bringing this first volume together, despite the pressures of time and institutional life; and to all the contributors for their texts and participation in the events from which the volume is derived. I hope there will be many more.

Malcolm Miles
Series Editor, and Reader in the School of Arts & Design, University of Plymouth

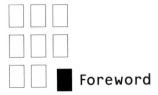

Foreword

Putting emphasis on my own recollections of the past two decades makes this a somewhat subjective introduction to the theme of art, locality and regeneration. Nevertheless, I suspect my experiences of a rapidly changing situation in one specific locality – the east and south-east of London – are symptomatic of a wider and more general pattern that has linked the nature and direction of art quite precisely to the infrastructure of urban planning and regeneration.

Buildings, and particularly buildings that have undergone regeneration, have played a significant role throughout my working life. As a first year student at Camberwell School of Art, I was set to work in an annex that had begun life a century before as a school. Shortly after graduating, and having wisely reflected on the folly of becoming an artist, I nevertheless progressed to my own working space in one of the recently vacated warehouses in Wapping. Later, as the property developers moved in, I moved further east, signing a lease on a 20,000 sq ft slice of a former Victorian sweet factory in Cable Street, a site that shortly thereafter became home to some 120 artists. My involvement in that project floundered at the first rent review, but undaunted a few years later I found myself running an international art magazine from what was once the Peek Frean biscuit factory in Bermondsey and subsequently the site of several of the most interesting artist-led shows of the past decade.

Traditionally the poor relations of the graduate world, collectively artists have long demonstrated a canny ability to identify and colonise those urban peripheries vacated by industrial collapse. Colonisation by the bohemian-chic, however, almost inevitably triggers a spiral of development that ultimately sees the artist as loser, continually forced into seeking new pastures.

My point, however, is not simply to underscore the commonplace of shifting demographics. My own experience of the London scene has suggested that property and location not only furnish an environment for artists to practice in, but in many cases have had a direct influence on the nature of the work produced and the manner in which it has been displayed. And by display, I include not only the physical environs in which art is exhibited, but the more nebulous philosophical context that determines our address to the art object.

At Camberwell I first came across Gleizes' and Metzinger's claims regarding the impunity of a work of art that retains its integrity whether in a drawing room or cathedral. With hindsight, that remark strikes me as wholly appropriate to the ethos of Camberwell itself, whose Victorian annex made no concessions to its new role as an art school and whose students were not encouraged to consider their immediate environs germane to the art they produced. The building merely provided a roof over the naked models in the life class and corridors for the storage of dusty plaster casts of Greek antiquity.

Arriving in Wapping in the early eighties was quite a different experience. The Wapping studios were largely artist-run and free of the trappings of a hierarchical bureaucracy. Here were artists like Alison Wilding whose work seemed to be determined by the lingering industrialism of London's recently defunct docks and could be seen in direct relation to the confines of her studio space. Wilding would shortly after be linked to artists like Richard Deacon and Bill Woodrow, both of whom worked in and were similarly indebted to equally down-at-heel former-industrial studios across town in Brixton.

But if those studios provided a particular environment for making art, the other half of the equation was display. By the early eighties it was already an established tradition for the various studio groups to hold annual open studio exhibitions (some of the first and most significant were held at the Stockwell Depot in the late sixties). In the Wapping shows artists took charge of their own destiny, fundraising and organising publicity, assured of substantial audiences by dint of the sheer number of exhibitors. But while many artists refurbished their white-cube studios to resemble miniature galleries, there was an odd pride taken in those shambolic openings which couldn't have been further from the professionalism of the West End. In retrospect, this naivety appeared underpinned by a shared belief that the real business belonged uptown, that somehow this annual invasion was tolerated only if the event was ultimately construed as an outing for family and friends.

Once the developers had forced us out of Wapping, I became involved with the running of Cable Street, one of the larger complexes of its kind in London. But while Cable Street succeeded in providing relatively affordable studio accommodation, its outlook was still rooted in the naiveties of Wapping. The building itself allowed art to be produced, artists to meet, and studio exhibitions to take place – it even established its own gallery in the years after my departure – but except in the most incidental sense the building didn't contribute to the structuring of attitudes towards the work manufactured under its own roof. Although a far cry from Camberwell, the art produced there could almost have been made and exhibited anywhere.

That this attitude to the relationship between art and site changed in the later eighties was in some measure connected to the demise of the Greater London Council in 1986 and the rise of the London Dockland Corporation throughout the mid-eighties. The loss of the GLC spelled less financial support for artists and projects in general, while the Thatcher-backed development of Docklands – and a specifically formulated body to secure and promote that end – created new possibilities within that particular enclave of east London. Damien Hirst and his contemporaries from Goldsmiths College were the first artists to exploit this short-lived bubble of commercial optimism by mounting the three-part Freeze exhibition in the then empty Port of London Authority Building in 1988.

While Freeze echoed the old formula of artist colonisation, it differed from Wapping and Cable Street in several key respects. As these artist were not exhibiting on home turf, the space had the neutrality of a blank canvas. Then again, the space was taken as found with no concessions to the white-cube. Indeed, the site of display within the PLA's cavernous, dilapidated areas was incorporated as an integral element

of the work. Of equal importance, the naivety of the seventies and early eighties had finally given way to the entrepreneurial spirit of the mid eighties. In effect, Freeze set out to take on the art world by creating a professional display on a scale with which none of the West End commercial galleries could compete.

Many of the same artists showed again two years later in four artist-led exhibitions – *Modern Medicine, Gambler,* the *East County Yard Show* and *Market,* a solo installation by Michael Landy – all but one of which took place in the vast empty space of Building One, formerly part of the Peek Frean biscuit company in Drummond Road, Bermondsey (the same complex of buildings I moved my magazine to some eight years later). Although Freeze had been poorly attended and barely reviewed, these shows together became a symbol of a new artist-led entrepreneurship, a combination of calculated anarchy and an astute reading of the changing relationship of the artist to the market.

It would be misleading to romanticise this; its roots lie as much in eighties capitalism as in any idealised confrontation with the 'establishment'. Nevertheless, the initiatives which followed Freeze substantially redressed the issue of what art gets exposed, and so helped determine the nature of art in the nineties and beyond. As a consequence of the kind of buildings artists began to exhibit in – their affordability and ultimately their availability – the nature of the art world has radically changed. Working in situations with little historical baggage, little hierarchical ordering, and little financial risk, the new breed of artist-curator is generally younger than counterparts in the commercial and public sectors, and so tends to have a more informed insight into a peer generation of artists. And while this may have generated unrealistic expectations of premature success, the off-Broadway venues of east and south-east London have, within a single decade, challenged the once-accepted prerequisite for a period of gestation between leaving education and achieving recognition.

Most significant of all, the emergence of an artist-regulated infrastructure has created the kind of support system that was so patently lacking in the not so distant past. The socialist-fired idealism of conceptualism in the late sixties was rapidly compromised because the one support system open to those artists was the commercial market. Ironically, the return to a neo-conceptual position in the nineties has been made possible precisely by artists abandoning the moral high-ground and creating a commercial/exhibiting infrastructure for themselves. No matter that many subsequently sided with the establishment venues of the West End, the conceptual framework of an artist-generated support system remains in the myriad of artist-run spaces which continue either as semi-permanent features or as hit-and-run gestures.

None of this would have been conceivable without access to a particular urban infrastructure. It seems to me there are constantly two directions of movement or change. The first is the unceasing migration of the artist in search of the ever elusive grail of cheap rent. The other is a movement within values and self-perception, a movement that has over the past twenty or so years seen the place of urban industrial architecture in this equation shift from a simple workplace to a position central to the forms of display of contemporary art, and ultimately a key determining factor of the ways we perceive art in the broader frame.

Keith Patrick – *Editor, Contemporary Visual Arts*

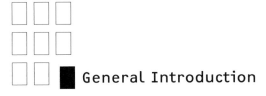

General Introduction

This book is situated in the contemporary discourses of urbanism. This is a field, always multi-disciplinary, which has grown rapidly over the past two decades, and seen several shifts of emphasis and ideology. Through the 1980s, geographers such as David Harvey and Edward Soja began to reinvent their subject, introducing concerns for social justice and inclusion; through the 1990s, the influence of feminism and post-colonialism, as in the work of geographer Doreen Massey, sociologist Elizabeth Wilson, and planner Leonie Sandercock, extended analysis from a framework of class and capital to include gender and ethnicity. At the same time, new practices in art, such as new genre public art in the USA, and a new awareness of the relation of theory and practice in some areas of architecture, raised the profile of visual culture in debates on cities. Developments in theory through this period were informed in the anglophone world, as a result of interpretations by Soja, Massey and others, and the appearance of English translations, by the work of French Marxist philosopher Henri Lefebvre. Lefebvre emphasises the production of space, as opposed to its naturalisation, and that space, perhaps more than time, is a dimension of potentially revolutionary change. Most recently, architecture has begun its own re-invention through an emerging literature of the everyday, in which Lefebvre's influence is again felt and the role of dwellers as partners in planning and design respected. All this takes place against a background of globalization and encroachment on public space by spaces of privatised consumption. Debates on city futures, then, are lively and contentious as well as complex, and inclusive enough to accommodate artists, architects, planners, sociologists, geographers, ecologists, environmental activists and philosophers. Few divisions of knowledge, as represented by departments in Universities, are now untouched by these debates, though this brings with it a danger of a new fragmentation if the methodologies and specialist languages particular to each discipline act as 'keep-out' notices to those for whom their mysteries have yet to be acquired. But the critical mass of interest from so many disciplines and professions, and from urban dwellers, has enabled a range of conferences, symposia and publications to take place, in many of which the interaction of people from different backgrounds has produced new insights. This volume adds a further contribution to an already rich literature.

The texts collected together in this book began, for the most part, as papers for seminars and symposia in the Universities of Plymouth, Bath and Barcelona, and are written by artists, cultural, social and architectural theorists and critics, and social scientists. All have been specially revised for publication. Several were first presented at events organised within Public Art Observatory, a project of the European League of Institutes of Art (ELIA) which coordinates an EC thematic network of the arts. The book's specific contribution to the growing literature in which it is situated is in bringing together different perspectives from several countries, linked by a common

11

interest in urban visual cultures, and in juxtaposing theoretical frameworks and broad critiques with accounts of local conditions and individual projects. It also raises some fairly big questions, as in Jane Rendell's essay, which asks to what extent categories such as public space and the public realm remain useful, or might inhibit the shaping of cities for the well-being of all their diverse publics. Ron Kenley, too, approaches the city of Paris as a space to be read through the traces, often only just discernible, of multiple occupations. Similarly, the critical analysis of the *Window Sills* project, by Sarah Bennett and Gill Melling, which responds to the localised conditions of one neighbourhood in Exeter, problematizes aspects of power and participation, whilst refusing the easy answers of conventional public art and its advocacy. If some of the texts ask more questions than they answer, this is because the map is complex, because insights gained in one context or locality cannot directly be translated for general application, and because solutions tend, in any case, to be closures of argument.

On the events from which the texts were generated, and the institutions and organisations which supported them: several of the texts began as papers for seminars in the Exeter School of Arts & Design, University of Plymouth. These were small-scale events providing opportunity for all participants to contribute around a large table. Another text was first presented at a larger symposium in the School of Architecture at Bath University, within a visual culture programme. Others were initially written for symposia and workshops in the Faculty of Arts at the University of Barcelona, through Public Art Observatory. One of several projects within ELIA, Public Art Observatory has core members in Spain, Portugal, the UK, the Netherlands and Finland, organizes annual workshops and seminars on art in urban development, and is coordinated by Antoni Remesar, of C.E.R. Polis, a research centre in the University of Barcelona. Several of the contributors to this book were present at most or all of the events noted above, or were involved in similar and related events which took place, in the late 1990s, at the Tate of the North in Liverpool, Oxford Brookes University, and the Willem de Kooning Academy and de Geuzen Stichting, both in Rotterdam. All the contributors participate in academic or professional networks, and the book seeks to advance and inform the discussions which such networks allow.

The book establishes some relatively new directions – as in the area of non-metropolitan cities (such as Exeter), and the construction of post-industrial landscapes. Mark Gottdeiner, in the April 2000 issue of the journal City (Carfax Publishing, Abingdon) writes:

> ... *several overarching and popular concepts have dominated the agenda of urban studies. These include an emphasis on the large, central city, 'postmodernism', 'globalization', and, most recently, the 'information society' [critiqued by Manuel Castells]. Urban analysts have tried their best to fit ideas about space, location and everyday life into these large, essentially descriptive bins.* (p. 99)

This book answers such criticism by moving through description, critical commentary and theory, linking the word-based and the visual, the broad condition and the local response.

In the first section, *Women in Space*, contributors look to the issues inherent in considerations of the public realm. Jane Rendell sees conventional categories, such as public and private, public space, the public realm and public art, as restrictive, and interrogates their relation to each other, and to questions of gender, ethnicity and sexuality. She identifies an in-between of collective action and shared resistance. Sally Morgan, looking at different readings of Bristol determined by history and class, focuses on Bristol's memorial landscape, juxtaposing two prominent figures, both outsiders but from opposite positions of economic power, and both intent on influencing and controlling memory, through public sculpture and architecture, and through graffiti. Judith Rugg provides a critical commentary on one artist's work – Anya Gallacio – and, like Morgan, uses this to enter a broader, critical terrain of feminist exigency, and of the contention of what is public and what is private. Through the use of the partly visible, she argues, in non-gallery sites, and using transient, mutable materials, artists challenge conventional values of stability.

In the second section – *Divers[c]ities* – the contributors offer different approaches to urban regeneration. Through references to development in specific sites, they reflect on the dangers of globalization, and ask what strategies artists might adopt in face of it. Taking Paris as a point of departure, Ron Kenley proposes a methodology for urban regeneration built on the necessity for studying inter-dependent logics and lattices; traces of habitation and occupation provide clues to city lives which conventional design regards as invisible or unimportant. Malcolm Miles draws on experiences of post-industrial cities and waterfronts, particularly Pittsburgh, USA, to illustrate a shift from the convention of public art as a sign of affluence to a more resistant, but negotiated, approach in the reclamation of democratic space and bio-diversity. Floris Paalman takes the case of a failed development on the edge of Amsterdam, in Bijlmer, to investigate the social problems created by such segregated ghettos of deprivation, designed in a utopian but functionalist spirit as bright new housing for the poor, but which become dreary traps of poverty. He argues against grand-scale solutions, and proposes the participation of the current occupants in the reclamation of the site. Jane Trowell presents the work of PLATFORM, a London-based group for inter-disciplinary creativity, ecology and democracy, through a series of projects and tactics. She notes the complexities of working in this area, but also retains a belief that through activist intervention art might contribute to the shaping of London's future. Jesús Pedro Lorente looks to the cities of Liverpool and Marseilles as sites of post-industrial regeneration, in which the arts and the occupation by artists of alternative spaces for work and exhibition play a key if sometimes ambivalent role. He argues for the involvement of artists in the decision-making process as a precondition for sustainable regeneration.

Section three – *On the Ground* – deals with the practitioner's approach to issues of identity, inclusivity and sustainability. Sarah Bennett and Gill Melling demonstrate the importance but also problems of collaboration, through an analysis of *Window Sills*. This project uses processes of participation which are increasingly common, yet interprets them for specific localities and social situations in a non-metropolitan city. Peter Dunn illustrates how creative process, incorporating the use (but not dominated by the technicalities) of digital imagery, can offer opportunities for people to make an

imaginative leap from present actualities to future possibilities. His focus is on identities, in a multi-ethnic society, and concern for the local as resistance to globalization. John Gingell, working in Barry, expounds the problems, from direct experience, of working as an independent artist in the public realm. He accepts certain failures, but weighing these against innovations in recent art in addressing the fabric of a city, sees the venture as still worthwhile. Antoni Remesar and Enric Pol describe a particular case of city development in which the needs of diverse publics have not always been given the same importance as design and the kinds of visibility of change used in trans-national place marketing. They propose a method for participation through urban workshops in which citizens have a voice equal to that of the city's authorities – a variant of the workshops used in Pittsburgh, described by Miles.

Some of the texts might fit as easily in one section as another, not least because they are all informed by dialogues within the networks and events noted above. But the organisation runs, in the most general sense, from the broad to the particular. In the book as a whole, insights into the specificity of practice and locality are seen as of equal value to those gained from investigation of theoretical questions. But without a re-visioning of the categories and methodologies through which the concept and actuality of the city have conventionally been addressed – a re-visioning possible only in the multi-disciplinary terrain in which artists, architects, planners, geographers, social scientists and philosophers can meet (all of whom are also dwellers) – the future shape of cities may be much as it was through the twentieth century: a site of dis-empowerment, deprivation and exclusion alongside the exercise of power and accumulation of wealth and other kinds of capital (such as the cultural) which have reached obscene proportions.

This is why it matters, now, to ask what is meant by a term such as public realm: whose city? Who decides? And this is why, when dwellers are shaped by cities, they have, for the most part as yet, little opportunity to shape for themselves, readings not of monuments to national memory or civic pride, but of the traces of occupation, experience, memory and desire are a ground for new kinds of urban democracy, realised as much through cultural work as through politics. This raises the question of a re-politicisation of culture in a period of the de-politicisation of politics itself, but that, as they say, is another story.

Enough, here, to say that the book is, we hope, a basis for further conversations about urban futures and the role of visual culture, and artists, in them. It offers no map, no solution, no formula for urban regeneration. But neither does it say the city (which it would in any case refer to as cities) is a pathless land. The paths are not always heavily beaten and their geometry is complex. Our readings remain our own – subjective, as Keith Patrick points out in his Foreward – but, as in this volume, they can be put in relation to each other. That is what we have tried to do. The work continues.

John Butler, Malcolm Miles, Exeter, August 2000.

The Editors wish to thank the University of Plymouth, ELIA, and all contributors and organisers of the events in which the papers in this volume were first presented for their support and assistance.

Contributors

Sarah Bennett is an artist and senior lecturer in Fine Art, sculpture, in the Exeter School of Arts and Design at the University of Plymouth where she is a member of the Art and Urban Futures Research Unit. Her own practice is context based and temporary sited work.

John Butler is an artist and curator. He is Chair of Art and Course Leader for Fine Art at Exeter School of Arts and Design, University of Plymouth and a member of the Art and Urban Futures Research Unit. He is vice President, responsible for Research and Development, of the European League of Institutes of Arts and a member of the Public Art Observatory.

Peter Dunn is an artist and Co-Director of *The Art of Change*. Educated at the Slade, he is currently part-time lecturer on the MA in Design and Media Arts, University of Westminster and in Public Art at Chelsea College of Art and he is widely published on themes related to art, communities, regeneration and recently on the implications of digital media and the Network Society.

John Gingell is an artist and directs the MA Fine Art Course at the University of Wales, Cardiff. He has undertaken several major public sculpture commissions in the last 15 years, most recently the Crystal Beacon at the Oracle Project in Reading Town centre.

Ron Kenley is a British Architect living in Paris. He teaches at the School of Architecture, Paris – la Seine as well as at the University of Art and Design, Helsinki. He is a consultant on projects developing the architecture of spaces of communication in multimedia formats in relation to European urban regeneration initiatives.

Jesús Pedro Lorente teaches in the Department of Art History at the University of Zaragoza. He is author of the book, based on his PhD: *Cathedrals of Modernity, The First Museums of Contemporary Art, 1800-1930* (Ashgate Press, 1998) and editor of The Role of Museums and the Arts in the Urban Regeneration of Liverpool (Centre for Urban History, 1996).

Gill Melling is an artist, and a researcher for the *Window Sills* project at the Exeter School of Arts and Design, University of Plymouth and a member of the Art and Urban Futures Research Unit. Her practice is installation and sited work and she has been a coordinator of Channels Artists Initiatives since 1995.

Malcolm Miles is Reader in the School of Arts and Design at the University of Plymouth and Director of the Art and Urban Futures Research Unit. He is author of *Art, Space and the City* (Routledge, 1997) and *The Uses of Decoration: essays in the architectural everyday* (Wiley, 2000), and co-editor of *The City Cultures Reader* (Routledge, 2000).

Sally J Morgan is principal Lecturer and Head of Fine Art at the University of the West of England, Bristol.

Floris Paalman is an anthropologist and artist. He is a graduate student on the Postgraduate Programme in Fine Art at the Willem de Kooning Academy, Rotterdam

Keith Patrick is the Editor of Contemporary Visual Arts magazine and has written numerous articles for catalogues and art journals and is author of the book *Oil on Canvas* which accompanied the BBC TV series. As a freelance curator he has curated exhibitions of contemporary art in the UK, Italy, France, Spain, Germany, Portugal and the USA.

Enric Pol is Professor in the Department of Social Psychology and Director of the MA in Environmental Intervention, University of Barcelona. He is a member of the Board of IAPS (International Association for the Study of People and their Surroundings).

Antoni Remesar is Professor in the Department of Sculpture and Director of the Doctorate Programme – 'Public Space and Urban Regeneration' at the University of Barcelona. He is the Director of the Research Centre, POLIS (Environmental Intervention: Art, society, sustainability) and coordinator of the Public Art Observatory.

Jane Rendell is an architect and architectural historian, and editor of 'A Place Between', *Public Art Journal* issue 2 (October 1999); co-editor of *Strangely Familiar: Narratives of Architecture and the City* (Routledge, 1995) and *Gender, Space, Architecture: An Interdisciplinary Introduction* (Routledge 1999). She lectures at the Bartlett School of Architecture, University College London.

Judith Rugg is Programme Co-ordinator for Fine Art Contextual Practice at the University of Plymouth and a member of the Art and Urban Futures Research Unit. She is currently researching a doctoral thesis at Middlesex University on the contribution to public art discourse and spatial theory made by women artists' temporary site specific installations.

Jane Trowell joined PLATFORM as a project collaborator in 1991, coming from a background in contemporary visual art, theatre and art history education. A member of the core group since 1993, her particular interests are pedagogical and social processes; she also teaches at Birkbeck College and Chelsea College of Art and Design.

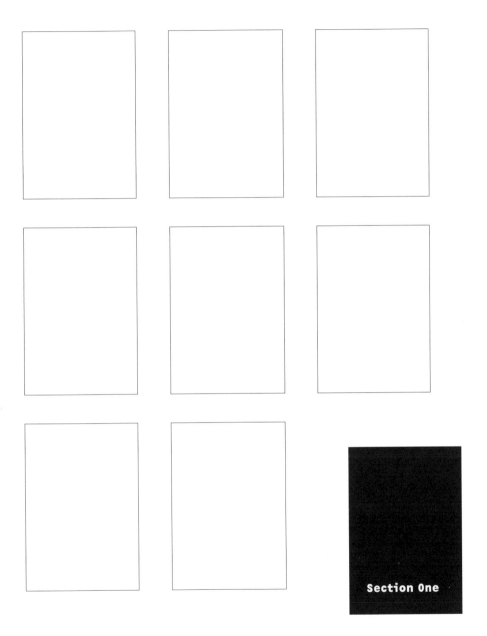

Section One

Women in Space

Jane Rendell

▪ Public Art: Between Public and Private

"What does it mean for space to be public? – the space of a city, building, exhibition, institution or work of art?" asks Rosalyn Deutsch at the start of her essay 'Agoraphobia' (Deutsche, 1996: 269).

For art to be 'public' raises a number of important questions about the definitions and inter-relations of the terms private and public.

The category has historically been employed in a restrictive capacity – to describe sculptural works placed outside the gallery. Here 'art' describes an object and 'public' suggests the terrain into which the object is placed. Public art places 'private' art in 'public' space. Extrapolating this mode of thought, takes us to a far more disturbing position – where the 'art', believed to derive from the 'private' world, the personal interests of the individual artist, is placed into the 'public', where the public indicates a passive and homogenous body of people, rather than a collective group of individuals who actively identify with one another.

So we tend to consider space as inert, as a backdrop for human action to occur in, and as homogenous, as undifferentiated. But this is not the case. Space is dynamic – it is both producing of and produced by people, people of different kinds, who relate to each other in a myriad of ways. Understood as such, as socially produced space, public space can only be considered heterogeneous, patterned with differences of all kinds.

The boundaries drawn around notions of private and public are not neutral or descriptive lines but are contours which denote specific value systems. The terms appear as social and spatial metaphors in geography, anthropology and sociology, as terms of ownership in economics, as political spheres in political philosophy and law. They are culturally constructed and change historically. Public and private, and the difference between them, can mean different things to different people. They can indicate protected isolation or unwelcome containment, intrusion or invitation, exclusion or segregation.

It matters that the terms are used differently and that they mean different things to different people. To indicate spatial forms and architectural layouts, rather than kinds of property ownership, or attitudes towards political liberty and citizenship – types of social relations/activities makes a difference.

Let's turn now and look at some of the ways these terms have been defined. So first...

Public Space
Public Space as Non-Private Space: if public is defined by virtue of being with others and of not being the domestic or familial setting, being social but not domestic, then

any non-domestic space is public. Spaces of consumption for example are then by definition public even if they are 'privately' owned. In this sense public space is whatever is not private space (private space being defined as the place of the family).

Public Space as Free Space: the place for free debate between two or more controlled realms – between the state and the private realm of the individual. For example, in England, during and following the political reforms of 1688, the removal of politics from a private monarchy to multiple public arenas created sites where citizens could form reasonable and political judgements. The coffee house, for example, provided a forum for particular philosophical circles of the seventeenth and eighteenth centuries and for radical debate and free speech and transfer of information through the public press. In Habermas' view it is the entry of the non-bourgeois class, the mass media and the welfare state, that has eroded the origin of the public sphere – the secure border between the private and public.

Public Space as Democracy: in this case, public space is defined by a certain quality – accessibility. Here, public space relies on democracy and vice versa. But what kind of democracy? Democratic public space is endowed with unified properties, but one of the problems of aiming for an homogenous public is the avoidance of difference. Chantal Mouffe argues instead for radical democracy, one that embraces conflict and passion. For Mouffe, antagonism designates the relationship between a social identity and a constitutive outside that blocks its completion. Core to democracy is the unknowability of the social; this is what generates public space (Mouffe, 1992).

In the western democratic tradition – public stands for all that is good – for democracy/accessibility/participation/egality versus the private world of ownership/elitism.

For those who support this public realm the absence of public implies lack. Private is only defined as lack of public and is necessarily a bad thing. Privacy is not a right, privilege or prestige, it is a lack, a lack of autonomy. The private implies deprivation, repetitive labouring, dominance and submission.

From a marxist or socialist perspective, the private is connected with a negative viewpoint, with the notion of private property ownership. Private again denoting the absence of public.

Now let's look at the relationship the other way around...

Private Space

Private as Privacy: from a liberal rights based perspective, privacy provides positive qualities; autonomy and intimacy, the right to be alone, the right to confidentiality and the safe guarding of individuality.

Privacy as Distance: this too is a good thing. For romantically influenced liberals the conception of privacy is one that asserts the importance of distance as well as closeness of others.

Privacy as a boundary between state and civil society: in liberal doctrine, for John Locke and others, the realisation of liberty requires the sharp separation of state and civil society. Some liberals believe in the creation and policing of a private sphere. This is the space of civil society, free from the pressures of public morality, legal constraint and corporate interest of the coercive state or public realm.

Private as a distinction between the social and the personal: the distinction lies between the social and personal, the importance of individual seclusion, intimacy and individual reflection are stressed in relation to fears of coercive group power within civil society.

For those who support the private realm the absence of private is necessarily a bad thing. Public spaces are seen as potentially threatening, places of dissidence, in need of regulation; whereas privatisation provides an increase in places where individuals are controlled, surveyed, regulated, according to class, ethnicity, sexuality – for their own safety and well-being

In different ways the discussion seems to be about the construction of spaces for social relationships which provide political 'rights', specifically 'freedom'.

The increasing privatisation of public space can signify either increased safety or increased control, this varies according to access to political power and the potential to control space. The relation of public to private differs according to class, gender, ethnicity and sexuality.

We may be critical of the 'privatisation' of public space, the loss of public places and their replacement by a series of private places with associated social and spatial hierarchies, rules governing entry and use. We are also critical of the loss of 'privacy' associated with surveillance.

The ways in which the terms are related makes a difference. The problem here is that the terms 'public' and 'private' are related in a binary way, one is prioritised over the other, one is defined in terms of the other. Either way, the relationship between them is not seen as one between two equal but different categories. To understand the public-private as a static and hierarchical binary pairing rather than as an ongoing redefining dialectical relation indicates something problematic.

Instead can we not, at the same time as asking "what does it mean for space to be public?" equally ask, "what does it mean for a space to be private or privatised?" In this way we can start to see the relationship between the two as dynamic and changing, and constantly open to critique.

Public and Private as Gendered Terms

I want now to consider the public and private as gendered terms because feminism, drawing on deconstruction, allows us to view the relation between public-private differently and not according to binary oppositions.

For feminists the main problem with the terms is that they are inflexibly gendered – public-man and private-woman – and held in a fixed and hierarchical relationship, where public interest overrules private interest.

Feminist critiques focus on the falsity of the ideology of separately defined public and private spheres, and explore ways of describing the gendering of space which go beyond the binary. Just how this is occurs depends on political positioning.

Some feminists are keen to reassert the importance of terms represented negatively in patriarchal ideology, terms such as female, nature, reproduction, suburb or private. This involves a reassessment of the importance of the devalued private sphere of home and family and spaces of intimacy.

Other feminists are interested in focusing on the public sphere and modes of oppression: that the public realm is a man-made environment, lacking places designed for women and children, with serious problems of security, possibilities of rape, and oppression through pornography.

Another strategy is to consider how the valued side of the binary is built upon the suppression of various qualities of the under-valued side.

For a woman to occupy the public sphere has historically often been a problem. To enter the public sphere women have to pass as 'men' or else they are subject to definitions of woman linked solely to their private and sexual status. The ambiguity of the public private-woman is clear in her association with the figure of the transgressive prostitute.

Women's presence in the public sphere has been invisible, ignored or erased. Indeed, for some feminists, the public is itself, defined through the exclusion of women.

A feminist position may involve tracing a positive relation of women with the city, making links between women and patriarchy's positive terms, such as male, culture, production, city or public, looking at the ways women have occupied the public spaces of the city, enjoyed the anonymity of urban life with freedom from the constraints of the roles of wife and mother.

Whilst safety is seen as a key issue for women in public space, security devices also carry traces of surveillance. From a psychoanalytic perspective, the watchful eye may be associated with gendered relations of looking and knowing, with a male gaze and masculine formulations of subjectivity and phallic power.

Between Public and Private

Thinking between is a way of moving beyond the binary of public and private. In deconstruction theory — from revaluing one side, to destabilising the pairing — the third and final move is to consider terms which include both and/or neither. This may be the space between public and private one that includes gaps, overlaps and blurred edges. To consider instead that definitions cannot be static over time or space, that public and private are shifting and mobile boundaries — choreographed through looking and moving, determined by personal/cultural/social/historical conditions.

As the privatisation of public space increasingly occurs in all directions — through global extensification and psychological intensification — as ownership of property (land and people) by multi-nationals rises and ever-more sophisticated advertising strategies probe our unconscious desires, it becomes vital that we try to understand what we mean by public and private.

We need to map a new topography of places that exist between the two — spaces of collective action and shared resistance. Places which embody threshold conditions.

The border experience is ambiguous, unsettled and unsettling. The borderline state disturbs us. It is a liminal zone.

Between the 'internal' space of individual subjectivity and the 'external' space of the urban realm are a series of shifting thresholds. It seems that much of the contemporary anxiety about public art today is located precisely on these slippery borders between inside and outside, between private and public.

Public Art: Between Private and Public

To place 'private' art in 'public' urban sites, raises a number of important questions about the definitions, inter-relations and boundaries of the terms private and public.

To place art outside the gallery is potentially threatening, but also means that the role of the artists working in the urban realm is charged.

In public art discourse, 'public' refers to 'site' in its physical state, as it is represented and understood conceptually as a terrain for intervention. A public site might be defined in terms of morphology (outdoors) and/or in terms of activity (outside the art gallery).

However, the so-called 'public' nature of these sites requires closer examination in order to reveal their often rather problematic 'private' status in terms of ownership and accessibility.

For example, public art outside the private institute of the art gallery may still be inside the corporate world of private property and finance, and further still inside the private world of the elite group of artists who get the commissions.

'Art' is most often considered to derive from the 'private' world, the personal interests of the individual artist, whereas 'public' indicates a social group, a number of individuals who identify with one another.

Art itself is often considered a subjective and personal activity, and so the placing of art in public, represents the placing of a private self in a public space – the social space of public art is at once both public and private – 'private' art in a 'public' site.

Artists whose work is concerned with their own private interests, rather than those relating primarily to the social space of the site, (as an architect for example might do), are considered self indulgent and arrogant. On the other hand works which supposedly relate to/grow out of site specific concerns may be criticised as patronising.

Public Art: Between Theory and Practice

Public art affords an uncomfortable relationship with academic research policies. Currently, the highest value is placed on the most private research – on those heavily footnoted articles in missing copies of refereed journals in university library stacks or on the single artists work displayed in the Tate Modern.

Public art rather contradicts this endeavour by valuing instead the outcomes of collaboration with those outside the institution, which exist only fleetingly in city streets.

The place of research into public art highlights the fact that the academic institution also exists in this borderline world between public and private, between the often 'inside' world of theory and the 'outside' world of practice.

Although there is a current fashion for interdisciplinarity, multi-disciplinarity and collaboration, the academic institution has tended to drive a hard line between different disciplines.

I argue that in order to engage with practical problems of public and private space, we must operate at a theoretical level. We must construct what Julia Kristeva has called "a diagonal axis" between theory and practice, "a place between" the two, where a more integrative approach to the making and interpretation of public spaces can begin.

In theoretical terms, critical debates concerning urban space and culture have reformulated the ways in which space is understood. As we have already seen, stemming

from gender theory, the shifting boundaries of 'public' and 'private' allow us to consider the thresholds between inner and outer, subject and object, person and social, from cultural geography, the notion of the 'socio-spatial dialectic' suggests an inter-active relation between people and places, allowing us to consider the city as flux and from anthropology, the term 'material culture' refers to the whole world of cultural artefacts from the macro to the micro, allowing us to view art in relation to the everyday.

There are many locations between public and private – they can be spatial, methodological, emotional – concerned with places, processes and people.

In terms of place...

Many artists operating today are concerned with the kind of sites Michel Foucault might describe as heterotopic. Places already considered marginal, neglected, abandoned in some way, in some way 'outside' conventional ways of operating. Often through their emptiness, such places offer possibilities for imagining new kinds of occupation of space. Artists seek to make work that develops out of a close relationship with the site, work which makes manifest histories previously rendered invisible or which suggests alternative ways of using the space.

Henri Lefebvre draws attention to the possibility of liberation in the everyday. Lefebvre suggests that everyday places, people, processes and products offer multiple possibilities, not least for public artists.

The everyday is constituted through practices such as walking and shopping, and objects such as litter and bricks. The ordinary, the mundane, the repetitious allow a critique of 'fine art' and of 'cultural elitism', instead reinstating the importance of popular culture and the found object where the whole urban fabric can become a kind of art. But if the city is understood as art, when everyday urban fragments and practices already say it all, what is the role of the artist?

In terms of processes...

In Walter Benjamin's work, a dialectical image is a thought which occupies a threshold position in space, time and consciousness: the dialectical image is a constellation of antiquity and modernity, dream and awakening.

In his writing, Benjamin played on the juxtaposition of sub-title and content in each of his prose pieces, using the sub-titles to bring to life private and hidden meanings in the text. In art practice dialectical imagery can mean juxtaposing pairs of images, using text or titles to displace perceived meanings, or placing an object in a site in order to recontextualise meaning.

For Michel de Certeau, the notion of "spatial stories" stresses the spatial element of story telling – stories are events which take place. The spatial story acts as a theoretical device which allows us to understand the urban fabric in terms of relationships between people, things and places.

In contemporary urban and architectural discourse, we are increasingly obsessed by figures that traverse space: the *flâneur*, the spy, the detective. These urban figures are metaphors for our journeys of discovery.

These figures are 'spatial stories' exploring the territories between public and

private, past and future, real and imagined, space and subjectivity. They locate us physically and conceptually in both space and time, allowing us to make links between otherwise disconnected elements of the city. A series of contemporary urban art projects fascinated with notions of dispersal and narrative articulated different versions of the spatial story.

In terms of people...

For Luce Irigaray the potential of the 'to' in her phrase 'I love to you' suggests a new social order of relations between two different sexes. Work made through collaboration with others involves interaction of this nature, where what becomes important is no longer the qualities of particular end products but the processes of making them.

Even if the outcome is not determined in advance, ways in which relationships between artists/architects and their publics are constructed can constitute a major part of the conceptualisation and realisation of the project, providing aesthetic and formal value.

This may tend towards the choreographic, where the work is manifest less as an object and more as an event, a series of relationships people make with one another.

The making and receiving of art work is an economy – a series of relationships of exchange between people. Art is not just produced by artists – it is the product of viewers, users, subjects and urban dwellers of all kinds.

Some interventions choose to subvert the existing hierarchical relationship between viewer and collector, critic and curator, re-positioning the viewer in such a way that they are able to take an active role in the choosing and evaluating of art works.

Such an economy, where the artist relinquishes all control over the final form of the work, and instead seeks to give it to the viewer, might be described in terms of a Helene Cixous's notion of a gift economy or a politics of generosity.

The conditions described through these six writers set out spaces which are endlessly mutable, perceived more as thresholds than places.

Thresholds between Public and Private/Theory and Practice

The threshold condition is both an end and a beginning, a transformative condition.

This indicates to me a place not yet defined but full of possibilities – a place between. This place is neither one thing nor the other. Yet it is not a lack, absence or gap, but rather a potential space, a place as yet undefined. New ideas emerge in such places.

So we return to the beginning.

Almost, but not quite.

Implicit in rethinking public art practice through critical theory, is also a rethinking of 'public' as something necessarily ambiguous and contingent upon the private.

Instead of continuing to aim for a homogenous and knowable public, I would follow Mouffe in arguing for a radical democracy, one which embraces conflict and passion, where the public space of democracy is generated through the unknowability of the social.

It is more useful to focus on the more interesting complexities offered by contested, interstitial and ephemeral spaces between public and private where differences are embraced.

Art has an important role to play here. Compared to architecture, it has been argued that art has no use or function. But art is useful in its provision of moments, places and tools for self-reflection, critical thinking and radical practice.

Art provides gifts of time and space, creating occasions where new mediations between public and private might yet start to be articulated.

References

Benjamin, W (1992) *OneWay Street*, London: Verso.

Borden, I, Kerr, J, Pivaro, A, Rendell, J (eds.) (1996) *Strangely Familar, Narratives Of Architecture In The City*, London: Routledge.

De Certeau, M (1988) *The Practice Of Everyday Life*, Berkeley: University Of California Press.

Cixous, H (1994) 'Sorties' in Susan Sellers (ed.), *The Helene Cixous Reader*, London: Routldge, pp. 37-46.

Deutsche, R (1996) *Evictions:Art And Spatial Politics*, Cambridge, Mass: Mit Press.

Foucault, M (1996) 'Of Other Spaces: Utopias And Heterotopias' in Neil Leach (ed.), *Rethinking Architecture*, London: Routledge, pp. 348-367.

Hearn, J (1991) *Men In The Public Eye*, London: Routledge.

Hill, J (ed.) (1997) *Occupying Architecture: Between The Architect And The User*, London: Routledge.

Irigaray, L (1996) *I Love ToYou*, London: Routledge, pp. 109-13.

Kristeva, J (1998) 'Institutional Interdisciplinarity In Theory And Practice: An Interview' in Coles, A and Defert, A (eds.) *The Anxiety Of Interdisciplinarity, De-, Dis-, Ex-*, v. 2, London: Blackdog Press, pp. 3-21.

Lacy, S (ed.) (1995) *Mapping The Terrain: New Genre Public Art*, Seattle, Washington: Bay Press.

Lefebvre, H (1998) 'The Everyday And Everydayness' in Harris, S and Berke, D (eds) *Architecture Of The Everyday*, Princeton Architectural Press, pp. 32-7.

Miles, M (1997) *Art, Space And The City*, London: Routledge.

Mouffe, C (1992) 'Democratic Citizenship and the Political Community' in Mouffe, C (ed.) *Dimensions of Radical Democracy: Pluralism, Citizenship, Community*, London: Verso.

Pateman, C (1989) *The Disorder of Women*, Cambridge: Polity Press.

Ryan, M. P (1990) *Women In Public: Between Banners And Ballots, 1825-1880*, London: Johns Hopkins University Press.

Squires, J (1994) 'Private Lives, Secluded Places: Privacy As Political Possibility', *Environment And Planning D: Society And Space*, v. 12, pp. 387-410.

Walby, S (1990) *Theorising Patriarchy*, Oxford: Blackwell.

Wilson, E (1991) *The Sphinx In The City: Urban Life, The Control Of Disorder, And Women*, London: Virago Press.

Wolff, J (1990) *Feminine Sentences: Essays On Women And Culture*, Cambridge: Polity Press.

Sally J Morgan

Memory and Identity in the Urban Landscape:
A tale of two Barons

Introduction

In our cities memory and identity are inextricably linked through the ordering and naming of spaces, and the placing of monuments and memorials. Real and false memory is incised into the urban landscape everywhere we look, sometimes as an act of national solidarity, as in the case of the many twentieth century war memorials to be found across the country, and sometimes as an apparent affirmation of local identity. But, as Foucault says, power creates its own points of resistance (Foucault, 1990: 95) and the power over memory and identity held by any dominant social group is rarely left unchallenged. Disruption may come from a rival faction or from discontented individuals.

This text is, in the main, a discussion of a number of such points of resistance to the dominant memorial landscape of Bristol [which will also be briefly discussed]. There are two examples that are of particular interest in this discussion: one that took place at the beginning of the twentieth century and one at the end, and they are, superficially, very different from one another. One arises from a position of personal powerlessness and the other from a position of personal power. Nevertheless the strategies, however limited or liberated by economic necessity, are strikingly similar, as, I would suggest are the motives. This is a tale of two barons: Lord Winterstoke, Baron of Blagdon, also known as Sir William Henry Wills, Bart; and 'Lewis the True Baron', the ubiquitous graffiti-ist of South Bristol.

Memory and Landscape

Simon Schama points out that our word landscape was a sixteenth century adoption from the Dutch. He goes on to explain that in Dutch the word landschap meant "a unit of occupation, ... a jurisdiction" (Schama, 1996: 10), and therefore signified power and control of territory. This understanding of the word provides a particular insight into the ways memory and identity are controlled in our towns and cities. Here issues of occupancy and jurisdiction are sometimes in conflict, as those who 'occupy' a territory may not necessarily have 'jurisdiction' over it. As the French historian, Jacques Le Goff, has argued, memory is history's "raw material" (Le Goff, 1992: xi), so it follows that the ownership of memory is extremely important in the construction of history, of those agreed, shared stories that so influence our sense of national or civic identity. It may be argued that those who control memory control identity, and those who control the landscape control memory. Michael Rowlands has proposed that places and things become 'official memory' by being named, placed [or even destroyed] in a particular way, and thereby becoming a substitute for lived memory (Rowlands, 1996: 10). If this is the case, then the power of naming, placing, or destroying, is crucial to the shaping

of the memories from which stories, histories and identities, may be constructed. Le Goff has said that the historical "document is not objective, innocent raw material, but expresses past society's power over memory ... the document is what remains" (Le Goff, 1992: xi). If you substitute the word 'Landscape' for document then I would suggest that the same principle applies.

Like nations (Hobsbawn, 1994: 77), cities act out collective acts of commemoration, in which they endeavour to justify and ensure the continuity of the present status quo through narrative constructions of an appropriate past. Given that what civic memory "contrives to forget is as important as what it remembers" (Samuel, 1996: x), then the marking of the landscape with names, effigies, memorials and built monuments, is a conscious act of history writing (Samuel, 1996: 443). In this form of public history, identity is agreed, or perhaps, asserted, by those economically and politically able to gain jurisdiction and thereby claim occupancy.

Monuments are in Christine Boyer's words, "sites of rhetorical meaning," and "as staged events they are studied representation of civic authority, becoming the official memory book of significant events or the metaphors of national life" (Boyer, 1996: 343). The emperors of Rome, according to Paul Veyne, confiscated collective memory, "particularly by means of the public monument and by the inscription, in a sort of delirium of the epigraphical memory" (Veyne cited in Le Goff, 1992: 68).

Since the mid-nineteenth century the good burgers of Bristol have managed a similar sleight of hand through the stage management of monuments and memorials to its most favoured sons. In the centre of Bristol, on Colston Avenue there stands a statue to the eighteenth century slave trader and politician, Edward Colston. This sculpture is part of an eruption of commemorative marks made on the landscape of Bristol during the late nineteenth and early twentieth century. As Jacques Le Goff points out:

> From about the middle of the nineteenth Century, a new wave of statuary, a new civilisation of inscriptions (monuments, street signs, and commemorative plaques on the houses of famous people) floods Europe. (Le Goff, 1992: 87)

The plethora of nineteenth century memorials made to Edward Colston bear witness to the construction of this man as a great Bristolian philanthropist. His "great fortune was built largely on the Slave trade" (Little, 1991: 64-66), but this doesn't seem to lessen his civic standing. The source of his wealth is overlooked, and what became the focus are the schools and almshouses that he set up in Bristol during the eighteenth century. It is not incidental to this discussion that Colston was a member of the exclusive and influential section of Bristolian society, the Society of Merchant Venturers of Bristol. This mercantile cartel had been in existence since the sixteenth century, and indeed, still exists today. As the city's controlling oligarchy it was able, over a very long period of time, to indulge in the "confiscation of collective memory" (Le Goff, 1992: 67-68), and much of this subversion and control of civic memory was done through a concentration on the person of Edward Colston. The reason for their lionisation of Colston [as I have argued in length elsewhere (Morgan, 1998: 103-113)] is that in celebrating him, one of their own, they were memorialising themselves and their own

values. It is perhaps not surprising then that he came to represent the power and authority of the merchant class of Bristol, nor that this representation of power should be 're-presented' as an embodiment of benign paternalism.

As Foucault says, where there is power, there are points of resistance (Foucault 1990) and the power over memory and identity held by any dominant social group is rarely left unchallenged. Disruption may come from a rival faction or from discontented individuals, as Foucault puts it:

> These points of resistance are present everywhere in the power network. Hence there is no single locus of great Refusal... instead there is a plurality of resistances, each of them a special case... by definition they can only exist in the strategic field of power relations.
> (Foucault, 1990: 95-96)

Lewis the true Baron

All around the riverside areas of South Bristol, such as Southville and Bedminster, you will find the trademarks of 'Lewis the True Baron' the persistent graffiti-ist of Bedminster. Since the mid-nineteen-nineties his clumsy and misspelled daubings have appeared on every available wall-space and even across footpaths. They are usually done with emulsion paint, as opposed to spray-can, and display no aesthetic qualities whatsoever. His favourite colour at one time was orange, followed by a spate of works in yellow, (although to call them 'works' would be to stretch the definition somewhat). His unembellished name is the important thing, accompanied by a self-aggrandising comment ("Bader [sic] than Bad, Ruder than Rude"), or descriptor – such as 'the Baron' or 'the Dominator'. His graffiti are barely more than hurried scrawlings done with cheap household paint. Sometimes the paint gets spilt and the traces of his panicking footprints can still be half-seen on the pavement months later. As graffiti artists go, Lewis is pretty low down on the scale. As one local 'tagger' (graffiti artist) said to me, "Lewis isn't a tagger, he's just a bloke who writes his name everywhere".

Lewis gave a telephone interview to UWE Fine Art student Simon Horton on video in 1998. When asked what his various catch phrases meant, such as "one time lyrics up your bum", or "Oh no, the Baron's on one again", he gave a revealing, and rather poignant, answer in a distinctive Bedminster accent: "So as people think you've got a personality", he said, "not a lonely, sad, pathetic sort of person".

James E. Young calls the state-sponsored monument the locus for a self-aggrandising national memory (Young, 1992: 52). Lewis operates in the same terms but on a personal and local level. An extremely interesting element in his self-acclaim is his relationship with time. All his graffiti are 'post-dated.' His 1997 signatures are styled: "Lewis 98"; his 1998 graffiti are always dated "99". He projects himself into the future; he imagines posterity. Lewis is trying to control memory.

To Lewis the Baron the landscape is a 'memory document' in the way that I have suggested earlier. He uses the names Baron and Dominator, he says, because a baron was 'like the utmost person' and a dominator 'sort of dominated'. He has also said that to him the city was like a newspaper that he used to 'show I've been there.' He attempts, in the crudest of ways, to dominate the city's memory landscape through the literal

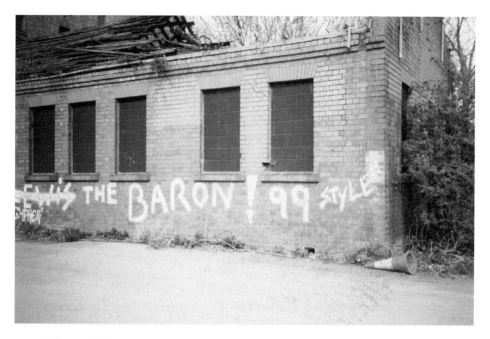

Graffiti by Lewis the 'Baron', Bedminster, Bristol 1998 – Photo: Sally J Morgan

inscription of his identity upon it. At the height of his powers in late 1998 he had, in a way, succeeded in that project. An interviewee in Horton's video expressed an opinion commonly held amongst South Bristol residents [including myself], that Lewis's graffiti was 'almost synonymous with the place'.

No site is sacrosanct to Lewis the True Baron. His name has appeared on listed buildings and, most contentiously, on that symbol of Bristol itself, the Clifton Gorge, where it vies for attention with Brunel's suspension bridge. The main criterion for this huge graffito, which he considered his apotheosis, was not that it should be beautiful, it was that it was legible from the main road on the other side of the Gorge, "You've got to do it so big that you can see it on the other side of the river".

To Lewis each graffito is "like a status symbol", it's "like having the last word". However, Lewis was perhaps too successful in his domination of the landscape, and too persistent in his determination to have the last word. Resistance, to quote Foucault again, "is inscribed in [power] as an irreducible opposite" (Foucault, 1990: 96). His very success, his very power, meant that Lewis would generate opposition out of his own forms, his own strategies. From about the time of Horton's interview, points of resistance to Lewis himself began to appear. Other people, and groups of people, laid claim to the memory/identity-landscape that Lewis had so boldly asserted as his own. For a while the landscape became a palimpsest, an overwritten document, not just metaphorically but in actuality, and Lewis's habit of writing over the complex work of local 'taggers' began to backfire on him. Slowly a variety of people began to react against him, sometimes writing over him, sometimes adding an insult to his name,

and sometimes parodying his style in phrases like "Oh no, Lewis needs viagra". Everywhere you walked in late 1999, and in 2000, instead of "Lewis the Baron" you saw, at one end of the scale of subtlety: "Lewis the Cunt", or at the other end: "Lewis > Cypher" referencing Alan Parker's film *Angel Heart* in which the Devil goes by that name. A whole range of people had begun, independently, to resist Lewis's claims to territorial over-lordship:

> Just as the network of power relations ends by forming a dense web that passes through apparatus and institutions, without being exactly located in them, so to the swarm of points of resistance traverses social stratifications and individual unities. (Foucault, 1990: 96)

Lewis had achieved his end. He had written his name on the landscape. He had been the Dominator, the Baron, but in doing so he had created such a web of reaction that the strategy had turned in on itself and his name became systematically obliterated by the community he purportedly belonged to, the community of graffiti artists. His bid for immortality, his will to impose his identity on the urban landscape of Bristol, seems to have been unsuccessful in the long term. He has been painted over, he has worn away and there are no 'Lewis 2001' slogans to be seen anywhere. In the end his strategies were limited by economics, his means of domination were too fragile to withstand the resistance they created.

Sir WH Wills, Bart

The Baron Winterstoke of Blagdon was born William Henry Wills in what is now South Bristol, but was then Bedminster, in 1831. He, along with his cousin, Henry Overton Wills III, was the third generation of the Wills tobacco dynasty. The Wills family, along with most of South Bristol, was non-conformist in religion and Whig (Liberal) in their politics. The second generation, the brothers WD and HO Wills II, supported the Reform Bill and were members of the Anti-Corn Law League (Watkins, 1991: 28 and 31). As a boy WH was sent to Mill Hill School, set up in 1807 as a "Protestant Dissenters Grammar School" (Watkins, 1991: 32) and received a liberal, non-conformist education. 'Dissenters', as all non-Anglican Protestants were known, were discriminated against in a variety of ways at this time, not least in the field of education. They were not eligible to study at Oxford or Cambridge, and William Henry felt this keenly. As a substitute for going to Oxford where he had wanted to study, he made plans to go to University College London which had been set up precisely to cater for dissenters. However illness made this impossible and he entered the family business instead.

Limitations on the rights of dissenters were not lifted until the end of the nineteenth century and were still very much in play during most of WH Wills' life. *The Merchant Venturers of Bristol* had a long history of discrimination against non-conformists. Edward Colston, the famous eighteenth century *Merchant Venturer* and 'philanthropist', had established a school in Bristol, to be run by the *Venturers*, from which Dissenters were expressly excluded. In its inaugural deeds he states:

> The Master, Wardens, Assistants and Commonalty of Merchant Adventurers in the City of
> Bristol and their successors for ever, hold and enjoy the said Manors and Premises and
> apply the Rents and Profits thereof for the Maintenance, Schooling and Education and
> binding Apprentice of One hundred poor boys. Now know ye further by these Presents that
> I the said Edward Colston do make several Orders Rules and Direction to the end that all
> such Children as shall be admitted to the Hospital may be educated and brought up in the
> true faith and belief of the Church of England and may not swerve, stray or fall off from
> the same. (Colston)

Even boys who were Anglican but who were to be indentured to non-conformist masters were to be debarred (McGrath, 1975: 211) such was Colston's dislike of non-conformity, which, like most men of his rank at the time he considered to be a dangerous, radical heresy, injurious to both church and state.

Whilst the establishment of the Gloucestershire city of Bristol, as embodied by the *Society of Merchant Venturers*, was traditionally Tory and Anglican, the rising classes of the separate 'hundred' of Bedminster across the river in Somerset, were, like most of the population, Liberal and non-conformist. This area across the river and outside the city boundaries, kept separate by tollgates on roads and bridges, was viewed with suspicion by the ruling classes of Bristol who saw it as a hotbed of dissenting sedition. In the year that WH Wills was born, 1831, an Anglican church was built on the south side of the Avon as a response to the number of non-conformist Chapels springing up in Bedminster and to counter the influence of dissenters in the region (Bantock, 1997: 23). When the Bishop of Bath and Wells came to consecrate it a riot ensued and many houses of the affluent across Bristol were destroyed. The Wills' properties, however, were left untouched, their political leanings and religious non-conformity being well-known in the community in which they lived.

WH Wills, as rich and famous as he was, was excluded from membership of, or influence with, the *Society of Merchant Venturers* on a number of counts. Firstly he was a manufacturer not a merchant and thus precluded from membership other than by family connection, which he did not have. He was also not officially a Bristolian because at the time of his birth Bedminster was not part of Bristol. Thirdly his religious persuasion was anathema to the *Venturer's* Anglican membership. And finally, his politics were Liberal, whereas the merchants "members were primarily Conservative in allegiance" (MacQueen, 1976: 8).

So by the end of the nineteenth century, although rich and powerful, WH Wills, like the rest of his family, was an outsider to the long established social order of Bristol. From this point the Wills family, mostly, though not exclusively in the person of William Henry himself, along with other non-conformist manufacturers in Bedminster, such as the Frys who were Quakers, began to constitute a rival power base to the *Society of Merchant Venturers* in Bristol. As their economic power grew, so did their will to influence the mnemonic landscape of Bristol itself.

In 1894, WH Wills was returned to Westminster as the MP for East Bristol, and to mark this event he paid the artist Harvard Thomas to produce a statue of Edmund Burke, who had been the Radical Whig MP for Bristol between 1780 and 1786. The sculpture,

erected on St Augustine's Parade, was unveiled on the 30th of October 1894 and bore the dedication "To his fellow citizens from Sir William Henry Wills, Bart. MP".

One can only imagine the effect on the members of the *Society of Merchant Venturers* at the time, but it must have been a substantial affront to their dignity. In 1868, after a General Election, the Merchants Treasurer, William Claxton, had written:

> The Conservatives are beaten by ... the most violent intimidation from Roman Catholics and Seamen, mobs of organised gangs of ruffians – mostly Irish ... It is almost and indeed altogether a religious question and especially as to the Continuance of Church and State.
> (McGrath, 1975: 255)

For the *Merchants*, to have a statue of a radical Whig Irishman erected in the heart of Bristol by a Liberal, non-conformist, Bedminster-born, industrialist must have felt like pure impertinence. Like 'Lewis the Baron', 'Wills the Baronet' made his mark on the Bristol landscape in a way designed to confront and outrage. However, the *Society of Merchants* didn't take long to respond. By the spring of the next year John Cassidy's sculpture of Edward Colston, the epitome of Bristolian *Merchant* virtues, had been erected on Colston Lane in the centre of Bristol. Supposedly paid for by public subscription, there was a significant shortfall and an anonymous benefactor provided the large amount needed to complete the project.

So in 1886 there was a stalemate in the mnemonic landscape of Bristol. The Baronet had made his stand, and the *Merchants* had responded. In the next phase of this struggle for jurisdiction the *Merchants* upped the ante. They began to think big – they began to think 'Architecture' for, as Lewis put it so neatly when discussing the criteria for a really successful, self-aggrandising, piece of graffito: "It's got to be big enough so you can see it across the river".

On the top of Brandon Hill in central Bristol, there stands to this very day an ornate, Victorian minaret. This is Cabot's Tower, built in 1897 to celebrate the 400th anniversary of the discovery of Nova Scotia by Giovanni Cabotto, (better known by the anglicised form *John Cabot*) the Genoese 'Bristolian' who 'discovered' North America. As I have argued in 'Memory and the Merchants', although the object of the celebration was supposed to be captain Cabotto, the real purpose of the memorial act was to celebrate Bristol's civic virtues as defined by the city's mercantile oligarch (Morgan, 1998: 103-113).

The Tower, designed by the architect Wm V Gough, was 105 feet tall and (Hodges, 1897) was opened on the 6th of September by the Marquis of Dufferin, Bristol born and a *Merchant Venturer*. He arrived by train and was greeted by Bristol's great and good, a group who included the Mayor and Sheriff, Sir W H Wills, Bart, Sir George Edwards, Mr Fry, MP, and the Master of the *Society of Merchants* (Latimer, 1902: 71). He was taken to Brandon Hill where he was welcomed by the Lord Lieutenant of the City (also a member of the Society of Merchant Venturers [McGrath, 1975: appendix]). The memorial's door was unlocked with a golden key, which was then given to the Mayor as the representative of the Corporation to whom custody of the tower was to be committed in perpetuity (Latimer, 1902).

Cabot's Tower, 1897 – photo: Robert Bennett

Present at this ceremony, and active in it, was Sir WH Wills, Baronet. By now the Wills family were perhaps the richest in Bristol. They were at the peak of their success as tobacco importers and manufacturers of cigarettes and were rapidly expanding their business in what is now South Bristol. The tower that was being ceremoniously dedicated to the memory of *Merchant Venturer* achievement in the person of John Cabot could, and still can, be seen from right across the river. At that time it would have been the highest point on the Bristol skyline, and this symbol of Conservative, Anglican, *Merchant Venturer* virtue would have been clearly visible from the Wills factory in non-conformist, Liberal Bedminster. Elin Diamond has argued that "memory performed is an occasion for ... cultural mythmaking" (Diamond, 1996: 8), and this occasion would seem to be an example of this. This performance of a memorial act, its ceremony and its aspirational reference to 'perpetuity' was a deliberate, even laboured, moment of civic mythmaking. It is tempting to think, in the light of subsequent events, that this fact was not lost on WH Wills as he looked at the golden key and imagined the memory of John Cabot as a *Merchant Venturer* hero being inscribed on both building and landscape 'in perpetuity'.

In fact, when the Cabot Memorial Tower was in the process of production, in 1896, Wills was already involved in plans for the building of a civic art gallery, which would bear his name and stand as a memorial to himself. In 1899 he declared his intention that the city have an art gallery, housed in a building that he would pay for that would be "worthy of the artistic traditions of the city" (Walton, 1981: 4). In 1902 the size of his donation was upped to cover the entire costs of the project. This, it is recorded, was done to enable him "to have an entirely free hand" (Walton, 1981: 6). His architect of choice was his cousin, Sir Frank Wills, and the project became a family affair.

By 1905 the gallery had been built along the hill from the Cabot Memorial. This gallery was, of course, not a tower, a symbolic place of surveillance from which one may view the many and all are aware of the possibility of being watched. This was something subtler: an art gallery, a place that would be viewed from the inside as well as outside, and where, as Tony Bennett proposes in his essay, 'The Exhibitionary Complex' that the spectator becomes spectacle (Bennett, 1996: 81-112). Both Tony Bennett and Carol Duncan have seen Victorian and Edwardian galleries and museums as sites of social discipline where the populace may be controlled educatively: i.e. by the example of their 'betters' and by coming into contact with the 'finer things in life'. WH Will's art gallery was a place where people would linger, learn how to behave in refined society, look at art, be uplifted by it – and finally – remember who it was who had afforded them this luxury. On the front of this building, out of all proportion to its scale, is perhaps the biggest dedication plaque I have ever seen. "To his fellow citizens from Sir William Henry Wills, Bart. MP", reads the sign carved deeply in stone and impossible to miss even at a distance. You cannot find yourself mistaken about the building's origins. Once again we are told very clearly who has marked, and indeed defined the landscape in this way, who has jurisdiction – who indeed is the 'Dominator'.

Although this was the last memorial erected by solely by WH Wills, he and the rest of the Wills family had not finished with the mnemonic landscape of Bristol, nor with

their rivalry with the Merchant Venturers. Perhaps unsurprisingly the focus for the next phase of Wills' Civic intervention was educational. As non-conformists the family had experienced religious discrimination, and had felt the fact that they had been debarred from Oxford and Cambridge very sharply. In 1886 WH Wills had contributed to the founding of Mansfield College Oxford, which would be dedicated to the education of non-conformists, and in 1876 a confederation of influential Bristol nonconformists, centred on the Frys and the Wills, brought the University College, Bristol into being. The institution was very small and did not have the power to award its own degrees, but it soon became identified with Non-conformists and Quakers and was felt to be of a Liberal, radical persuasion. As S J Watson puts it, this was the catalyst for "Anglican Tories [to] set up a rival institution through the Society of Merchant Venturers by the name of the Merchant Venturers Technical College" (Watkins, 1991: 112).

When the University College made moves towards establishing itself as a fully chartered university, the Merchants opposed it strenuously and the struggle was maintained until Henry Overton Wills III, WH's cousin, very uncharacteristically intervened in early 1908. He outmanoeuvred the *Merchants* decisively and economically by suddenly donating the then enormous sum of a hundred thousand pounds towards the project (Watkins, 1991: 112).

On June 9th 1925 King George V and Queen Mary opened Bristol University's Wills Memorial Building fourteen years after it had first been designed. Like a Cathedral it had taken years to build, and like a cathedral it powerfully dominated the city around it. It was completed by HO's sons and WH's nephews Harry and George Wills and the words 'Wills Memorial Building' are clearly emblazoned on the front. It is as Roger Gill said, in his essay 'The University and the Bristol Environment' (MacQueen, 1976: 15), "a monument to the Wills Family". The building, especially the tower, has no other purpose other than that of imposing one family's identity on the civic landscape. King George in his address at the opening of the building said that: "The New Buildings of Bristol University are a conspicuous and beautiful landmark on an ancient city, and serve ... to keep fresh the remembrance of a great gift". The building certainly is conspicuous, where the Cabot Memorial Tower stands 105 ft tall, the Wills Tower is 215. It imposes itself on the city from the top of Park street, allowing you to see nothing else on the skyline as you walk up the hill, and, importantly, whereas the Cabot Memorial is most clearly seen from South Bristol, the Wills Memorial Tower dominates the cityscape of West Bristol – the territory of the *Merchant Venturers.*

Conclusion
In marked contrast to Lewis, the economic power of the Wills family meant that their own self aggrandising marks on the landscape have lasted. It will take more than a few cans of spray paint to cover up the Wills Memorial Building or WH Wills' Art Gallery. However, although Lewis's interventions are illegitimate and crude, and the Wills family's are socially acceptable and complex, I would suggest that many of the same impulses are in play. The most basic shared impulse is the urge to leave some trace of yourself in the landscape, coupled with the desire to 'be someone' and to have the world know that fact. This is the desire to influence or control memory.

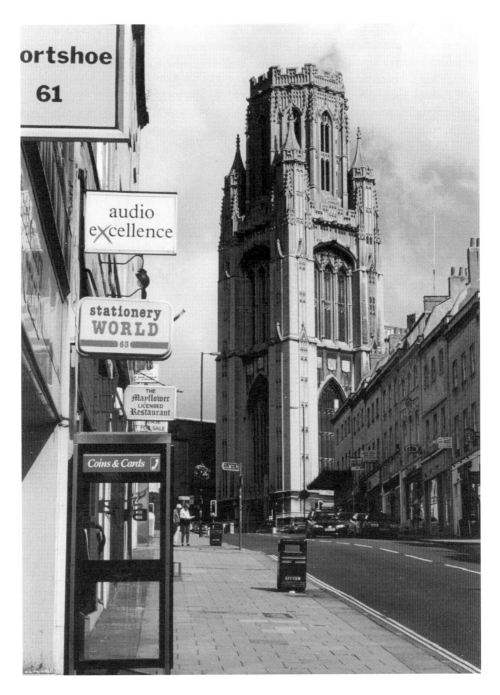

Bristol University's Wills Memorial Buiding, 1925, seen from Park Street – photo: Robert Bennett

WH Wills died childless, his avenues for remembrance were therefore limited. In response to his situation his mementoes became grandiose, became big enough to impress a stranger, especially those extreme strangers; 'posterity'. Lewis, unlike Wills has achieved no monetary success – all he has is a projected fantasy in which he is the hero, the 'Baron', the 'Dominator'. We remember him only because he wills us to.

A more complex motive at work here is related to Foucault's "web of power" and the points of resistance that are generated to it by its own strategies. Lewis wants to be part of a community of taggers who mark the territory of South Bristol with what they would claim to be artwork. He can't be part of that group because his work simply doesn't match their criteria. As he can't co-own their territory he contests it by painting on or over their pieces, or by painting places that they would never choose. This is a very male activity – like a dog scent-marking its territory and another dog marking over it in an attempt to obliterate the other's presence. Likewise, WH Wills, the Baron Winterstoke, was an outsider because of his religion, politics, and place of birth in a city where his wealth alone should have made him naturally influential. Like Lewis he contests the power of the group he may not join by marking their territory, by challenging their right to control civic memory. The other key to this activity, is, I think the pure pleasure of the act of resistance itself. Ian Hodder, the Post-Processual Archaeologist, once did some work with the Nuba people. The Nuba believed that women were associated with the territory inside the compound and men with the land outside. Women were believed to be 'polluting' as were the materials associated with them such as the ashes from the hearth. Women, then, were expected to empty the ashes inside the women's area and not to pollute the outside, the men's area. However, Hodder observed a woman deliberately, and publicly, dumping her ash well outside the compound in the male domain. In doing so "she was acknowledging that the rule existed, but deliberately breaking it" (Johnson, 1999: 105). In my view these two South Bristol boys, Lewis the Baron and WH Wills the Baronet, were indulging in precisely that kind of pleasurable and knowing Foucauldian resistance when they decided to make their marks on the Bristol urban landscape.

References

Bantock, A, (1997) *Bedminster: Bristol*, Stroud: Chalford Publishing.

Bennett, T (1996) 'The Exhibitionary Complex' in Greenberg, R, Ferguson, B, and Nairne, S (eds) *Thinking About Exhibitions*, London: Routledge.

Boyer, M.C, (1996) *The City of Collective Memory*, Cambridge, USA: MIT Press.

Diamond, E (ed.) (1996) 'Introduction', Performance and Cultural Politics, where: Routledge.

Foucault, M, (1990) *The History of Sexuality Volume 1*, London: Penguin.

Hobsbawn, E, (1994) 'The Nation as Invented Tradition', in Hutchinson, J, and Smith, A (eds) *Nationalism*, Oxford: Oxford University Press.

Hodges, E, (1897) *The Cabots and the Discovery of America*, London: Nister.

Johnson, M, (1999) *Archaeological Theory*, Oxford: Blackwell.

Latimer, J, (1902) *The Annals of Bristol in the Nineteenth Century 1887-1900*, Bristol: William George's Sons.

Le Goff, J, (1992) *History and Memory*, New York: Columbia University Press.

Little, B, (1991) *The Story of Bristol*, Bristol: Redcliffe Press.

Macqueen, J.G, and Taylor, S.W, (eds) (1976) *Essays to Mark the Centenary founding of University College Bristol*, Bristol: Bristol University Press.

McGrath, P, (1975) *The Merchant Venturers of Bristol*, Bristol: the Merchant's Hall.

Morgan, S.J, (1998) 'Memory and the Merchants: Commemoration and Civic Identity', in Howard, P (ed.) *International Journal of Heritage Studies*, Volume 4, no 2.

Rowlands, M, (1996) 'Memory, Sacrifice and the Nation', Carter and Hirschkop, *New Formations*, No 30.

Samuels, R, (1996) *Theatres of Memory*, London: Verso.

Schama, S, (1996) *Landscape and Memory*, London: Fontana Press.

Walton, K, (1981) *1905-1980: City of Bristol Museum and Art Gallery*, Bristol: Bristol Museum.

Watkins, J, (1991) *Furnished with Ability: The Lives and Times of the Wills families*, Salisbury: Wills Families and Michael Russell Publishing.

Young, J, (1992) 'The German Counter-Movement' in Mitchell, W.J.T (ed.) *Art and the Public Sphere*, Chicago: University of Chicago Press.

Judith Rugg

Regeneration or Reparation:
Death, Loss & Absence in Anya Gallaccio's
Intensities & Surfaces and Forest Floor

Intensities & Surfaces was commissioned by the Women's Playhouse Trust and was sited in the disused boiler room of Wapping Pumping Station, London from February to April 1996. It consisted of 32 tons of small blocks of ice constructed into one large block and a half ton boulder of rock salt and measured 3 x 3 x 4m. Over a period of three months the ice melted eroding the surface of the block and creating pools of water in which the work and its site were reflected.

In comparison to Richard Serra who sought highly visible locations for his art and "sought sites (for it) that could not be missed" (as evidenced by *Tilted Arc* which was 'overbearing' in scale and for which the site was a function of the sculpture, not the other way round), Anya Gallaccio's works which are outside the conventional spaces of art – *Intensities & Surfaces* and *Glaschu* for example, occupy the neglected and only partly visible sites of empty industrial buildings.

Intensities & Surfaces does not share the pretensions of many public artworks in their role in the permanent transformation of space or perform as a cultural sign of economic ascendancy, nor is it a deception created by the art object to manufacture a 'fake historicism' that heritage culture imposes on old buildings. On the contrary, *Intensities & Surfaces* and *Forest Floor*, another work of Gallaccio's, sited in a Forestry Commission forest outside Oxford, address notions of 'the illusory nature of all experience' through their disintegration and eventual invisibility, returning the spatial elements they occupy to dominance.

It has been noted that "dirt is matter out of place" (Douglas, 1966) and works of art outside the gallery, in spaces not normally associated with or designated for art which do not conform to the conventions of the monument, risk becoming a form of pollution, a fly in the ointment of cultural orthodoxy. Women artists making work in such sites are engaged in a process of risk taking, and as Gallaccio has said "make a lot of mistakes very publicly, more so than studio – based artists". In their elements of opening and revealing, her works relate to the vulnerability both exposed and subverted by feminist performance artists of the 1970s and 1980s. In their addressing of intimate notions of death, loss, absence and desire, and their public exhibition(ism) in outside spaces, *Intensities & Surfaces* and *Forest Floor* are part of the feminist predicament of the engagement with the public and private. Gallaccio's interest in danger confronts the historical threat imposed on women in public spaces and her work deconstructs the Freudian assertion that women represent a de-stabilisation of order. Her strategy to carefully create a work like *Intensities & Surfaces* as a 'good enough' object and then leave it to erode and disintegrate can be seen as a metaphor for liberation – a process which inevitably involves some form of destruction. Women normally maintain the integrity of things and are the traditional

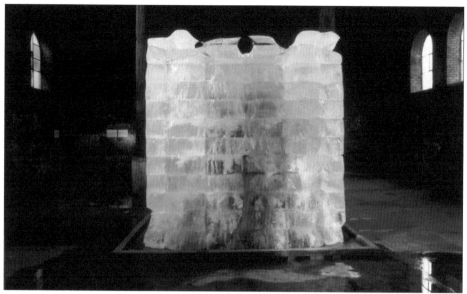

Intensities & Surfaces 1996 – Anya Gallaccio

custodians of the hearth and home, yet *Intensities & Surfaces* is left to leak and spoil, *Forest Floor* is left open to the elements, defenceless against pollution.

Many critics have commented on Anya Gallaccio's references to loss, order and disorder, life and death. Her use of mutable materials create a state of flux and her works critique the stable (art) object. Gallaccio refers to the "nature of disappointment" in her work rather than a morbid fascination with death, but death and loss have associations in her work if not as an end than as a process of transformation. Her use of organic materials which by their nature decay, melt, rot, grow and inevitably refer to themes of mortality and provoke irreversible processes of change. Her references to impermanence and her willingness to let go of the work and grant it a life and death of its own is an acceptance of loss which she steadfastly controls. The works critique notions of stability associated with the masculine; the phallus' association with wholeness; the feminine association with notions such as disorder, pollution, nature and death and the masculine with order, purity, society and life.

Both *Intensities & Surfaces* and *Forest Floor* address death through their incorporation of the abject and the uncanny. Abjection is experienced when, according to Kristeva, the subject breaks away from the maternal figure. In evoking this figure through associations of bodily wastes and references to the border, the works question the stability of identity and point to the fragility of the (male) symbolic order. The base material of *Intensities & Surfaces* (water) has an association with 1970s feminist maintenance art but is no purifier. As women we are closer to ideas of corporeality in our relationship to menstruation, childbirth and blood and the works reference dirt, disorder and pollution and the feminine abject. In *Intensities & Surfaces'* association with body fluids and the corruption of the body, and in both works' dissolution of the boundaries which set them apart from their (public) sites, they examine the abject as 'a

Forest Floor 1995 – Anya Gallaccio

place where meaning collapses' and question notions of fixity in public art as well as those of the material object where meaning may be fixed. *Intensities & Surfaces* becomes polluted in its own dissolution: a dark congealment of part ice, part object undermines its idealised former self. *Forest Floor's* borders suggest disintegration and a sense of threat from its 'natural' environment. At the same time the art object as the 'other' is the site on which anxieties about the loss of control and the dissolution of boundaries (against which the self is defined) are projected.

The commissioning of *Intensities & Surfaces* by the Women's Playhouse Trust was part of the regeneration of Wapping Pumping Station into the Trust's permanent HQ. Gallaccio claims that her work is not about death or decay but "about the changing state of things and concern the fleeting nature of possession", but set on the edge of London's Docklands and the East End the building evokes the past outside of its own frame. The development of the M11, the closure of the docks and the displacement of people which the globalisation of capital inevitably produces are all part of the sense of absence which the work produces. 'All that's solid melts into air' and the demise of buildings like Wapping Pumping Station and of its nineteenth century industrial technology reflect the inevitable obsolescence created by the expansion of capitalism and the internationalisation of production and consumption. The building's late nineteenth and twentieth century role in creating the power for most of London made it one of the most important buildings of the city. New technologies and communication systems have replaced steam power as the primary energy of capitalism. Where once the curtains in the theatres of the West End were raised and lowered from here, now the pipes used to channel that energy are housing optic cables.

Like a tourist in search of the sublime, the viewer's experience of *Intensities & Surfaces* includes the negotiation of the empty passageways and stairwells of Wapping Pumping

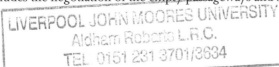

Station. The otherwise disused space evokes a sense of absence: of the work carried out there, long abandoned and of the impending absence of the work itself in its imperceptible dissolution. The presence of the ice block radiating light from its glistening surface which over time becomes rock like and irregular, are part of Gallaccio's play on water, heat, ice and disintegration. All contribute to the association of meanings with the space in a collaboration between artist, artwork, viewer and site. The viewer's compulsion to touch the surface and to leave their mark(s) on it critically reviews this relationship. The water which the work ultimately becomes seems to reflect a sense of melancholy of the previous use of the space-infusing 'the present with the past, instead of doing away with and repressing the past' and suggesting both its and the work's demise and return to the base material from which all things spring and to which we all return. Water is the material 'left behind' by the space itself ("it would have had a lot of water running through it") and is a trace of its function, signifying absence. *Intensities & Surfaces* empties itself into a space devoid of function and becomes transformed into its own leavings. At first it idealises itself and its site as a stage for the unfamiliar but it ultimately fails as a monument: in becoming excessive, it disappears.

Presence, it has been be said, is the essence of sculpture, but Anya Gallaccio abandons the object in her work and the overwhelming characteristic of *Forest Floor* and *Intensities & Surfaces* is that they both ostensibly vanish: *Intensities & Surfaces* in melting, disappears; *Forest Floor*, in becoming overgrown and overtaken by its environment becomes invisible; other works, for example flower works, disintegrate. They are perhaps no longer works, recalled only in the memory of those who have seen or witnessed them, or as colour documentary photographs. In transgressing the notion of the stability of the art object, Gallaccio's works are quietly volatile, unfixed, impermanent, discontinuous: they are transient in an unfixed present.

The formal beauty of *Intensities & Surfaces* covers its built-in imperfection: the ice block contains a rock of salt, catalyst for its disintegration. In its beauty, it is an object of desire radiating light, but time corrodes its status as an object, ultimately forbidding it. In becoming absent, the work illustrates that beauty is not eternal and in their fading, Gallaccio's works illustrate death's presence in life. In the cultural construction of death, death is absence, loss, invisibility. *Intensities & Surfaces* and *Forest Floor* confront the boundary between life and death. In their timely disintegration they hang imperceptibly between the visible and the invisible, between there and not there, the desired object is destroyed, denying possession, stabilising desire which is at the same time sustained by loss in its link with unobtainability. *Intensities & Surfaces* alludes to desire through loss and absence. Desire can only function if it remains unfulfilled ('To provide desire with its object is to annihilate it'). Yet "to understand desire not in terms of what is missing or absent, nor in terms of depth, latency or interiority, but in terms of surfaces and intensities" (Grosz, 1995: 179), seems to articulate Gallaccio's claim that the work suggests meanings such as being "possessed from the inside...by an overwhelming state like love".

Gallaccio's other works in their implications of commemoration and mourning obliquely refer to death: the use of candles for example, in *Untitled* (1996) suggest 'religious offerings made in remembrance'; her use of flowers particularly refer to

death: *Red on Green* (1992) has been likened to a mass grave or a 'shallow tank of blood' and she refers to loss in her use of the dead patches of grass from the imprints of long gone sculptural works in *Keep off the Grass* (1997). The relationship between longing (for those lost) and a melancholic sense of the works' inherent quality of mutability – suggested also by the site which contains it – and the inevitability of death is experienced in witnessing Gallaccio's work; we are the survivors in her 'elliptical, slow motion dramas'.

Intensities & Surfaces comes to life by disintegrating and in doing so disappears, becoming absent; it is in a process of revealing – to 'reveal' absence (all is not what it seems). Both it and *Forest Floor* (in its atmosphere of abandonment) ultimately are as if they have never been. They are veiled and hidden by time, as time's ultimate consequence is absence. Our experience of *Intensities & Surfaces* cannot be visualised in real time as Gallaccio displaces the sense of loss over time and our perception of the changes occurring in it and *Forest Floor* is subsequently itself invisible. Therefore the works' ultimate disappearance becomes something known rather than experienced. Our fear of decay is overcome perceptually in seeking out images of wholeness; we therefore experience the works' absence and dissolution only in retrospect, after the 'event'. Time occludes their transience; *Intensities & Surfaces* and *Forest Floor* create illusions of wholeness although both are in a process of transformation and in witnessing this in the work, we anticipate their loss – we remain, the works disintegrate. The site itself subsequently becomes the object – embodying memory and evoking absence.

Anya Gallaccio's employment of cutting, pouring and fragmentation is part of a range of strategies used by a number of female contemporary artists including Rachel Whiteread and Louise Bourgeois as part of current feminist interest in Kleinian aggression and loss. Klein asserts that subjectivity is partly based on the ego's attempt to deal with loss and *Intensities & Surfaces* is a kind of *momento mori* – the threat of death in life. Gallaccio goes out of her way not to represent the body directly in the work, and subsequently *Intensities & Surfaces* subverts notions of the body as a subject for the erotic gaze. The (female) body in Western art is always a metaphor and *Intensities & Surfaces* can be seen as a metaphor for the body. Ice both suggests the preservation of the body and the dissolution of the body after death and the work is inscribed with bodily characteristics. The salt block inside the work to hasten the melting process, Gallaccio has associated with "a bruise from under the skin" or as a "cancer" or a "heart". Part of her intention with the work was to "make it appear as though it had a life", and its liquid state has been compared with "the womanishness of body fluids". The boiler room can also be seen as a representation of the body in its containment of the work: it is the receptacle of which the work is both the surface and the contained. The pitted and marked surfaces of the work inscribe it with bodily associations and associate it with the body as a site of struggle (against decay, disease and ageing).

In Kleinian theory (see Mitchell, 1991), aggression arises from the fear of the loss of the loved objects. The part-objects of the mother's body and that which it contains (breast, milk, penis, children, womb) are that which the child both fears and attempts to destroy through its teeth, mouth, faeces. *Intensities & Surfaces* as an idealised 'good' object, through the process of its melting becomes a part-object. The work performs an

excretion of itself, and its waste products are in turn part of its destructive process. In this sense the work is part of a group of contemporary feminist artworks which investigate the body and its relationship to the Kleinian death drive. We project both our desire and fear of mortality and our identification with death only through the death of another. *Intensities & Surfaces* as a metaphor for the body, dissolves, missing the corpse stage (the body literally ultimately becomes invisible, absent). The work leaves no 'body' behind, only its liquid excess. Gallaccio can be said to pivot the viewer between the two positions of 'the self' (familiar) and 'the other' (strange, hostile) as the viewer of *Intensities & Surfaces* experiences loss displaced through the object and feels their own vulnerability, subsequently identifying with the process of destruction (made to appear 'natural' by Gallaccio).

Death and femininity are both aspects of 'otherness': femininity is the uncanny difference of masculinity – it is masculine 'otherness'. Gallaccio's works are linked to notions of femininity (e.g. the flower works) and as a product of a woman artist the works could be said to be displacements of 'the female' (woman). The female image and the representation of the female in Western culture is largely defined by men, as a consequence, her image hovers between presence and absence. Woman in her idealised form signifies the inaccessible and represents the male 'lack' and in her position between absence and presence, woman represents *potential* loss. Gallaccio's works imply a paradigm of desire, longing, loss and aspects of femininity. *Intensities & Surfaces* is a process of denial (it occupies the space between a Beuysian order and chaos) and subverts ideas of a continued, secure presence. Notions of stability are linked to both an anxiety about death and the desire for death in order to create stability. Gallaccio's control over the work corresponds to a feminist strategy to create both stability and instability, disrupting the masculine desire for security.

Woman in Western culture is also represented simultaneously as victim and destroyer, the (male) father on the other hand is representative of culture, and the 'lost' (absent) maternal body is a symbol for death. In their allusion to potential absence, Gallaccio's works reference the Freudian 'fort da' game (Freud, *Beyond the Pleasure Principle*). In an interpretation of the game, 'fort' represents the disappearance of the female body (the absent mother) and 'da' signifies the mother's continued absence. The core of the game in its repetition of an unpleasurable/pleasurable experience (absent/present) represents the child's active role in controlling his mother's absence through symbolisation of the disappearance and continued absence of the maternal body. In Kleinian analysis, the maternal body invokes potential loss but the child's control over the (mother's) disappearance, is an articulation of his fear of her loss and the fading of her image.

Repetition can be seen as the search for the lost object and Anya Gallaccio is interested in repetition; it is an aspect of her work. She has repeated actual artworks in different situations (*Stroke, Prestige*), and repeated formal elements in her works (roses in *Red on Green*, individual ice blocks in *Intensities & Surfaces* and *Absolute*, salt blocks in *Into the Blue*, gerberas in *Preserve, Beauty*, coins in *Loose Change*, and oranges in *Tense*) and works are repeated in terms of devices (*Couverture* and *Stroke, Two Sisters* and *Into the Blue* for example). There are also further elements of repetition in *Forest Floor* in the play on images of

'nature' and in Intensities & Surfaces in the ice block and its reflection in the water of the work's demise. Cixous has argued that repetition is a form of enactment of loss, to ensure that nothing therefore is sufficiently 'dead'. The familiar is re-enacted in the unfamiliar site, becoming a temporary triumph over death.

The urge to return to the inanimate state, to the beginning, is conversely an attitude against change and difference. Repetition also represents death through eternity and could be said to recreate the object and therefore overcome loss – through repetition loss is both confirmed and again displaced. In Freudian terms repeating and doubling is an insight into one's own mortality. Doubling can figure as a harbinger of death as well as a compensation for it; repetition as a strategy makes the deceased present again. In repeating works Gallaccio recreates loss and re-presents absence: the game of loss is repeated over and over again. Intensities & Surfaces and Forest Floor can be seen as a part of Gallaccio's site specific works which re-enact (and repeat) the unstable which include Into the Blue, Couverture, Keep off the Grass, Two Sisters. The works become performances of absence, enacting a kind of search for the lost object as in the process of mourning: in the non-acceptance of death, the mourner's idealisation of the lost object restores it through a series of destructive, reparative, aggressive and loving feelings. Anxiety that the (loved) object will be destroyed is co-existent and competes with the desire to control and triumph over it.

For Melanie Klein, repetition is part of the reparation process designed to overcome loss and the impulse to destroy the 'good objects' are part of the subject's anxiety about loss (the mother is the original 'lost' object). Loss is suffered through aggression but through repetition is also potentially recoverable.

Forest Floor (1995) consists of an 8m x 8m section of domestic Axminster carpet with a floral pattern laid on the floor of a forest and fitted around larch and birch trees. Over time, the work becomes overgrown and hidden by its environment.

The domestic is re-located outdoors in an act of recklessness by Gallaccio – the dumping of a carpet in an idyllic setting ("in a bluebell wood") is a 'bad girl' gesture and the association of the home, order and femininity is subverted in the work. The carpet as a focus for the continual maintenance of the home by domestic (female) labour has been extricated as a metaphor for the unheimlich and the agoraphobe's fear of chaos is established. Forest Floor seems to embody a blurring of the real and imagined, making it like a shrine to a work rather than a work. It appropriates the idea of naturalness and parodies itself – the living forest floor and its dead image; representing the artificialisation of the real, erasing the former both literally and metaphorically. It confirms that the lost object (the real forest floor) cannot be retrieved by an image. The image is not a double, making 'real' nature inaccessible, irretrievable even in our memory. The carpet, in smothering the organic, is rendering it powerless, blotted out and repressed, it kills it. It seems to be asserting that death is irrevocable and there can be no return of the natural; it enacts the triumph of the banal over the exquisite. The real is buried under an image, yet there is an uncertainty in the viewer's experience of the work – there is an ambivalence to the scene as one approaches. It appears to be illusory but in actuality it underlines difference. At first one sees it as an uncanny copy, a parody and mockery of nature. In its artifice, the carpet is nature's revenant in its initial

triumph over death. The work in becoming overgrown in time reverses this, re-creating a sense of death and decay by its living material: seemingly to signify death like an abandoned grave.

Forest Floor both embodies Freudian notions of the 'uncanny' and is an evocation of the surfacing of the Kleinian death drive. In the return of its repressed 'nature' it is neither living nor dead, neither absent nor present but stages a duplicitous presence. It utilises both similarity and difference; resemblance (to nature) disguises the animate from the inanimate but in its approximation of the familiar and the unfamiliar it masks death by the substitute of the organic with the inorganic.

Whilst housework (evoked by the carpet) is a defence against dirt, Forest Floor inevitably returns to chaos. Eventually time separates the order of Forest Floor from that which threatens its stability (the forest itself). Defilement is connected with ideas about the boundary, the margin and order (Kristeva, 1982) and the work alludes to notions of the (masculine) symbolic order under constant threat from the (feminine) nature which surrounds it. In becoming polluted by nature, nature becomes the defiler. The work's conditions for potential chaos are also set by its position 'outside' society in the forest (and therefore outside order). "Disorder spoils pattern: it also provides the materials of pattern...Disorder...is unlimited...its potential for patterning is indefinite....though we seek to create order...we recognise that it is destructive to existing patterns. It symbolises both danger and power." (Douglas, 1966: 94). In its attempts to unsuccessfully fix its boundaries the work becomes abject, threatened with extinction from the place both inside and outside its borders. "We may call it a border, abjection is above all ambiguity. Because while releasing the whole, it does not radically cut-off the subject from what threatens it – on the contrary, abjection acknowledges it to be in perpetual danger" (Kristeva, 1982: 4). The living body (the plants) is smothered by the 'dead body' of the Axminster carpet which in itself is also threatened with eventual engulfment by the forest.

Forest Floor deconstructs and investigates notions of surface and superficially of art – art is hoax and in a modernist sense is eventually 'all ground'; the ground overwhelms the 'figure' in a kind of parody of modernist abstract painting in that the empty ground is the subject matter of art from Malevich to Mondrian to Newman. The work suggests that all things in life are ultimately acculturalised so that all life is eventually effaced. Death is at the same time, always culturally constructed and metaphorical – it is outside of human experience and can only be represented.

Femininity and death are linked in Western culture – it is littered with images of (whole) dead women (Bronfen, 1992) and in the development of the cultural myth that death is woman's apotheosis. Anya Gallaccio's disguise of her femininity enables her to enact the male pose and render her femininity invisible. In representations of herself (the photographs of her pouring lead on to a gallery floor where her gender is hidden, for example) she evokes images of Richard Serra throwing molten lead. But in her insistence on employing devices of dissolution and decay, Gallaccio threatens the patriarchal fixed order and the narcissistic, whole, stable object. In Lacanian terms, the masculine illusion of stability hides a lack; Gallaccio's manipulation of notions of (masculine) wholeness and completion in her unstable works both subvert notions of

intactness and provoke the lost object. According to Freud, loss is associated with castration anxiety and injury to the ego, and death is a castrative threat to life. As a woman artist, Gallaccio controls the theme of loss, manipulating its performance and in her use of the unstable spaces of outside environments she confronts the 'vulnerability' of femininity, re-addressing the 'appropriate' spaces for art and their discursive effects.

References

Ash, J (1996) 'Memory Objects' in Kirkham, P (ed.) *The Gendered Object*, Manchester: Manchester University Press.

Barrett, M (1987) 'The Concept of Difference', *Feminist Review*, Summer, pp. 30-41.

Benjamin, A (1994) *Object Painting*, London: Academy Editions.

Berman, M (1988) 'All That Is Solid Melts Into Air: Marx, Modernism and Modernisation' in *All that is Solid Melts Into Air: The Experience of Modernity*, NY: Viking Penguin Books.

Bickers, M (1996) 'Meltdown', *Art Monthly*, April, no. 195, pp. 3-8.

Boyer, M C (1994) *The City of collective memory*, Cambridge, Mass. : MIT Press.

Bronfen, E (1992) *Over Her Dead Body: Death , Femininity and the Aesthetic*, Manchester: Manchester University press.

Cixous, H and Clement, C (1986) *The Newly Born Woman*, Manchester: Manchester University press.

Cousins, M (1996) 'Inside Outcast', *Tate Magazine* Winter, pp. 37-41.

Creed, B (1993) *The Monstrous Feminine*, London: Routledge.

Douglas, M (1996) *Purity and Danger: An Analysis of the Concepts of Pollution and Taboo*, London: Routledge.

Godfrey, T (1995) 'Anya Gallaccio at Stephen Friedman', *Art in America* vol. 83, December, p 101.

Green, D (1997) 'Minimal Interventions', *Contemporary Visual Art* no. 17, pp. 18-25.

Greenham, A (1996) 'Wet', *Women's Art Magazine*, April/ May no. 69, p 23.

Hubbard, S (1998) 'Cheapness Means Forgiveness', *Contemporary Visual Art* no. 19, pp. 54-60.

Hurn, R (1996) 'Louise Bourgois: Deconstructing the Phallus Within Exile of the Self' in De Zegher, C (ed.) *Inside the Visble: An Elliptical Traverse of 20th Century Art*, Cambridge, Mass. : MIT Press.

Grosz, E (1995) *Space, Time and Perversion*, London: Routledge.

Irigaray, L (1977) 'The Mechanics of Fluid' in *This Sex Which is Not One*, Ithica: Cornell University Press.

Isaak, J A (1996) *Feminism and Contemporary Art*, London: Routledge.

Iverson, M (1998) 'In the Blind Field: Hopper and the Uncanny', *Art History* vol. 21, Sept., pp. 409-429.

Kristeva, J (1987) 'Women's Time' in Moi, T (ed.) *The Kristeva Reader*, Oxford: Blackwell.

Lee, D (1996) 'Anya Gallaccio', *Arts Review* vol. 48, April, pp. 10-12.

Lingwood, J (ed.) (1995) *Rachel Whiteread's House*, London: Phaidon.

Lippard, L (1995) 'The Garbage Girls' in *The Pink Glass Swan: Selected Feminist Essays on Art*, New York: The New Press.

McEvilley, T (1999) *Sculpture in the Age of Doubt*, NY: School of Visual Arts, Allworth Press.

Mitchell, J (1991) Selected Melanie Klein, Harmondsworth: Penguin Books.

Musgrave, D (1997) 'Anya Gallaccio' *Art monthly* no. 208, July/August p 41.

Nixon, M (1995) 'Bad Enough Mother', *October* 71, Winter, pp. 71-92.

Norman, E (1998) 'Feminising Public Space', *Issues in Architecture and Design* vol. 5, no. 2, pp. 70-76.

Pawley, M (1998) *Terminal Architecture*, London: Reaktion Books.

Philips, P (1995) 'Maintenance Activity: Creating a Climate for Change' in Felshin, N (ed.) *But Is It Art, The Spirit of Art as Activism*, Seattle: Bay Press.

Pollock, G (1999) *Differencing the Canon*, London: Routledge.

Rimmer- Kenan, S (1988) 'The Paradoxical Status of Repetition', *Poetics Today*, pp. 151-159.

Rugoff, R (1999) 'Leap of Faith' in Chasing Rainbows, Newcastle upon tyne, Locust/ Locus+.

Rugoff, R (1992) 'Dark Art', *Vogue* 82, September, pp. 352-358.

Shone, R (1994) 'Anya Gallaccio', *Burlington Magazine* vol. 136, March, pp. 3-5.

Stewart, S (1984) *On Longing: Narratives of the Miniature, the Gigantic and the Collection*, Baltimore, (MD): Johns Hopkins University Press.

Tanner, M (1994) ' Mother Laughed: The Bad Girls' Avant-Guarde' in *Bad Girls*, New York: The New Museum of Contemporary Art.

Tong, K (1997) 'No Pretentions to Monumental Solidity or Minimal Love' *Make* no. 76, June/July, pp. 6-7.

Worsdale, G (1995) 'Anya Gallaccio', *Art Monthly* no. 188, July/ August, pp. 38-40.

Divers[c]ities

Ron Kenley

Tracing Gazes: Three Aspects of Paris

The aim of this text is to attempt to explore the possibilities presented by the theme 'public space, public realm'. This is of course an old question, so I will not start with its history, except to make reference to institutional invention. Before I am misunderstood, I should explain this statement. Gregory Ulmer, of the University of Gainesville, Florida remarked, in correspondance with me, that alphabetic writing was accompanied by the invention of institutions such as the school and associated with learning practices:

> The modern university is the most recent institutionalization of literacy, part of a tradition going back to the first school — Plato's Academy, founded as part of the Greek appropriation of alphabetic writing. Writing as a technology is a prosthesis of analysis: it augments the analytical powers of human thought tremendously. Plato is credited with inventing the first concept, and his 'phaedrus' is credited as the first discourse on method in the Western tradition. The dialogue form (invented as the institutional practice for his school) was the vehicle for dialectic, the seed from which the mighty oak of science eventually grew. The point of this history is that university disciplines are part of the apparatus of literacy, relative to it, and not absolute. Actually the fit between the world and the disciplinary manner of knowing the world is not all that good. The perfection of literacy in print produced an information explosion that schooling never has responded to completely. Specialization is the institutional form of analysis, and it guarantees its own inadequacy by exacerbating the information overload (producing ever greater bodies of 'literature' about increasingly fragmented parts of what is). (Ulmer)

If we study the contemporary city, a number of logics appear which function as institutions. The circulation of information, of ideas and values across the different logics has the capacity to transform them. The important aspect here is that these logics are determined by different points of view. A number of dependences between the points of view become visible in the process. They define on the one hand the framework in which questions such as 'public space' and 'public realm' may be addressed in an Arts, Design or Architecture course at a university. On the other hand, they allow the consideration of the consequences of any strategic proposals for urban development in a kind of ecology of the city. We could take the example of a food chain (wolves, sheep, grass) and easily find that the interesting link is the one of the wolf to yoghurt, or feta if you prefer. The sense here is the one where a network appears as a figure of the social, rather than the alibi of sociability. I would introduce next my translation from the introduction that Bruno Latour and Emilie Hermant wrote in *Paris, ville invisible*.

Fragments/Traces

Latour writes:

> We will pass from the cold and real society to the warm and virtual plasma: from the whole of Paris seen as a panorama to the multiple Paris, which one can find in Paris, of which the whole, that nothing manages to ever assemble composes the whole of Paris. This invisible Paris is finally describable via the proliferation of IT: this book of images explores the properties of this plasma, which are no longer those of social life, traditionally conceived. Fragmented, fractured, destructured, atomised, anomic (:adj. 1. Socially unstable, alienated, and disorganised: 'anomic loners musing over their fate' Francine du Plessix Gray n. 1. A socially unstable, alienated person: 'The picture [is] about two anomics who inch their way to spiritual rebirth' Pauline Kael), this is how it seems Society presents itself nowadays and this is why it would be pointless to try to make a global theory: impressions, juxtapositions, fragmentation, but more structure and above all, more unity. Or, conversely, everything would be levelled, made uniform, globalised, standardised, liberalised, rationalised, Americanised, watched, while the social world will have disappeared, surviving in reservations, under the name of 'sociability'. The only thing left would be to cling to the last traces of the old world, to the museums of the social: little cafes, small shops, narrow streets, little people. Sociology would be finished; in any case, the time of humanities would have passed. Enough to be suffocated alive.
>
> (Latour and Hermant, 1998: 14)

Latour picks up *en abîme* on essential aspects from the dynamic philosophy of Leibniz:

> And as the same city regarded from different sides appears entirely different, and is, as it were multiplied perspectively, so, because of the infinite number of simple substances, there are a similar infinite number of universes which are, nevertheless, only the aspects of a single one as seen from the special point of view of each monad. (Leibniz, 1965: 157.)

Let us attempt an approach to the public realm through the fragments Latour mentions, the simple substances, or the universes of Leibniz. They are 'infinite' in number, while being different 'aspects' of a single one. The implication has been known and used in differential and integral calculus for a long time. Latour describes the fragments as that which has happened to destroy the traditional cohesion of society, processes at work in the city, such as the fragmentation of a structure which defies unity, so that the society as a whole, is fragmented. A reference for the image of the city of fragments is the work of Aldo Rossi, in particular two buildings, one in Tokyo, the other in Paris (Attali, 2000). The Tokyo building, a hotel, was referred to by Rem Koolhaas as an example of the operative power of difference. Only Rossi, an Italian, could design such a building, and it is only the Japanese who could build it.

The second example, an appartment block in Paris at La Villette has two notable characteristics: it is located at the back of a block, and sports a large cornice. Fragments of the city, fragments of building. Looking at the drawings of Rossi, these fragments offer a critique for the question of context and the arguments of continuity and time

and space. How then does Rossi understand the fragments if not as an archeological restitution of the coherent body of the city? His book, *A Scientific Autobiography* proposes another answer. He refers to the car accident that broke his body and meditates on the bone and flesh fragments in the lifeless, or at any rate, incapacitated body, that was his own. All one has to do, to imagine this, to understand the city of Rossi, is to refer to a painting of the deposition, and the representation therein of the body of Christ: the context and the object (Rossi, 1981).

No Beautiful Images

The proposed law for urban renewal and solidarity in France is similar to the dynamic of urban regeneration existing in the UK. The scale is one of proximity, of neighbourhoods, of quarters of the city. The level of intervention, of stimulation has national ambitions and means. The question of relations between the different powers quickly becomes primordial: the Ministries represented in the commission led by the Min.de la Ville, the 'Mediator of the Republic', with a specific function and role, the prefect and the deputy, and the new function of the 'relay adults' (see below). The state intervenes through education and training, financing initiatives in priority areas, ensuring the co-ordination between: physical interventions; infra-structural development and maintenance; equitable and anti-exclusion policies. The evidence of public space is in its use. The traces of such uses are the means engaged primarily by Latour and Hermant in a work of collaboration seeking the figure of the social in the city, as a way to overcome the obsolete vision of Paris from above. The panorama is replaced by the recording of traces, as and when they are produced: 'We made the opposite hypothesis:...' to follow the ephemeral traces in light, as signals. The social, the snake of the social, the figure of the social will become visible if we manage to link together one by one these traces.

> No beautiful images, only paths; no picturesque narratives, only theory. Theory here makes reference to the etymological dictionary: processions of ambassadors going to consult the oracles. The proposal is to contemplate, not just quote, and to follow the images that we capture: we may get to the cryptic answer of the Pythia to questions such as: 'What are we doing then together?' 'How can we coexist in such large numbers?'
> (Latour and Hermant, 1998: 14-17)

To which can be added "Where?" and "When?" I am about to propose another reading of the theme for discussion in terms of space and time. Coupling space and time together with the description perimeter/parameter opens up alternative scenarios for engagement as well as programmatic proposals. Their territory is defined in the articulation, proposal/potential. This is evaluated in the actual urban situation where the questions pertaining to the public space and realm are formulated. The evaluation takes place through direct negotiation with the actors of the initiatives of urban regeneration or renewal (depending on which side of the Channel you are...). This work can only function if it is allowed to develop a cyclic character, so that its unfolding finds a rhythm and the advance can be measured.

A Methodology of Tracing

I am proposing the above as a methodology which can engage the multiple points of view and the logics they determine, in a framework of public space – public action. And now for the gaze. This approach will replace the panoptic with the oligoptic, as a way to look at traces as they happen, along a predetermined route. A projection of the world on to the world we are studying, at that particular time. So equipped, we can advance to an example, discussed in *Paris, ville invisible*:

> *Désigner* – To designate or the lovers of the Café de Flore. At breakfast, an American couple, him a sociologist, her a photographer. They are about to take a 'cliché', a typical Parisian scene. Lovers engrossed in their conversation, the academician reading his paper, the waiters...'Paris is always Paris' she says, 'Plus ça change...' he responds with a smile. But if one looks beyond this easily fitting schema, there are details which summon up the sense of the scene: A girl sitting at a table, what is her name, what does it remind me of, what is she wearing, what are the stories of those clothes, the lipstick, the died hair...One could say, they are ordinary persons of individual character. On the other hand, they are more like targets for a whole lot of arrows, just like St. Sebastian: the bite of love, jealousy, grace, the fire of ambition, viruses and bacteria. All these vectors are intersecting at the precise location of the girl, offering to define her, situate her, name her, authorise her, carry her away, make her live. But she will not only be the registering target of all the signals; she will also send some back, with a smile, a gaze, a call. The interchanges make up a star shape or even a mesh, a network activated in all directions by all the possibilities. There is no more Element as there is an Ensemble, a provisional network which could be recorded via its traces. This figure of the social becomes bizarre, ignoring the Society as much as the Individual, the local as much as the global. Each part is as large as the whole, which in turn is as small as any odd part. It is an uneven, holey net. (Latour and Hermant, 1998: 70-72)

The first thing to notice is the apparent familiarity of the public space of the Café de Flore. Its institutional logic unfolds in a predictable way. There are no differences, the tourists seem to say. And yet the clothes the girl is wearing are describing loops to do with the locality (the jeans come from Paco, the scarf from a second-hand shop near Barbès, the jumper from Samaritaine, the other side of Pont-Neuf...and, how could I forget, the blouse was a present from). The details, the proximity of description make the public realm visible. The place where it unfolds, continuously leaving the traces of the gaze which may or may not meet another gaze, or just gaze upon a stranger, has the character of public space. When Proust was meeting people socially, with someone new, he would ask them what do they do? Where do they work? In ensuing conversation, he would always ask for more details. It is through the details, through the exhausting of all possibilities of looking at the object in the discussion, that the story could take shape, told from all possible points of view. A public space is then made of available details, a great many of them. The public realm renders them possible. Available means here legible, identifiable, describable. They describe different levels of order, from institutions of public order to customary behaviour in an anthropological sense.

We have seen that the inter-ministerial Commission on the City in France proposes a new kind of public function: the 'relays' (mentioned above). These 'adults' will have responsibility for improving the social links between the inhabitants, the public services and the local facilities. This is about creating visible social links in the neighbourhood (those that leave traces which can be seen), to prevent and resolve minor conflicts of the everyday and to facilitate the actions of local associations and the like. These positions, acting as guides, catalysts, and facilitators are reserved for the local, jobless people. They have to prove their initiative in the voluntary service, belonging to associations that work in the social direction and so on.

In his *Monadology* Leibniz wrote that each element 'conspires' towards the totality in the same way as each individual expresses the whole. This depends on the regulated relationships that exist between the observed elements (objects, actors) and made manifest through their expression. There is no doubt a conspiracy between the public realm and its public spaces. The challenge is to recognise this as it requires updating.

References

Attali, J (2000) *Globalisation*, unpublished Seminar Intervention, EAPS.

Latour, B and Hermant, E (1998) *Paris, ville invisible*, *Les Empêcheurs de penser en rond*, Paris:La Découverte.

Leibniz, G.W (1965) *Monadology and Other Philosophy Essays*, Englewood Cliffs, New Jersey: Prentice Hall.

Rossi, A (1981) *A Scientific Autobiography*, Cambridge, Massachusets: MIT Press.

Ulmer, G, Unpublished correspondence with the author.

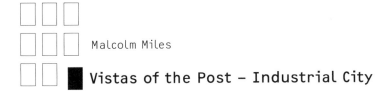

Malcolm Miles

Vistas of the Post – Industrial City

Introduction

At the beginning of the twenty-first century, what are the possibilities for an art of urban engagement, which takes a position on issues such as democracy and power, or social justice, which is committed? It is not a question of mapping past avant-gardes onto today, not because there is nothing to be learned from history, nor even because past avant-gardes failed to deliver a new society, but because history is change. What is understood from past conditions may lead to insights into those present or future conditions most likely to bring about a particular direction of change; but present realities also require understanding if strategies are to be effective.

The circumstances in which an avant-garde might act today include economic factors such as globalisation, and cultural frameworks such as post-colonialism. Economic futures are now determined by trans-national flows of capital, and the industrial base of many cities is replaced by one of new technologies and financial services. This translates into a new urban landscape of enclaved development – office towers and gated apartment compounds, even in cities in non-affluent countries (Seabrook, 1996: 210) – and economic colonialism, as the same logos appear in every city. Following the growth of the financial services sector in the 1980s, more recent trajectories for urban development include the knowledge economy and the cultural quarter, as knowledge and culture become emblems of affluence. But the designation of cultural zones by planners does not mean increased opportunities for art; artists are often the first to lease studios in redundant industrial buildings, but also the first to go when designation as a cultural quarter leads to higher rents. Meanwhile, private development encroaches on public space, and in a world in which there is only one economic system, the operations of capital are set on processing the Earth into dust. The view may seem bleak, but within the dominant society are cracks in which other realities take shape. This essay considers one such case: the *Nine Mile Run Greenway* project in Pittsburgh, which aims to transform a site of industrial waste into a zone of public space and bio-diversity, linking the agendas of democracy and environmentalism. Using participatory processes, the project seeks a negotiated space of change in which an urban future can be shaped through the collaboration of city authorities, developers, environmentalists, water engineers, agronomists, artists and citizens. The essay begins with the context of post-industrial cities, describes the project, then attempts to say why it might be of interest.

New Cities – The Post-Industrial

The planned city of the eighteenth century, such as Washington DC, was set out as a series of spaces for circulation and display. From Sixtus V's erection of obelisks along

the processional routes of Rome in the late sixteenth century (Sennett, 1990: 153), cities become representations of a concept, their form a mirror of an order drawn down, as it were, from above, rather than emerging in the experiences of life at street level. Through planning, cities are conceived, then physically constructed, separating concept and building in a new way. Whilst the mediaeval city grew organically, its streets the gaps between buildings, the new city appears as a design in space, its squares and avenues set out rationally, as if on a *tabula rasa*. This is paradoxical: on one hand, rational thought allows dreams of freedom, and is free from fate; on the other, it objectifies the world as representation, giving rise to fantasy, or idealism. When a concept of the ideal city is projected onto the extant city, the outcome is a dynamic of purification, as elements which seem out of place are excluded or concealed, or, as with the vagrant and insane, confined in institutions. The idea of making new appears at the inception of modernity in Descartes' *Discourse on the Method of Right Thinking* (1637), in which he takes architecture as a metaphor, seeing the buildings designed by a single hand as superior to those to which additions have been made over time. Descartes refers, at the end of the passage, to an engineer (architect) drawing regular places from his free imagining. The planned city, then, begins when an imagined hand traces rectangles in the sand.

But at least, in Charles L'Enfant's Washington, free movement symbolised a free society. According to Richard Sennett, L'Enfant saw the combination of grids and broad diagonals as creating spaces where the social and political might merge, on the model of the fora of the Roman Republic (Sennett, 1994: 267). In The Mall, citizens could move freely in the open air, breathing freely being a metaphor, for Thomas Jefferson, for political freedom (Sennett, 1994: 270). At the beginning of the 21st century, these conditions no longer apply, and, symptomatically, phrases are inserted into the colloquial language of urbanism which retract the autonomy of the Enlightenment city – terms such as 'planning blight' with its image of crop failure, as if natural or inevitable. Yet cities are the most regulated of all spaces, produced through processes of planning and design under political and economic control. The danger, then, of naturalising explanations is that the political is overlooked, as if the logic of progress were to be worked out by 'the powers that be' or its form pre-destined like rain on a bank holiday.

Today, urban development is complex, comprising at least three layers represented by the global city, the cultural quarter, and globalisation as a pervasive condition of both. Briefly, the global city is a single but dispersed entity comprising financial districts in cities such as Frankfurt, London, New York, Rio de Janeiro and Tokyo. These enclaves, signified by utopian office towers and associated apartments, are more closely linked to each other than to adjacent geographical neighbourhoods by information super-highways along which twenty-four hour dealing takes place in stocks and shares, currencies and futures (Sassen, 1991). Canary Wharf and Battery Park City are cases. Cardiff Bay follows a related model, being a zone of high-rent apartments without a financial district. The Bay was enclosed by a barrage to provide developers with vistas of still water, depriving wading birds of a habitat and, in a kind of poetic justice, creating an ecological imbalance which means the barrier now has to be regularly opened to prevent the smell of stagnant waters wafting into the apartments of the new rich. Waterfront vistas, however, are one of the hallmarks of enclaved development.

If the global city, and associated developments such as Cardiff Bay or Baltimore Harbor area, represent one phase of development which peaked in the 1980s, in the 1990s cultural quarters mark a second phase, as a means to revitalise the economies of cities in decline. The Tate at Albert Dock, Liverpool, was a forerunner, again beside a waterfront, though separated from the city by a four-lane highway. The model seems to be that a major cultural institution funded by the public sector – the Tate Modern at Bankside, The Guggenheim in Bilbão, Barcelona's Museum of Contemporary Art (MACBA) – acts as a flagship, denoting cultural status and gentrification. Private sector development then follows, as property values spiral and new businesses in fields such as communication design move in, along with boutiques, hairdressers, wine-bars and florists, and residual populations are evicted. Although this kind of development, as cultural policy, characterises the 1990s, the earlier case of SoHo in New York, discussed by Sharon Zukin (1982), demonstrates the impact of culture on real estate.

Waterfront development and the cultural quarter, then, are signs for the post-industrial city. Cases such as London Docklands, Albert Dock in Liverpool, Temple Bar in Dublin, Cardiff Bay, the waterfront casino-district in Melbourne, and Barcelona's Port Vell represent the transformation of districts of industrial decline into areas of new prosperity. But the diverse publics of a city do not have equal access to the image of abundance. Jon Bird notes that the façades of council estates were renovated and lofts in Docklands were screened from the sight of nearby social housing by "... all the contradictory signifiers of uneven development" such as rebuilt picturesque dock walls (Bird, 1993: 125). Rosalyn Deutsche, like Zukin, writes of the divisiveness of urban development in New York and its link to a rising rate of eviction (Deutsche, 1991a; 1991b). So the rich get richer looking out on their vistas and enjoying the impression of power such distances lend, while the poor are deprived of visibility. And all this is in context of globalisation, defined as the global mobility of capital:

> In the post-space-war world, mobility has become the most powerful and most coveted stratifying factor; the stuff of which the new, increasingly world-wide, social, political, economic and cultural hierarchies are daily built and rebuilt. (Bauman, 1998: 9)

For Bauman, one of the functions of the state now erased is that of maintaining an equilibrium between the growth rates of productivity and consumption; this stands for a wider erasure of intervention to retain stability in the economy for the well-being of citizens of all classes. Faced with the volatility of markets and ease with which production can be switched from one place to another, there is, it seems, little governments can do to protect the interests of their subjects against those of the directors and shareholders of trans-national corporations and privatised utilities. The economic increasingly takes the place of the political, as some trans-national companies have larger budgets than the smaller European states. But if the state intervenes only marginally, what possibility is there for intervention through art?

To approach the question, it is necessary to move beyond a simple cause and effect model. Sociologist David Byrne argues that in the post-modern "dual city", modern, linear causality and post-modern chaotic urban theory – which references chaos

theory in science and denotes an extended intricacy rather than a lack of consequence – can be integrated in what he terms a "post-postmodern programme" (Byrne, 1997: 51). In other words, to liken Byrne's model to the semiotic model of Roland Barthes, cause does not lead to given effect any more than signifier denotes given signified, but may lead to seemingly contradictory effects. For Barthes signification is ideological, for Byrne more pragmatic, but the point is that causes produce effects, and these are determined in a history the complexities of which prevent prediction but open possibility. Byrne's aim is to reclaim a space for intervention through what he terms a "taxonomy of possible urban futures" which assists urban policy to modify the direction of development for the public good (Byrne, 1997: 60), whilst accepting the prospect of a meandering path – the 'drunkard's walk' to Birmingham via Beachy Head. He summarises his position as:

> What this means is agency. It is precisely the human capacity to imagine and seek to construct a future which is so crucial to understanding the potential of trajectories within a complex world. Of course, this does not guide us towards 'blueprints', towards the imposition of centrally designed plans … neither does it leave us with only the market as a method of information processing and decision making. Instead, a participatory democracy has the capacity for collective realisation of urban … futures. (Byrne, 1997: 67)

For artists, or for a re-politicised avant-garde (if there is one), this offers a strategy for intervention through, for instance, the creation of transparency in the urban process. Engagement means working in the crevices of the dominant city, understanding the re-coding which characterises the post-industrial urban landscape, and subverting it from within.

Pittsburgh

Pittsburgh, set in the rust-belt, is not a glamorous city. The steel industry which produced the wealth of nineteenth-century art collectors and philanthropists such as the Fricks and the Mellons has gone, leaving a legacy of brownfield sites as much as museums and libraries. The city has three major universities – Carnegie Mellon, Pittsburgh and Duquesne – and a growing cultural infra-structure which includes the Warhol Museum and the Mattress Factory, in redundant commercial and industrial buildings, respectively. Parts of its waterside have been reclaimed for jogging and cycling trails, one of which will reach to Washington. Pittsburgh is not a metropolitan city, though the first view of it for visitors emerging from the tunnel on the airport freeway is of a skyline as dramatic and architecturally interesting as any. Its population is declining, as graduates move elsewhere, and much of its strategy for a new identity is aimed at reversing this through construction of a knowledge-based economy and an attractive environment.

One of the city's brownfield sites, called Nine Mile Run, is a 238-acre wooded valley adjoining Frick Park to the north and the Monongahela River to the south, used over a period of 50 years, for part of that time illegally, for slag dumping. The site is now re-zoned for housing, subject to a planning partnership between the city authorities and

Pittsburgh: part of a parade of dogwalkers passing a demolition site – photo: Malcolm Miles

the private sector through an Urban Redevelopment Agency. Since 1996, a team based at the Studio for Creative Inquiry at Carnegie Mellon University, a research centre attached to the Fine Arts School, have worked with the city, environmental experts, citizens and the developers in an effort to reserve around a third of the site – the Greenway – as a zone of public space and bio-diversity, which they term a post-industrial landscape. The team – artists Tim Collins, Reiko Goto, Bob Bingham and Richard Pell, and lawyer John Stevens – see their role as facilitators, bringing together groups and individuals who may have widely differing interests and agendas, ensuring that all parties have equal access to information, using walking tours to draw attention to the remaining bio-diversity of the valley, and one- and two-day workshops to go beyond confrontation to a working through of problems and possibilities. The artists are advocates of community needs to the developers, and of a wider city viewpoint to local citizens' groups. They state their strategy, which owes much to Habermas, as:

> Our process is based on the philosophy and ideals of democratic empowerment through discourse. We are a culture that has fractured the complex experiences and understanding of life into specific disciplines ... We have learned to leave our decisions in the hands of experts, yet at the same time we have learned to mistrust those experts depending on who is paying for their opinion. The [Nine Mile Run Greenway Project] team would argue that brownfield sites provide an ideal environment to reclaim the individual's role in the discursive public sphere. We need to reclaim our relationship to complex public issues. (Simony, Brodt and Pryor, 1998: 6)

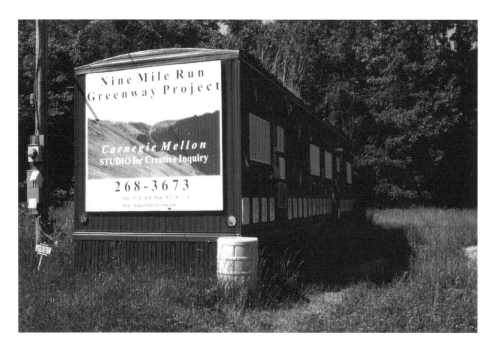

Pittsburgh – Nine Mile Run Greenway project, the trailer on site – photo: Malcolm Miles

The project has no predetermined plan for the site, though it seeks to create through broad participation a design which can be implemented by the city, the developers and other professionals in due course. One specialist input made by the artists is in visualizing ideas which emerge from the workshops, using digital image technologies.

The slag mounds are arid, not especially toxic but highly porous, so that vegetation grows only in pockets where other debris, such as rubble from house demolition, has been deposited. In public perception the site is a dump for old tyres and televisions. To give a greener aspect, some of the steep slopes have been sprayed with a mulch containing oat and other grass seeds. This is not so much to reintroduce growth, which it will do only superficially, but to make the site look green and be seen as a space worth valuing. Along the stream bed vegetation is quite lush, and the valley was identified in 1910 by Frederick Law Olmsted Jr as "the most striking opportunity" to create a public park. Wild turkeys still live in some of the trees, and fish survive in the stream despite the input of sewage from storm drains. The proposed re-development for green public space is not natural, in that to return the site to its pre-slag condition would mean relocating 17 million cubic yards of material, causing environmental destruction elsewhere; like all managed land, the post-industrial landscape will emerge from a series of interventions within a set of conditions. The team carry out research on plants most likely to flourish, based on adjacent sites such as Frick Park, itself a managed landscape from the nineteenth century; trial plantings are carried out, and species which have invaded excessively, notably Japanese knotweed, removed from selected areas. This offers opportunities for public participation, and a trailer parked

where a road crosses the valley acts as a focal point for meetings, walks and planting sessions, and a store for tools. Assumptions that the site was beyond salvage have been shown to be wrong, and an education programme in schools has drawn attention to the causes of pollution. To date, the project has achieved significant shifts in city policy, including agreement that a third of the site will remain green.

Nine Mile Run is contextualised by the complex and interlinked issues of community, democracy and sustainability; and the relation of local initiatives to the process of globalisation. In brief, the project demonstrates that participatory democracy has a capacity to realise collectively imagined futures. But the problem remains as to how notions of community are reconstructed in cities when groups of people are no longer linked by common roots to geographical site. The publics of Pittsburgh include nineteenth and twentieth century immigrants from several European countries, as well as people of colour whose first origins are in Africa and Asia. There is no such thing as the community of Pittsburgh, though residents of specific districts may feel some commonality, whilst their links through work may be city- or state- wide, and through family world-wide. Leonie Sandercock sees narratives of community as in any case nostalgic, arguing that:

> In the light of processes of globalization ... processes which are remapping social relations and giving rise to unprecedentedly complex senses of place and belonging, earlier meanings of 'community' begin to seem naive, if not dangerous. (Sandercock, 1998: 191)

She cites Sennett's discussion in The Uses of Disorder (1970) of myths of community as reinforcements of the values of white suburbia, and notes that narratives of belonging repress difference rather than support democratic exchange. As a model of a sanitised (and anti-democratic) re-invention of community, she cites Celebration, the Disney town in Florida, designed, as she quotes, "to look and feel like a Norman Rockwell painting" (Sandercock, 1998: 194 citing Katz, 1997: 9). Celebration is totalitarian in its regulation of design and hence styles of living, down to details such as the colour of curtains and type of shrubbery. Dean MacCannell points out that the design of houses eliminates privacy and enables surveillance by drawing a sight-line from the front to the back door, in answer to "a nostalgia for central authority that penetrates the most intimate details of life" (MacCannell, 1999: 113). Sandercock contrasts the conformity of Celebration's white picket fences to "communities of resistance" in more deprived areas, but concludes that both state-directed and locally driven planning have transformative and repressive aspects which need to be seen in an unresolvable tension. Further: "What the new cultural politics of difference signifies is that the modernist norm of a homogenous public has become unacceptable" (Sandercock, 1998: 197). But does this mean that people no longer share concerns? Or, that, as Byrne argues, agency is still possible in complexity?

Unlike the community architects and community arts groups of the 1970s, for whom neighbourhoods and their supposed communities provided a kind of art – or architecture – zoo, the Nine Mile Run Greenway project begins from diversity. In part it learns from a pre-history in the politicised happenings of the late 1960s, and, like them,

refuses the convention of the art object and with it the sculpture trail. The work is the social process, for which visual material is a tool, made available for conviviality. The project does not seek an easy solution to the problem of community definition, opting instead to see tensions between viewpoints as a creative territory, which can be investigated through dialogue. But why, apart from its benefits to people in Pittsburgh, should this matter? One response to the question begins in a consideration of publicity, as the space of visibility in society, where people meet and contend.

Thresholds and Boundaries

Cities have always been sites of boundary. From the earliest settlements in Anatolia, around 10,000 years ago, the city has stood distinct from the surrounding land. Henri Lefebvre sees new economic conditions in Tuscany in the thirteenth century as the ground for a new form of perception imaged in linear perspective, and a new form of spatial production, as perspectival order is projected onto reality, translated from description to prescription in the design of buildings, arcades and open squares. This adds internal boundaries to that of the city wall. Lefebvre terms the new spatial process "representations" of space, and sets it in a complementary relation to the "representational" spaces of bodily experience and emotive attachment (Lefebvre, 1991: 38-9). He is careful to point out that the cerebral does not, for villagers and townspeople, drive out, but does dominate, the sensual mode of spatial apprehension (Lefebvre, 1991: 78-9). Perspective, like rationality, can be seen in two ways. Sennett, curiously, writes of it that: "Conventional wisdom usually describes the cultural values motivating perspective as those of a Renaissance version of Hannah Arendt's politics" (Sennett, 1990: 155). The aspect of Arendt's political thought to which he refers, in The Human Condition (1958), is her idea that people become themselves through awareness of the perceptions of others. Maybe, in the Renaissance piazza, citizens are seen and see others in a free association in open space like that of L'Enfant's Washington. Yet who, historically, are the citizens? In Athens it was around one in ten; in late eighteenth century England one in eight of the male population. Today, only half the electorate in the USA vote in presidential elections, and the inhabitants of ghettoised neighbourhoods feel no common ground with the residents of gated apartments. Perspective space, then, with its fixed viewpoint, which Lefebvre sees as the language of the dominant culture, may be not so much a site of freedom as of an ordering of society which involves the exclusion of the majority of people, and the construction of a public realm which excludes diversity – as the idealised city, after successive purifications, excludes dirt.

Today, cultural boundaries exclude minorities, on grounds of gender, ethnicity, sexual orientation and disability, from visibility in the public realm, a realm which Doreen Massey argues is a space for men both actually and in cultural representation (Massey, 1994: 233-8). Crossing the street, in some neighbourhoods, may mean crossing from one group's territory to that of another. But such divisions simply extend the boundedness of cities since the Enlightenment. City planning has tended to be a matter of zoning, and zones, until recent moves to re-integrate inner city areas as spaces of dwelling, work and leisure, tend to be mono-functional as well as gendered. Culture, on one hand, enforces

boundaries through stereotypes of family and citizen; and on the other, with television, merges the public and private when world news is instantly transmitted into the domestic sitting room. Zukin writes of another merging, in which the culture industries are agents for a new language of difference: "… a coded means of discrimination, an undertone to the dominant discourse of democratization" when styles which emerge in street culture are appropriated by mass media as "images of cool" and claims for social justice are in turn redirected as "a coherent demand for jeans" (Zukin, 1995: 9). Similarly, the art market is adept at subsuming to its purposes any deviant art.

Freedom, then, might entail a re-statement of difference. And difference is the pre-condition, for Arendt, for that kind of mixing in the visible society (publicity) which allows what she terms "natality" – a re-construction of the self through the perception and perceptions of others. Kimberley Curtis, writing on Arendt's political philosophy, draws attention to the dangers which arise when presence in the public realm is denied to one group in society, such as Jews in Germany in the 1930s. She writes that Arendt's theory "is fired by a feeling … for the suffering that accompanies the injustice of living in obscurity" and that this is "… because of the way it attenuates the power of mutual aesthetic provocation through which our sense of the real is born" (Curtis, 1999:21). Reality, then, is produced in plurality, and a sense of the real through willing exposure to difference.

Where is difference produced, when production implies a cultural and social construction? Not in perspective drawing, which, along with the conventions of cartography and city planning, homogenises space. Not in globalisation, which subsumes all social forms to that of a free market, which is very expensive for the non-affluent majority. Not in the marketing of consumerist lifestyles in which the world, in an extension of Cartesian representation, is reduced to a quite small set of brands and their logos. But perhaps difference and its counterpart of publicity is produced in the processes used by the *Nine Mile Run Greenway* project, and perhaps it is at this micro-level of the local that resistance to globalisation not only begins but is at all possible. When the team state "Our process is based on the philosophy and ideals of democratic empowerment through discourse" adding that "… brownfield sites provide an ideal environment to reclaim the individual's role in the discursive public sphere" (Simony, Brodt and Pryor, 1998: 6), they echo Arendt's desire for a realm of visibility and contention. If the project produces a zone of public space and bio-diversity, it will have environmental benefits. But it may equally matter as a demonstration that a social process, in which diverse publics and interests are able to negotiate possibilities, partakes of dreams of a world which is better, but is not a dream.

Art in the Post-Industrial City

To sum up: the idealism consequent on rationality, by virtue of its distancing from a world reduced, in Cartesian space, to its representation in signs, has not delivered freedom. Its harvest is bitter, as a false homogeneity produces fragmentation whilst suppressing diversity. So Los Angeles burns, but the story is not all of war. It is also of the right to the city as a site of excitement and conviviality for women and people of colour (Wilson, 1991) and of the need to reclaim the urban as a location for the production of

space by dwellers. This space will be sensual as well as rational, and, unless the Earth is to be processed into dust, it needs to be sustainable. The implication of sustainability is mutability, to be prepared to let go of the brittle imagery of utopia and embrace the imperfections (which are imperfect only as the other of perfection) of a critically perceived and complex reality. Agency, as Byrne argues, remains possible. But, as Laclau argues, it does not produce anything so simple as freedom, more what he terms a negotiated zone between freedom and unfreedom (Laclau, 1996:19). In the post-industrial city, with its global culture of surfaces, the cracks are more evident; these, where contradictions become apparent, are spaces for intervention, through the creation of transparency – exposure, access to information, participation in determination – and through giving form to possible futures. That form, however, is not in allegories of abundance, or landscapes of the far-away, and may be not in the art object as much as the process of facilitation, underpinned by social research and critical reflection.

References:

Arendt, H (1958) *The Human Condition*, Chicago: University of Chicago Press.

Barthes, R (1982) *Empire of Signs*, New York: Hill & Wang.

Bauman, Z (1998) *Globalization: the Human Consequences*, Cambridge: Polity.

Bird, J (1993) 'Dystopia on the Thames' in Bird et al, pp. 120-135.

Bird, J, Curtis, B, Putnam, T, Robertson, G, Tickner, L (eds) (1993) *Mapping the Futures*, London: Routledge.

Byrne, D (1997) 'Chaotic Places or Complex Places? – cities in a post-industrial era', in (eds) Westwood and Williams (1997) pp. 50-70.

Copjec, J and Sorkin, M (1999) *Giving Ground: The Politics of Propinquity*, London: Verso.

Curtis, K (1999) *Our Sense of the Real: Aesthetic Experience and Arendtian Politics*, Ithaca (NY): Cornell University Press.

Deutsche, R (1991a) 'Uneven Development: public art in New York City', in Ghirardo (1991) pp. 157-219.

Deutsche, R (1991b) 'Alternative Space' in Wallis (ed) 1991, pp. 45-66.

Ghirardo, D (ed) (1991) *Out of Site*, Seattle: Bay Press.

Katz, I (1997) 'White Picket Fantasia', *The Age*, 13 Jan.

Laclau, E (1996) *Emancipation(s)*, London: Verso.

Lefebvre, H (1991) *The Production of Space*, Oxford: Blackwell.

MacCannell, D (1999) 'New Urbanism and its Discontents', in (eds) Copjec and Sorkin, 1999, pp. 106-128.

Massey, D (1994) *Space, Place & Gender*, Cambridge: Polity.

Sandercock L (1998) *Towards Cosmopolis: Planning for Multicultural Cities*, Chichester: Wiley.

Sassen, S (1991) *The Global City*, Princeton (NJ): Princeton University Press.

Seabrook, J (1996) *In the Cities of the South*, London: Verso.

Sennett, R (1990) *The Conscience of the Eye*, New York: Norton.

Sennett, R (1994) *Flesh and Stone*, London: Faber & Faber.

Simony, Brodt and Pryor (eds) (1998) *Ample Opportunity: A community Dialogue, final report*, Pittsburgh (PA): Carnegie Mellon University.

Wallis, B (ed) (1991) *If You Lived Here*, Seattle: Bay Press.

Westwood, S and Williams, J (eds) (1997) *Imagining Cities: Scripts, Signs, Memory*, London: Routledge.

Wilson, E (1991) *The Sphinx in the City*, Berkeley: University of California Press.

Zukin, S (1982) *Loft Living: Culture and Capital in Urban Change*, Baltimore (MD): Johns Hopkins University Press.

Zukin S (1995) *The Cultures of Cities*, Oxford Blackwell.

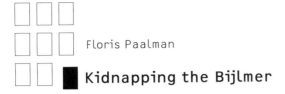

Floris Paalman

■ Kidnapping the Bijlmer

Introduction

From the assumption that the built environment steers perception, determines human behaviour, and thus has an influence on certain concepts and social relationships, arose the rationalist idea of the 'makable society'. Reality could be designed by means of architecture and urban planning. Man would be in a position to realise utopian ideas, particularly through large-scale housing projects like the Bijlmer area of Amsterdam. Architecture, however, does not determine just the behaviour of inhabitants. Inhabitants in their turn determine the function and meaning of architecture.

City of the Future

The enormous growth of cities during the period of industrialisation had given rise to an uncontrollable urban chaos at the beginning of the twentieth century. As a reaction to this, functionalist plans were developed which concentrated on the quality of life, the planned ordering of the environment and the combining of social interests. The first experiments were carried out worldwide between the First and Second World Wars. Only in the 1950s and 1960s could an actual start be made with the construction of functional housing estates on a large scale.

> These neighbourhoods in the (...) metropolitan periphery have been developed as an urban concept based on architectural insights into the separation of functions and into ways of materialising these on the one hand, and ideas about social organisation on the other. That is to say, they usually consist of pre-fabricated tower blocks and are intended as housing – with a lot of light and fresh air – for people who wanting to move out of the inner city renovation areas and for middle-income households looking for a modern lifestyle with family-sized housing, balanced facilities and social equality. (Hulsbergen, 1995: 86)

A radical example of such a functional district is the Bijlmer in Amsterdam. The Bijlmer is characterised by large-scale, communal housing complexes connected to each other by footbridges and interior walkways. The buildings form enormous sculptures in a park landscape, with different levels of infrastructure. The first level is reserved for pedestrians and cyclists, the second level for cars and the third layer for the metro which whooshes through the air. In this concept, the pedestrian is not disturbed by fast traffic, but carefully guided through the environment via measured paths, viaducts, galleries and lifts. The cultural critic Marshall Berman wrote about this comprehensive environmental planning and the striving to make more efficient use of urban space:

> The city development of the last forty years, in capitalist and socialist countries alike, has
> systematically attacked, and often successfully obliterated, the 'moving chaos' of
> nineteenth-century urban life. In the new urban environment...the old modern street, with
> its volatile mixture of people and traffic, business and homes, rich and poor, is sorted out
> and split up into separate compartments....(Berman, 1983: 168)

Where there is a lot of life there is also a richness to experience. When everything and everyone is in motion then different things, according to one's own knowledge and insight, can be combined with each other. There is a continuous stream of varying impulses that ensure that vision is activated. This creates new associations, new ideas, new plans, new strategies. Because of the attempts by policy makers and planners to prevent collisions and conflicts, the space for initiatives of one's own is minimalised. The "anarchic, explosive forces" of "moving chaos" are suppressed, instead of them being used as a source of energy. Because of the resulting vandalism and crime, areas like the Bijlmer are labelled as "urban problem areas". (Hulsbergen, 1995)

The Bijlmer was built according to rationalist principles, as a city of the future. The problem is that, as an idealistic project, the Bijlmer has not produced what people had hoped it would. And that goes not only for the Bijlmer, but for countless suburbs in Europe's large cities. Reference is often made, explicitly or not, to East European cities, where systematic planning was implemented in a radical way. These cities are invariably described in the West as 'drab and grey, where people live piled up as static entities in impersonal, monotonous flats, in vast concrete suburbs'. In fact, the collapse of the Soviet Union has also influenced how people think about 'Soviet architecture' in the West. The question, however, is whether this is correct if one looks at the actual situation in the former Soviet Union, as Bart Goldhoorn has done:

> No less than 90% of Moscow consists of system-built flats. Admittedly, the blocks of flats
> cannot be described as architectural jewels, but given the objectives of Soviet city planning
> – building a lot of living accommodation cheaply and creating equal living conditions for
> everyone – the result is more or less successful. There is even a certain beauty in these vast
> landscapes of seemingly chaotic residential buildings, especially as many of the negative
> side-effects of their European equivalents are completely lacking. There seems to be no
> question of ghetto-forming and the segregation that goes with it. Everyone – worker,
> doctor, engineer – lives in a decent flat. (Goldhoorn, 1993: 33)

Goldhoorn goes on to observe that these areas are more lively than similar areas in Western Europe. His observations are important when one considers the magnitude of the number of systematically built houses in the vast suburbs of Soviet cities. What is more, these quarters were constructed across the entire Soviet Union, in regions with diverse cultural backgrounds. A major contrast exists between the homogeneity of the standard architecture and the cultural diversity of the various former Soviet republics. This contrast is overcome by the inhabitants themselves. Now that the government has withdrawn, the inhabitants are left to their own devices and are able to 'appropriate' the environment. The situation in Armenia is a striking example of this. In the Soviet period

most of the flats there were rebuilt by their inhabitants. This development that has intensified even more since 1991: balconies are transformed into extra rooms, adjacent apartments are joined together by breaking down dividing walls, staircases are knocked up on the façades, cellars are converted into shops or bars and neighbours work together in adding a sort of platform to the building so that everyone can realise their own annex. Shops and markets arise in the public space around these flats, garages are built and little gardens and playgrounds for children are constructed. (Paalman, 1997)

Restructuring

It was recently announced that the Bijlmermeer Renewal Project Office intends to demolish three-quarters of all the blocks of flats in South East Amsterdam (Poorthuis, 1999). This, however, offers no solution to the problems of the Bijlmer, such as unemployment, vandalism, crime, lack of occupancy and rapid rates of moving on. These problems are simply ignored by policymakers and designers who are incapable of finding solutions, are not aware of the processes that are prevalent in the Bijlmer and have no notion of the role architecture really plays in this. "I think that the Netherlands is scared stiff of the form of urbanism present here", writes the architect Endry van Velzen in a special issue of the magazine *Archis* devoted to the Bijlmermeer (Van Velzen, 1997: 39). Arnold Reijndorp writes in the same issue that the Bijlmer evolved out of the model of the welfare state and that, starting out from the same model, solutions were sought to "correct a Utopia that has run amok".

> With the envisaged corrections such runaway ambitions are pruned away in the hope that the Bijlmermeer can be slotted into the mainstream of Dutch public housing and urbanism after all, consisting as this does of developments in a well-considered mix of high-, low- and mid-rise architecture, spread over the public and private housing sectors.
> (Reijndorp, 1997: 62)

What is surprising in the discussion about the Bijlmer is the general lack of insight. Statements are often made on the basis of limited and one-sided research. "The argumentation usually rests on a mixture of facts, interpretations, guesses and the sort of things that are generally accepted as going without saying", is the judgement that Edward Hulsbergen passes in his book *Stedelijke probleemgebieden* (Hulsbergen, 1995: 20). The problems go further than just the architecture. A large number of factors are of a socio-cultural nature. The social influence of architecture and architects, however, is grossly overrated. While in the 1920s it was thought that architects could design society, there is still a belief today that social problems can be solved by means of architecture, so that exactly what is labelled the big mistake is being repeated. It is often apparent that when there is no change in the future perspectives of inhabitants then renovation does little and at the most only helps temporarily, as Jan Willem Duyvendak recently made clear in *de Volkskrant* (Duyvendak, 1999). The origins of social problems are hardly ever of an architectural nature, and architecture offers virtually no solutions to social problems. Architecture is certainly important when it comes to consolidating

the social situation: it gives a society structure and concrete form. But architecture exists on a latent level: it facilitates, accommodates and conserves.

The restructuring of the Bijlmer is not so much about the improvement of the neighbourhood as about big money. Van Velzen noted already at an earlier stage that there are economic interests at stake:

> In the case of the Bijlmer it's worth noting that a few years ago (...) demolishing 25% of the high-rise was considered a lot. But early in 1996 the debate was all about how 25% was nowhere near enough. These are powerful forces — hundreds of millions in subsidies are involved. (Velzen, 1997: 38)

Arnold Reijndorp worked out in *Archis* that for the renovation of the Bijlmer there are 900 million guilders available for spatial interventions and 26 million for socio-economic development (Reijndorp, 1997: 63). In other words, 97% of the total amount involved in the renovation of the Bijlmer is being used for architectural solutions. Those who will benefit from this are not the inhabitants. The government is spending 10,000 guilders per head of the Bijlmer population. That's 50,000 for an average family of two parents and three children. This is in stark contrast to the often very limited incomes of families living in the Bijlmer. Significantly, the liberal Secretary of State for Housing, Remkes, supports the demolition plans for the Bijlmer. Indeed, Remkes even sees it as an ideal model for the demolition of similar neighbourhoods throughout the Netherlands. "Cheap flats and houses in postwar neighbourhoods should be replaced by more expensive single-family dwellings and apartments". Remkes literally wants to turn the underprivileged out into the street, demolish their homes and build expensive houses for the rich in their place. "He expects 'emotional discussions', since the demolition will make it more difficult for lower-income groups to find inexpensive housing" (Poorthuis, 1999). It is sad how short-sighted even the secretary of state can be. For had he gone into the issue of 'gentrification', then he would have been aware of recent developments in London, for example, where the same sort of social housing is not demolished but transformed into luxurious lofts for the well-to-do, and Peter Stuyvesanttown in New York, "which was just as vilified by architects and urbanists in the seventies as the Bijlmer", where, in the words of Reijndorp, "despite the unassuming architecture of the housing blocks", a "fantastic, traffic-free residential park" was created (Reijndorp, 1997: 63). Not that such an approach would help the present inhabitants of the Bijlmer very much. The examples only offer an extra perspective in order to look at the possibilities of the already existing architecture.

Vision

Writing in the NRC Handelsblad, Bernard Hulsman wonders how it comes that the Bijlmer can count on so much approval among architects. (Hulsman, 1999) The Bijlmer may or may not be seen as a total failure, but the fact is that the Bijlmer was built according to a clear vision: a city for the future. Whether one agrees with this vision, and whether this vision is outdated, is another story. The current restructuring plans testify in any case to no vision at all. The only thing that is currently being proposed is demolition and the

construction of nondescript low-rise buildings. There is no looking to the future whatsoever. On the contrary, the plans are a step backwards: safe and old-fashioned in intent. This contrasts considerably with statements by the urban developer Ashok Bhalotra in relation to his concept for a structural vision for the Bijlmer:

> People must think about the future systematically and work for the long-term. I have proposed the year 3000 as the target. What do you want things to be like in the year 3000; what's your ideal vision of the city? Then we have a thousand years to realize it. At least we know then what we're letting ourselves in for. And let's not be afraid to look beyond the limits of the present. But now you go from one meeting to another, and show up too late at both of them. Where's the time for reflection? There isn't any. It's a general malaise. (Bhalotra, 1997: 44)

Hulsman calls the architects who admire the design of the Bijlmer "pathetic sociologists". In his view it is a "miracle" that the Bijlmer was ever created; it was already an "anachronism" at the time, a realisation of Le Corbusier's "absurd plans". The Bijlmer is "with its endless repetition of the same dwellings the perfect expression of a riddled and already then outmoded ideal of equality". Hulsman thinks it is "sick" that Siegfried Nassuth, the designer of the Bijlmer, was recently honoured with the Oeuvre Prize from the Amsterdam Fund for Art, Design and Architecture (Hulsman, 1999). The big mistake made by Hulsman, and many others, is that he sees architecture as something static, as something that is finished as soon as it is handed over by the builders. However, an architectural concept is not finished at the moment it is realised. Furthermore, a design is not the cause of a particular consequence. Architecture only comes to life when it is used and when it is appropriated and altered by the users. Architecture offers a framework in which to act. Within this, users create their own routes and structures, making use of available materials. To this extent architecture provides possibilities. The experience of architecture is thus dependent on what is possible rather than what has been completed. "The demolition of a quarter of the thirty honeycomb shaped blocks of flats and the renovation of some of the others have not brought about the improvements that the Bijlmermeer Improvement [sic.] Project Office had anticipated in 1992", reports Hulsman (Hulsman, 1999). The conclusion that the Office draws from this is that three-quarters of all the flats have to be demolished – whereas they themselves acknowledge that the previous demolition has had no effect. The problem is the persistent belief that architectural interventions offer solutions. No account is taken of the actual habitation and experience of the architecture, of occupants and the way they experience the environment.

Perception and Use

Policy makers and designers should look at the way people organise their houses, as well as the way they deal with public space. Movements in the home and routes through the city need to be studied. People use mental maps for orientation. Specific elements form orientation points, while other elements are hardly noticed, even when they are prominent in a material sense. In experiencing the environment small-scale

Bijlmer: appropriation of public space – photo: Floris Paalman

things are of greater significance than formal structures, which can often only be identified from a distant view. A building is never experienced in its entirety. Users always pay attention to certain parts, such as their own home in a block of flats, which is furnished without paying any heed to the intention of the designers. The meaning of architecture is not determined just by the concept underlying it. Meaning is created through use, by the practice of everyday life.

We should look at the structures that inhabitants themselves develop in the environment, how they appropriate their surroundings. Something like this was already noted by Van Velzen, referring to the small-scale, semi-legal businesses, the so-called 'informal economy' of the Bijlmer. "I believe you have to think of a way of making space for that. I don't think it's enough to tackle the Bijlmer on the scale on which it was conceived" (Van Velzen, 1997:38). Bhalotra also talks about the informal economy,

> where the Bijlmer residents have 'kidnapped the city'. We've checked out where the activities are. And then you see the most important points: a temple here, a meeting place there, or newly dug allotments. These are the things that need keeping as markers for the new city. You have to say to the inhabitants, 'these things are yours'.
> (Bhalotra, 1997: 43)

But what happens when three-quarters of the surroundings are demolished? Then all the structures that the inhabitants have developed themselves are destroyed. The

Allotments in the Bijlmer – photo: Floris Paalman

ways of living the inhabitants have developed is denied and the diversity of cultures in the Bijlmer is ignored. If one really wants to make use of the 'multicultural society' then the very least that has to be done is to allow room for the inhabitants' initiatives to develop, according to their own ideas. At the moment, only solutions from outsiders are considered, ones that have been developed within the model of the welfare state. As Reijndorp writes,

> Along with an approach directed primarily at extending the mechanisms of the welfare state (more 'state'), greater attention is required for the Bijlmer's 'city potential', for the enterprises and activities often invisible to that 'state'. (Reijndorp, 1997: 62)

Industrially manufactured housing arises out of general, universal ideas. Through appropriation, however, it acquires an identity of its own. A block of flats can therefore be regarded as a 'shell'. If policymakers were to give inhabitants a free hand in designing the individual residential units, then the architecture would adapt itself and diversity would be created. It appears that standard blocks of flats can easily change in this way. All in all, even the most monumental structures can be characterised to a large degree as dynamic.

If 900 million guilders were to be invested in research and stimulating the inhabitants' own initiatives, then the Bijlmer could grow into an economically and culturally healthy neighbourhood, according to its own model, and without radical changes to the existing buildings. In order to bring this about, insight has to be gained

first and foremost into how inhabitants experience and appropriate the Bijlmer. The insight thus acquired can then form the basis for thinking, together with the inhabitants, about the way that policymakers and designers could support and, if necessary, streamline initiatives.

References

Berman, M, (1983) *All that is Solid Melts into Air*, New York: Verso.

Bhalotra, A, (1997) 'Goodbye to Utopia', in: *Archis*, no. 3.

Duyvendak, J. W, (1999) 'Geef wijk niet de schuld van achterstand', in: *deVolkskrant*, 4 Dec 1999.

Goldhoorn, B, (1993) 'Struggle for Life', in: *Archis*, no. 12.

Hulsbergen, E, (1995) *Stedelijke Probleemgebieden*, TU Delft: Delft Publikatieburo Bouwkunde.

Hulsman, B, (1999) 'Herzien', in: NRC *Handelsblad* 8 Oct 1999.

Paalman, F, (1997) *Visotkek, bewegend steen*, unpublished Dissertation, University of Amsterdam.

Poorthuis, F, (1999) 'Remkes wil oude huizen slopen voor dure huizen', in: *deVolkskrant*, 10 Dec 1999.

Reijndorp, A, (1997) 'Between city and state. Social renewal of theBijlmermeer', in *Archis*, no. 3.

Van Velzen, E, (1997) 'Aesthetics doesn't interest me', in *Archis*, no. 3.

This text is reproduced with permission of **Sites and Situations** *Publication, Willem de Kooning Academy, Rotterdam.*

□ □ □
□ □ □ Jesús Pedro Lorente
■ ■ □ ■ **Art Neighbourhoods, Ports of Vitality**

Introduction

Port cities have a special cosmopolitan charm which makes them particularly attractive to artists and – no less interesting for researchers in urban studies – most prominently those studying urban decline and redevelopment. This is because many traditional port cities are suffering heavy unemployment since the introduction in the 1970s of containerisation, which required new deep-water ports. What happened in Montmartre and Montparnasse in the Paris of the *Belle Époque*, can happen again in a derelict port area, as it occurred in the SoHo district of New York in the 1970s or the Temple Bar area of Dublin in the 1980s. Yet the special contribution of the arts to urban development is usually analysed as a matter of heritage. At most, certain publications have paid tribute to the role of new cultural venues as 'flagships' of image-management and urban regeneration. My aim is to point out that the birth of art districts is not merely the consequence of a renewal process but also a catalyst for the further re-use of other nearby derelict buildings for art purposes and, in general, for the boosting of standards of living. This is not another study of the trickle-down economic benefits created by cultural policies in distressed areas, but a plea for art investments to be wisely devised, aiming to produce knock-on effects in cultural targets. In order to emphasise this perspective the title chosen for this essay avoids the term 'urban renewal' usually linked to physical change, preferring instead 'urban regeneration' – the revitalising not just of dilapidated buildings but also a deteriorated quality of life.

Previous work on this topic has shown very interesting examples in districts of New York, Baltimore, Paris, Dublin, Barcelona, Berlin and London. But obviously in such rich and burgeoning cities urban revitalisation has been boosted by an array of vested interests, among which the arts sector was just one – and not necessarily the most consequential. No matter the size and history of the arts presence in particular districts, it seems that any derelict area in the heart of a prosperous city is bound to be revitalised by urban developers anyway. However, the prospects of redevelopment are less likely when dereliction lies in the middle of a declining city facing economic recession, unemployment, depopulation, social/ethnic unrest, and physical decay. If we can show that even in such adverse circumstances, arts-led regeneration can prosper, then we would have demonstrated its deeds beyond doubt. Liverpool and Marseilles are such cases: in the last decades everything seems to have gone wrong there, except the arts, which constitute the most world-renown winning asset of both cities' limited resources. Indeed, it is their cultural glamour that makes Liverpool and Marseilles especially interesting amongst many other cases of recent urban decay. As if to compensate for their decline in economic status and political context, both cities rank very high in the arts. The

two cities have become famous in modern times for performing arts and popular music, which has no doubt played a part in encouraging people to take a pride in their local life, and both cities passionately support the high profile of their football teams. Less celebrated is perhaps another common cultural characteristic, Liverpool has the most notable network of museums in England after London, whilst in France, Marseilles is second only to Paris. Moreover, the density of studios in Marseilles makes it the second highest artist population in France whilst Liverpool has more artists per head of its multicultural population than anywhere else in the country.

Arts in derelict quarters:
Historical precedents and recent trends

In what used to be East Berlin two former breweries of the Prenzlauerberg district are now very popular drinking, shopping and art places for the urban flâneurs and night socialites. Every year, new examples of these kind of grassroots initiatives are mushrooming all over Europe. But the installation of artists in forlorn urban spaces is by no means a new phenomenon peculiar of our time. Ancien Régime courts used to accommodate scholars and artists in the rooms of aristocratic palaces, or in disused buildings. For example, when Versailles became the official dwelling of the French Court, two Parisian palaces deserted by the royal family were gradually handed over to artists and craftspeople. A number of studio apartments for artists were allowed between 1608 and 1806 in the Louvre, some of them near the stables, others above the Grande Galérie, while part of the abandoned Luxembourg Palace was offered to the painter Charles Parrocel in 1745. This practice became an established policy after the French Revolution. The Church of Cluny, the Chapel of the Sorbonne, the Convents of the Petits-Augustins, Carmes and Capucins, the Louvre and many empty palaces abandoned by the enemies of the Republic, were partly given to artists. One hundred years later the Bolshevik Revolution did the same in Russia. As much as this cultural practice was grounded on what Aloïs Riegl called the monument-value of some architectural heritage, this was perhaps a corollary of the fact that such buildings were in many cases the only sites available. Similarly, the re-use of abandoned buildings for museums has been a key cultural policy since the French Revolution, when many deserted aristocratic palaces and deconsecrated churches and monasteries were turned into art galleries. Of course, that was mainly a political move, by which spaces hitherto closed to the general public were opened to the citizens. Nevertheless, it is clear that such a policy contributed to the conservation of historic buildings threatened by ruin and disrepair. Such was the case of Alexandre Lenoir's Musée des Monuments Français at the Petits-Augustins, and also of the Conservatoire des Arts et Métiers at the Abbey of St. Martin-des-Champs. This was soon emulated in the provinces in the locating of other well-known art museums. For example in Strasbourg the palace of the prince-bishops, in Dijon the palace of the earls of Bourgogne, in Lille the Recollets convent, in Toulouse the Augustins, in Reims the Abbey of St. Denis, in Arras that of St. Waast, in Lyon the Abbey St. Pierre and in Aix the Hospitaliers Priory. In nineteenth century France alone the list seems inexhaustible! But soon neighbouring countries followed suit, installing some of their most prestigious art museums in former palaces – like the

Tacheles Cultural Centre in East Berlin: ruins of a bombed shopping mall now used by artists –
photo: Jesús Pedro Lorente

Fine Arts Museum of Brussels at the Ancienne Cour or the National Museum of Sculpture at the Barghello in Florence – or in ex-religious buildings – e.g. the Museo Nacional de la Trinidad in Madrid and the Germanisches Museum of Nüremberg.

Nevertheless, interesting as the above examples might be as historic precedents, it seems that the present vogue of bringing the arts into disused buildings is a new trend that started with the economic restructuring which took place after World War II. Entire inner-city industrial quarters born on the wake of early capitalism became obsolete and redundant, but their brick and cast iron buildings infested with rats, revealed themselves to be attractive to artists because the rent was cheap. Converted factories, workhouses, slaughterhouses, hangars, silos and warehouses allowed a modern return to the role of the artist as host of meetings, parties, debates and artistic 'happenings'. These vast spaces made possible the creation of large-scale artworks, so typical of the artists of Abstract Expressionism, Pop Art and Minimalism. These pioneers in the re-occupation, legal or not, of such buildings during the 1950s and early 1960s New York, then emerging as world artistic Mecca, produced the most influential examples, like Andy Warhol's *Factory* or the co-operatives of artists living in SoHo lofts promoted by George Maciunas and the Fluxus movement (Zukin, 1982; Simpson, 1981; Broner, 1986; Crane, 1987).

Thus, thanks to the initiative and vision of some social outcasts, jewels of a then devalued heritage of 'industrial archaeology' escaped destruction. The agitated new life of these places embodied the alternative culture of the late 1960s and early 1970s. In Europe, as in the USA, former commercial/industrial capitals hosted famous examples of this urban fashion for art venues in alternative places: London (*Albany Empire, Arts Lab, Middle Earth, Oval House, Round House*), Amsterdam (*Melkweg, Paradiso, Kosmos*), Hamburg (*Die Fabrik*), Copenhagen (*Huset*) and Brussels (*Ferme V*). When a 19th-century hospital in Berlin was transformed in 1973-76 into Künstlerhaus Bethanien, a cultural centre and studios for artists, the re-use of warehouses and similar industrial edifices for artists' studios had become a common policy. This was especially true of London, allegedly the city with the largest population of artists in Europe, where during the last twenty years hundreds of buildings have been converted by developers, artists' co-operatives, and artists' associations like *SPACE*, created in 1968, or *ACME*, established in 1972, (Williams, 1993; Jones, 1995). It has been primarily thanks to such well-established initiatives that 'industrial archaeology' sites with their huge brick-made vaults have become so much in vogue as a setting for artists.

Most interestingly, modern artists and art critics love these new kind of spaces, considering them as challenges to contemporary creation. Since 1983 there has existed a European network *Trans Europe Halles*, linking independent art centres installed in warehouses, market-halls, factories, etc. Membership now stands with around twenty or so members: *Bloom* (Mezzago, near Milan), *City Arts Centre* (Dublin), *Confort Moderne* (Poitiers), *Halles de Schaerbeek* (Brussels), *Huset* (Aarhus), *Kaapelitehdas* (Helsinki), *Kultur Fabrik* (Luxembourg), *Kultur Fabrik* (Koblenz), *Kulturhuset* (Bergen), *L'Usine* (Geneve), *Mejeriet* (Lund), *Melkweg* (Amsterdam), *Moritzbastei* (Leipzig), *Retina* (Ljubljana), *Rote Fabrik* (Zürich), *The Junction* (Cambridge), *Ufa-Fabrik* (Berlin), *Vooruit* (Gent), *Waterfront* (Norwich), *W.U.K.* (Vienna). A number of associated-members complement this register: *Hôpital Ephemére*

Richmond House in Hackney, London: a former garage now headquarters of MOMART and reused by the association SPACE for artists' studios – photo: Jesús Pedro Lorente

(Paris), *La Friche Belle de Mai* (Marseilles), *Ileana Tounta Art Center* (Athens), *Kulturhuset USF* (Bergen), *Mylos* (Tessalonica), *Multihus Tobaksfabrikken* (Esbjerg), *Noorderligt* (Tilburg), *Petöfi Csarnok* (Budapest), *Retina-Metelkova* (Ljubljana), *Tramway* (Glasgow).

Now we see the emergence of another European network, younger and with no name, rules or definition, linking artist-run organisations. Many of the groups and spaces belonging to it are situated in urban regeneration quarters – for example BBB in Toulouse, B16 in Birmingham, *Catalyst Arts* in Belfast, *Cubitt* in London, *Peripherie* in Tübingen, *Purgatori* in Valencia, *Raum für Kunst* in Graz, or *Konstakuten* in Stockholm.

A tale of two cities: Liverpool and Marseilles

The urban fabric of Liverpool and Marseilles is different from that of most European metropolises. A geographer consulting modern maps will find they are the capitals of two densely urbanised regions called Merseyside and Provence-Alpes-Côte d'Azur, but these correspond to the new administrative boundaries put into effect in Britain and France since the 1970s. In fact, neither Liverpool nor Marseilles had, historically, a subordinated hinterland, for one was part of Lancashire and the other used to depend on Aix. Similarly, a traveller approaching them by land or by sea will be misled by the typical silhouettes towering over their cityscapes, the Anglican and the Catholic cathedrals in one case, the Major cathedral and the Basilica of Notre-Dame de la Garde in the other: actually, these are quite recent monuments. Liverpool received a charter as early as 1207 and Marseilles, established in 600 BC, can boast to be the oldest city in France, but neither of the two was an historic cathedral-city. Only in the seventeenth

and eighteenth centuries did they become booming and massive cities. Subsequently, at the peak of British and French colonialism, they became the main ports for those embarking for the colonies, for the importation of raw materials from these colonies, and for the exportation of manufactured goods to them. Liverpool was designated, during the nineteenth and early twentieth century, with the *sobriquet* 'Gateway to Empire' and Marseilles was then nicknamed 'Porte de l'Orient'. Accordingly, their most characteristic urban landmarks are the stone *façades* lavishly built on the main waterfront to accommodate the central headquarters of the navigation or insurance companies, and the functional brick-architecture of the docks and numerous warehouses which mushroomed in the vicinity of the port to keep stocks of cotton, timber, tobacco, sugar, food (Smith, 1953; Bailey & Millington, 1957; Sammarco & Morel, 1985 & 1988; Roncayolo, 1990; Aughton, 1993; Hughes, 1993).

These facilities became obsolete in the aftermath of World War II. The docks and railway goods terminals and warehouses were shut down by containerisation. Deeper waters, larger hangars and parking-sites were required instead of the old linear docks to locate bulk terminals, container ports and roll-on/roll-off methods of loading and unloading ships. Hence, in the 1960s and early 1970s, the MDHC (Mersey Docks and Harbour Company) and the DATAR (Délégation à l'Aménagement du Territoire et à l'Action Régionale) created concrete ports, gaining new access to the sea, in Seaforth and Fox-sur-Mer respectively (Hyde, 1971; Al Naib, 1991; Bonillo, 1991; Borruey, 1992; Borruey & Chaline, 1992; Brunier, 1993; Hughes, 1993; De Roo, 1994). Moreover, not only was the bulk of port-related activities transferred out of Liverpool's and Marseilles' city centres, but also the ownership of their merchant, industrial and food-processing business was taken over by international corporations based elsewhere. This became of great consequence for the present physical decay of both cities. The new political and economic realities in Europe did the rest. With the decolonisation process and the launching of the European Community, both cities have found themselves far from the new routes of wealth. Since Rotterdam acts as the central port of Europe, its more peripheral competitors have been condemned to languish in the backwaters and the urban effects of this are especially manifest in Liverpool and Marseilles, although this is also true in Catania, Genoa, Vigo, Bilbao, Bristol, Glasgow, Antwerp and Hamburg. Economic decline, unemployment, crime, depopulation, urban dereliction, political radicalism and social violence have been endemic in Liverpool and Marseilles since the world economic crisis of 1974, with particular virulence perhaps in the early 1980s (Cousins et al, 1980; O'Connor, 1986 & 1990; Becquart, 1994).

However, the shifting geography of macro-economics does not explain all the misfortunes of Liverpool and Marseilles. Neighbouring towns like Blackpool, Southport and Chester on the one hand, or Nice, Cannes and Arles on the other, enjoy a better fate, related to their popularity as tourist resorts and, increasingly, as retailing centres. But the counterpoint is still more striking when contrasting Liverpool and Marseilles to their great rivals, Manchester and Lyons; these traditional hubs of textile manufacturing have successfully overcome their post-industrial crisis to become fashionable for their tertiary sector. Thus, Liverpool and Marseilles are mainly suffering from a problem of poor self-image. Yet, no matter how strong the criticisms, it is

curious the level of attraction and personal attachment the two cities provoke amongst both locals and foreigners. They have a special charm; people might find them environmentally degraded, dirty, strident, dangerous, but never unattractive. There is a cultural dimension to this. Liverpool and Marseilles are vastly proletarian, cosmopolitan and multicultural cities. Their people are renowned in their respective countries for their vivacity, humour, strong clan loyalties... and for speaking a very peculiar English and French. All this is just commonplace, but is part of their glamour and cultural image (Baillon, 1989).

Recently, both cities developed a cluster of museums in areas of urban regeneration. A gallery of arts and crafts – Maison de l'Artisanat et des Métiers d'Art – was created in 1983 and located in Marseilles' newly restored seventeenth century naval dockyard of galleys. Also in Marseilles, a new Gallery of Contemporary Art opened in 1993 in a modern building aping industrial architecture, while in Liverpool the former Midland Railways Goods Depot has been restored to house the Conservation Centre of the National Museums and Galleries of Merseyside. But I want to concentrate now on the two most important examples, both of them of great symbolic value: the Albert Dock in Liverpool and the Hospice de la Vieille Charité in Marseilles. The state of dereliction of these monuments, two of the most neglected landmarks of their heritage, was a depressing sight at the very heart of Liverpool and Marseilles. Their restoration and opening to the public for mixed-use amenities, including several museums, has turned them into a shop window for the cities' image.

Liverpool's Albert Dock was designed by Jesse Hartley as the first enclosed dock warehouse in the world made entirely out of incombustible materials: cast-iron, brick and granite. It opened in 1846 and closed in 1972 – but it was defunct long before that time (Ritchie-Noakes, 1984: p. 49-56; Cockcroft, 1994; Newell, n.d.). With its five blocks, each of five storeys, it is Britain's largest Grade I listed building. Its restoration, which cost £30m, was conducted by the MDC (Merseyside Development Corporation), one of the Urban Development Corporations created by the Government of Margaret Thatcher in 1980 in opposition to some Labour-led local councils (Parkinson & Evans, 1988 & 1992). The riots of 1981 prompted the MDC to seek quickly a highly visible area for physical regeneration in part of the 865 depopulated acres under their control in Liverpool, Sefton, and the Wirral. Therefore, after largely unsuccessful attempts to redevelop the South Docks for industrial and commercial purposes, they turned towards a tourism and leisure-led strategy. The models for this strategy were urban renewal developments based on leisure events like festivals, aquariums and museums, in the former decaying waterfront areas of north American port cities: Boston, Baltimore, San Francisco in the 1970s, and more recently, New York's old port warehouses – South Street and Seaport Museum, and Chicago – with the opening of the Maritime Museum and a Children's Museum. So in 1984 an area of 50 ha of derelict oil installations, naphtha tanks and a domestic rubbish tip was developed into a greenhouse and theme gardens at a cost of £30m, to hold an 'International Garden Festival' which attracted 2 million visitors. However, the site has remained under-used since then. The best 'flagship' of MDC's achievements in developing the tourism industry in the city is the Albert Dock, which attracts up to 3.5 million visitors annually.

Tourists are the most usual customers of the Beatles Story, but it is worth pointing out that the Albert Dock's main leisure amenities are two major museums that are extremely popular with Liverpudlians: the Maritime Museum and the Tate Gallery. The Merseyside Maritime Museum was inaugurated in 1984 at Block D of Albert Dock and other adjacent buildings. The Tate Gallery opened in May 1988, based on designs of the celebrated Liverpool-trained architect James Stirling. Overly high expectations for boosting the economy and tourism were raised with the arrival of a new branch of the Tate to Albert Dock. It is only now that this junior sibling of the nation's gallery of modern art is being judged for questions related to contemporary art and curatorship (the same happened with the economic goals envisioned for MASS MoCa in North Adams, Massachusetts, cf. Zukin, 1995: 79-108). This led to disappointments and, most dangerously, to a feeling of estrangement between some Liverpudlians and the lavishly converted wharf, which was seen locally as a 'Wooden Horse of Troy', sheltering officials sent by the right-wing government in London for the conquest of left-wing Liverpool. It has taken much effort to normalise relations between this national museum and local citizens. With time, this centre of excellence, whose exhibitions are mostly free of charge, has contributed a great deal to bridge the initial gulf of the MDC with the local community – unlike the London Development Corporation, whose investment in London's Isle of Dogs created private offices. In particular, the Tate has upgraded artistic life in Liverpool, and many small independent art galleries and studios have flourished since 1988 in the derelict warehouses of the Duke Street area.

Marseilles' poor-house, La Vieille Charité, was built in 1671-1745 based on plans by the local architect, sculptor and painter Pierre Puget at the heart of the city's most popular district, Le Panier. It lost its original function in 1883, subsequently becoming military barracks, tenants houses, improvised shelter for the homeless and then finally remaining empty and derelict. The building basically consists of a three-store patio with porticoes and, in the middle of it, an oblong chapel crowned by an astonishing dome. The works of restoration carried out from 1970 to 1986, at a cost of 99m francs, were paid for by the city council, helped by the governments of the nation, the region and the province (Paire, 1991). Now the site houses several university institutions, four galleries for temporary exhibitions, a vidèotheque, the Maison de la Poésie, the Museum of Mediterranean Archaeology, and the Museum of African, Oceanian and American-Indian Arts (the latter seems a particularly happy choice, considering the number of non-European citizens living nearby).

The effect on the physical renewal of the quarter has been immediate; the regional government has restored another Baroque building just in front, an ex-convent, in which was installed the Fond Régional d'Art Contemporain, whilst the municipality refurbished old derelict houses nearby to open the Maison de la Poésie and studios for artists. Now, many rundown houses in the area have been refurbished and reopened by private business catering for culture. The mere presence of art-dealers and artists greatly enhances the urban milieu. The Panier quarter was becoming a ghetto for social and ethnic minorities who had come to seek homes left empty by the departure of many of the traditional inhabitants in the quartier, like port-workers and sea-folk. Now this process is slowing down because of the arrival of art-professionals, and the presence on

the streets of a number of university students and tourists going to the Vieille Charité to attend classes or to see the latest exhibition. This is a mixed blessing.

Agents of the successful Creative Quarter of Liverpool

The typical paradigm of arts led urban regeneration gives half of the story. In Liverpool especially, spaces for the production of art, such as artist studios and community centres, were not the only prime movers for the revitalisation of derelict areas of the city centre. Consumption-oriented art businesses have also been actively involved from the very beginning. In the immediate years after the opening of the Tate Gallery in Albert Dock, a number of empty Victorian warehouses of the Bold Street/Duke Street area were snapped up by commercial art galleries run by alternative art dealers or by art professionals turned 'mediators'. There was already an historic presence of art material suppliers in the area plus the shops and galleries of the Bluecoat Chambers, but the forerunner to the post-modern arrival of art-dealing hubbub in the area was the Hanover Galleries, founded by the painter Susan Prescott in 1983 in a charming Victorian building on 11-13 Hanover Street, originally a hat factory. Then, in 1984, an enterprising artist from Northern Ireland who studied at the Liverpool College of Art and was living in Toxteth, Janine Pinion, opened Acorn Gallery & Café in her own studio/kitchen on the top floor of a former warehouse off Bold Street: this soon became the favourite meeting place in the Liverpool arts-scene.

The next step came in 1989 when sculptor Arthur Dooley and garage owner Alan Johnson, established their own gallery – The Liverpool Academy of Arts – no connection with the historic institution of that name founded by William Roscoe. The gallery, which, since 1990, has doubled as a theatre is located in a Seel Street warehouse provided by Exhaust Supplies. The house was already home to the *Liver Sketching Club*, a café, a shop, the studio of two sculptors and the workshop of a clothes designer.... Such a neighbourhood offered a natural habitat to the new gallery, whose exhibitions feature mainly artists starting their professional careers. The new Merkmal Gallery, on the other hand, specialises in well-known national and continental modern artists and was opened in 1992 by Martin Ainscough and Wera von Reden-Hobhouse in a former shop and a semi-derelict city council property, at 5-9-11 Falkner Street. Since 1995 it has become the Ainscough Gallery and also runs a trendy pavement café. In 1994 the architect Ken Martin refurbished, at his own expense, the two top floors of a large warehouse building at 32-36 Hanover Street to install his studio and the View Gallery for private views of modern architecture and visual art displays.

This is not to say that every commercial venture has been a success story in the recovery of derelict buildings in the area; that would be quite strange in this kind of business which is marked by many short-lived ventures. Less fortunate have been other recent commercial ventures, but the strength of the local arts scene remains a great asset for the regeneration of the quarter as could be tested since 1992 on the occasion of the *Visionfest* Festival in October, now replaced by a biannual celebration featuring open studio events and alternative exhibitions arranged by the local community of artists, the North West Arts Board and the City of Liverpool, collaborating with galleries, universities, community artists' co-ops and individuals. As any other biennial

Quiggins building in Liverpool, an alternative shopping centre with artists' studios on the top level – photo: Jesús Pedro Lorente

or annual arts festival, it works primarily as a public showcase for the latest art, but with the peculiarity that here these events act also as a hothouse for innovative art making in new places: pubs; street billboards; warehouses; alternative galleries; ferries; schools etc. This started as a series of open studio events and alternative exhibitions arranged by local artists, but since 1992 has become a unique national event, partly funded by North West Arts Board and the City of Liverpool, collaborating with galleries, universities, community artists' co-ops and individuals. As any other biennial or annual arts-festival, it works primarily as a public showcase for the latest art; but in addition *Visionfest* also works as a hothouse for innovative art-making in new places: pubs, street billboards, warehouses, alternative galleries, ferries, schools, etc.

From the beginning, this growth of places for art production and consumption in a part of town containing many dilapidated landmarks of the Victorian splendour of Liverpool, has conjured up reminiscences of other famous art districts like SoHo in New York. Such comparison is only brandished with anger and menace by Liverpool artists, who fear a similar process of gentrification will eventually substitute trendy yuppies for poor artists, but amongst other Liverpudlians outside the arts-scene the analogy only came as a wishful inspiration for promoting urban renewal. Policy makers and urban developers hoped for a massive arrival of creative people, acknowledging the appeal for young socialites of a lively arts scene. Liverpool City Council, the regional arts administration and private developers started a publicity campaign claiming a new image for Liverpool, formerly a 'city of merchants', as a 'city of artists'.

Thus in 1989-90 Charterhouse Estates, a private company from London with a vision for Liverpool, bought from the city corporation most of the properties of the area – more than three hundred buildings. It was hoped that, like in the Marais quarter of Paris, SoHo in New York, or Temple Bar in Dublin, a market-led renewal of these run-down buildings would succeed in attracting a young population of urbanites to this district, which was thus optimistically renamed 'The Creative Quarter'. But selling city properties to London-based developers instead of local firms proved problematic and the massive wreck of London Docklands truncated the London developers' investments in Liverpool. The renewal of the 'Creative Quarter' came to a stand-still.

But now other developers are increasingly active in Liverpool's 'Creative Quarter'. Most remarkable is *Urban Splash*, a Manchester architects' partnership – based in a converted Victorian factory behind Piccadilly Station – run by two associates, Jonathan Falkingham and Tom Bloxham. They specialise in upgrading run-down inner-city areas by developing apartments, offices, pubs, clubs and young-life retailing. In Liverpool they have turned a number of Georgian warehouses in Slater Street and Wood Street into offices, tapas bars, youth shops (designer clothes, computer games, music, tattoos, etc). Often, as in The Liverpool Palace, they provide studio spaces for creative people (architects, designers, artists) or, as in Baaba Bar, they arrange temporary art exhibitions on the premises. Their strategy is to nurture a lively artists' presence as a means to enhance their establishments with an atmosphere of youth and alternative culture. The most outstanding initiative in this respect remains the opening of a nearby Victorian building as the first great department store for clubwear, alternative shopping and second-hand *bric-à-brac*, called 'Quiggins'. The latest development in the

Arty Neighbourhoods at Le Panier – photo: Jesús Pedro Lorente

premises has been the opening of the top floor by a group of artists, *Merseyside Arts Base*, who run an exhibitions gallery and five artists' studios. Thus even the private market of urban developers and business people sees great benefits in nurturing artists and arts venues in terms of bettering the image of an urban area. Hosting art exhibitions, inviting musicians and using designers is now becoming the new tune generally sung by artist-friendly developers.

Arty neighbourhoods at Le Panier
and other districts of Marseilles

Less developed is the nightlife economy of the old quarter of Le Panier in Marseilles, probably because this is still considered a dangerous area by night, but also because the noise and agitation would be a disturbance to the inhabitants of the houses in this district (this is an important contrast to the area around Duke Street in Liverpool, which is a non-dwelling district of warehouses). Artists started to move into Le Panier during the 1980s, because the rents were extremely cheap. Some painters like Guy Ibañez, François Mezzapelle or Gérard Fabre, from the Association Lorette, have been in the area for twenty years. But arts presence in the area started to grow and become noticeable only after the opening of the Vieille Charité cultural complex. Consequently, in the 1990s the art scene in Marseille has been torn in two halves: South of the Cannebiere Boulevard, in the well-to-do district, have remained professional art dealers, like the Galerie Roger Pailhas or the Galerie Athanor and the historic hub of well-established galleries (Veer, 1994), whilst the less favoured North districts and the Panier in particular have experienced a boom of fringe art, flourishing in alternative places.

Friche de la Belle de Mai, Marseilles: a former tobacco factory now housing an art complex with studios, alternaive theatres, and a radio station – photo: Jesús Pedro Lorente

However in Marseilles, hometown of Pagnol and other national glories of the French theatrical tradition, the leadership in arts-led revitalisation of derelict buildings has historically been galvanised by avant-garde theatre companies – a bit like pop music in Liverpool. The epitome of this kind of intervention has been the establishment of Théâtre National de la Criée Aux Poissons in the old fish-market, constructed in 1909. This cast-iron structure had become redundant in 1976 and a new national theatre was inaugurated there on the 22nd May, 1981, under the lead of the famous actor and director, Marcel Maréchal. Just a few blocks away, at number 16 Quai de Rive-Neuve, in a courtyard of warehouses, Anne-Marie and Frédéric Ortiz created the 'Passage des Arts' with the establishment there, since 1983, of two theatres: Théâtre Off and Badaboum. The site soon became a true Passage of Arts, fully deserving that name, because the association Arts Parallèles runs an art gallery there and the painter Jean Triolet has also moved in, installing his own studio and a reprographic business. A similar venture has come to life in the area of the port de la Joliette, where, since 1985, the Compagnie Théâtre Provisoire has used a former silo and mill as the Théâtre de la Minoterie. During the last two decades countless other buildings, have been converted into theatres in Marseilles. A milestone in this story was reached in 1990, when Alain Fourneau, from the Théâtre des Bernardines, and Philippe Foulquié from Massalia Théâtre de Marionnettes, with the backing of Christian Poitevin, then Head of Cultural Affairs of Marseilles City Council, founded Système Friche Théâtre, a structure of interdisciplinary vocation, the first location of which was a grain silo in the suburban boulevard Magallon. But the following year, with help from the Municipality, the Direction Régionale d'Art Contemporain (DRAC) and the Ministère de la Culture, the team moved into the so-called Friche Bel-de-Mai.

This immense site of 40,000 m^2, a former tobacco factory in the Belle-de-Mai quarter, a central working-class city district, allowed a capacity of one-hundred seats, making the Massalia the biggest permanent marionettes theatre in France. Apart from this attraction, other venues came to the Friche de la Belle-de-Mai in 1993: e.g. the Association des Musiques Innovatrices, led by Ferdinand Richard, and ten studios for visual artists administered by the Association Astérides. Then, in 1994, some music studios – Euphonia –, as well as workshops for photography and video creation – *Aye Aye Production* –, a 'gig' hall for up to 700 people, a nouvelle cuisine restaurant, a bistro, and various mass-communication ventures catering for the young and alternative multicultural audiences of the great metropolitan area of Marseilles: radio Grenouille, and the newspapers/magazines Taktik, Tk2 and Régie Bleue.

The Friche Belle-de-Mai is perhaps a very special case of public funds pouring generously into a grass-roots artist-led initiative, but regardless of the amount invested there, it has to be seen in the context of political practices in France, where cultural policies are not reluctant for tax-payers money to be spent supporting artists and encouraging art production. The political upheavals in France have brought some changes in arts spending, but not a significant change in cultural policies – in Marseilles the main promoter of the re-use of redundant buildings by artists remains the City Council. Firstly because a number of artists, chosen by established application procedures, can benefit from a free lease of about twenty-three months for a modern studio in one of the converted buildings administered by the *Ateliers d'Artistes de la Ville de Marseille*, a service created in 1990. Its headquarters are based in a former textile factory in the Lorette. The other main site they own is a former furniture workshop in the central Panier quarter, where two other buildings are now in refurbishment and will soon become artists' houses as well. Secondly, the Cultural Affairs Bureau of the Marseilles City Council has, in the last decade, run an ambitious programme of art commissions, some of which have consisted of artistic interventions on derelict sites. Third, the Office de la Culture, a semi-independent organisation financed by the City Council, seeks the co-ordination of public patronage of the arts in Marseille, giving special attention to art developments in derelict or less-favoured city areas. Thus, in contrast to the usual situation in Liverpool, it is rare to find in Marseilles inner-city area artists' associations which have not at sometime benefited from public money. This is generally the case of almost any organisation aiming to convert buildings into artists' studios. For example five visual artists, headed by Sylvie Reyno, who installed themselves in the former Pâtes-Bonhomme factory of La Calade. Or the exhibition/studio space created by Mary Pupet and Louis-Daniel Jouve, in a former silo not far from the port hangars in the distressed 15th city district. Or again the ex-priory of Le Canet, a nearby modest working-class area, transformed into artists' studios and an art-exhibitions centre in 1995 by the association Hors-Là. Or also the old Public Baths of the rue de la Palud, refurbished for public art in 1992 by the group *Avanti Rapido*, and later by the association New Baz'Art. But perhaps the most remarkable case is the association Lézard-Plastic-Production. They had started in 1989 at the former slaughter houses of the chemin de la Madrague, and in September 1995 opened new headquarters in the city centre, converting a forlorn furniture warehouse

near the port into an exhibition and performance space: the Centre International d' Arts Visuels Cargo.

Thus, tax-payers' money is not the only source of support for provision of artists' studios in Marseilles and to the private initiative of business-minded artists, we can add the contribution of corporate patronage, which often initiates synergetic partnerships with artists. Some companies see the presence of artists in their premises as enhancing the value of their property. This is the case of the Port Autonome de Marseille, the company in charge of Marseilles' port infrastructures, which holds art exhibitions along the main pier and every summer hosts some of the events of the *Fête des Suds* festival in one of its hangars (sculptor Harmut Bosbach has also been granted the use of a redundant hangar as his studio). Another local example is the Societé SARI-SEERI, administrator of the Docks de la Joliette, where every year a new block of these typically Victorian warehouses has been restored and converted into offices. Before the new spaces are offered for sale however, the company temporarily offers some parts for artists' studios and/or art exhibitions – this works well as publicity bait, because on the occasions of 'private view' and 'exhibition inauguration' parties the development company rallies a social gathering of wealthy socialites who might be potential clients for artworks *and* the property's future development as offices! These business-led initiatives are no arts charity; property developers are now very aware of the appeal of artists studios and thriving alternative life as an attraction for customers. Thus, ironically, artists and the arts have become a kind of bait both in Liverpool and Marseilles: an attractive packaging for mega-projects aiming at the renewal of entire derelict districts for sale/hire as mixed-use estates in the housing market. In the publicity campaigns of urban renewal operations launched either by city planning authorities or by real estate agencies, one often finds catch-phrases boasting about the involvement of the arts sector in the area to be developed.

General conclusions
A new approach to the 'knock-on' effect

Adding to examples examined by specialists in cultural policies for urban regeneration (Bianchini, 1993; Landry & Greene, 1995; Langsted, 1990; Remesar, 1997), what the two cases above demonstrate is that the level of success of urban regeneration policies cannot be adequately measured in solely physical terms. So much so that it is debatable whether a boom of new building-developments always constitutes a success. From my point of view this is not the case when real estate pressure scratches out the 'spirit of the place', transforming historic ports into a jungle of office-buildings, commercial stores and hotels, as in London Docklands, New York's Battery Park City, the harbourfront of Toronto, or the port of Tokyo. Urban developers should be encouraged to introduce public spaces in their projects. Many European cities like Antwerp, Brest or Genoa have learned from the celebrated examples of the ports of Boston and Baltimore that in the case of port cities some of the more appropriate urban renewal developments are maritime museums, aquariums and leisure waterfronts (Baudoin & Collin, 1992). Thus historic preservation of port waterfronts can go beyond merely keeping old buildings, saving not only the buildings, but also their utility and local morale.

Now Liverpool and Marseilles have shown that art galleries are also a successful investment, for they can become catalysts of further urban regeneration when an 'arts district' emerges closeby (Lorente, 1995). Obviously this is not a medicine suitable for every city with problems of urban decay, because not every place has the artistic background and the cultural glamour of Liverpool and Marseilles. But there are plenty of declining ports in Europe whose pedigree as artistic metropolises qualifies them for a similar cure expecting the same results. It is surely no coincidence if some of the most successful examples of the 'Cultural Capital of Europe' festival, like Glasgow (1990), Antwerp (1993) and Lisbon (1994) have produced arts-led rehabilitation of decayed waterfronts. Museums in general and art galleries in particular are not a panacea able to heal ailing ports everywhere, but they can work as catalysts of urban regeneration of port-cities in decline. In this respect cultural politics in Liverpool and Marseilles are succeeding where more celebrated cases like London and Dublin have failed.

A conclusion to be drawn from Marseilles and Liverpool is the existence of a second pattern of arts-led urban renewal processes, diametrically opposed to the general scheme taken for granted regarding the development of art-districts in the inner-cities. Examples like Montmartre and Montparnasse in the Paris of the *Belle Époque*, the SoHo district in New York between 1971 and 1981 or the Temple Bar area of Dublin in the 1980s, have led to the assumption that art districts come into existence in deprived neighbourhoods following this typical format. Firstly some non-established artists discover the existence of cheap atelier-spaces to rent in derelict unused buildings (the Bateau-Lavoir in Paris, the Victorian storehouses of downtown Manhattan, etc). Then art-dealers follow suit installing their galleries in the area while other private entrepreneurs come with alternative/youth amenities like fashion shops, trendy bars, restaurants. Eventually the arrival of museums, national theatres and public arts centres marks the 'officialisation' of such arts districts. The fatal culmination of this is the installation of apartments for yuppies, while artists move out. The typical story of this general cliché can therefore be described as a gentrification process: redundant buildings with stagnating rents in a deprived area get resuscitated thanks to the presence of artists, this attracts developers who transform the district into an 'arts quarter', which brings in a lot of people, institutions, and money but, eventually, will inevitably expel the artists. I do not intend to refute that scheme or even to contradict its final output – namely that the arts are victims of their own success and act as instruments of a gentrification process. But I believe that another scheme is also possible, where museums arrive first as a consequence of a political decision to bring derelict landmarks of city heritage into new life, then in a knock-on effect other derelict buildings in the district become cultural centres or art galleries, and finally artists move their studios Such has been the process, as we have seen, in the cases of Liverpool and Marseilles. One could conclude that arts-led urban regeneration is not always a spontaneous process originated by 'bohemians' finally benefiting speculators dealing in the housing-market. In some cases the process can start following political decision. This is of great interest in the realm of contemporary policies for sustainable cities. Nevertheless, the spirit of independence and revolt inherent in the personality of artists makes them more often eager to confront urban developers than to collaborate with them. Proof of this is the

fact that artists and artists' organisations have headed urban revolts. In Berlin, during the riots of 1981, artists and young students featured prominently in the world media as the squatters who radically opposed their eviction from the district of Kreuzberg (Colquhoun, 1995: 128). On these matters, art activism belongs with grassroot movements and communities, not with developers (Felshin, 1995). On the other hand, it is quite understandable if artists are often diffident and critical towards property developers and urban planners. Nobody would like to be used and abused as an attraction for other tenants, whose presence might eventually outnumber and undermine the initial high concentration of creative people.

Thus, regardless of the order followed in the process, there is a risk that the end might be the same for artists in Liverpool and Marseilles as in New York's SoHo, Paris' Latin Quarter, London's Chelsea and Butlers Wharf, or Dublin's Temple Bar. Everytime I visit Liverpool and Marseilles, I get mixed feelings of joy and concern when I see the bistros and nightlife increasing around Duke Street/Seel Street and in the narrow hilly lanes of the Panier quarter. The solution to the problem might come from a new spirit of collaboration between arts communities and public powers, so that instead of just helping creative people to convert buildings, grants are also directed at helping artists' co-ops to get affordable mortgages so that they can buy the buildings they have refurbished as studios and galleries.

Finally, it would be helpful if those involved adopted a more realistic and compromising approach regarding the funding of arts and urban regeneration. In an ideal world, the arts budget of a local, regional or national government should be used for nurturing the arts, whilst the budgets for city planning and urban renewal should be invested in housing and urban betterment schemes. Yet in times of hardship and cuts in arts expenditure, I see no harm in blurring these artificial limits, fostering synergetic collaborations between artists and urban planners. It is sometimes discouraging to do research on the arts scene and be permanently confronted with the bitter accusations of artists, always complaining that too much money is spent on consultants, curators, mediators, even if the fact is that the grant sponsoring the research in question is not squandering funds from the arts budget. But if artists need to give up their plaintive stance, city planners should also show a more co-operative attitude towards creative people. It is sad to see that the most ambitious projects for inner-city urban renewal now being implemented in Liverpool – *Liverpool City Challenge* – and Marseilles *Euromediterranee* – both financed with very generous European, national and local funding, and both steered by interdisciplinary teams of smartly clothed specialists, have had no position to offer for downdressed artists to have their say. These agencies are doing an admirable job in restoring the old hearts of the two cities to their former splendour, providing decent housing to some of the most deprived citizens, but it seems ludicrous that neither of the two agencies has plans to co-operate and give support to the arts scene, which has always been the historic harbinger of the urban regeneration of Liverpool and Marseilles.

References

Al Naib, S.K (ed.)(1991) European Docklands. Past, Present and Future. An Illustrated Guide to Glorious History, Splendid Heritage and Dramatic Regeneration in European Ports, North East London Polytechnic.

Aughton, P (1993) Liverpool. A People's History, Preston: Carnegie Publishing.

Bailey, F.A. & Millington, R (1957) The History of Liverpool, Liverpool: City Corporation.

Baillon, JC (dir) (1989) Marseille: Histoires de Famille, Paris, Éditions Autrement, 'Série Monde' H.S no 36.

Baudouin, T and Collin, M (1992) 'Patrimoine et capital portuaire', in Le patrimoine portuaire. Le Havre, Association Internationale Villes et Ports (actes de 'Le port et la Ville. Rencontres du Havre', 16-17 Novembre 1992): pp. 65-70.

Becquart, D (dir.) (1994) Marseille: 25 ans de planification urbaine. La Tour d'Aigues, Éditions de l'Aube.

Bianchini, F (1993) Urban Cultural Policy in Britain and Europe: Towards Cultural Planning (Nathan Qld.): Griffith University.

Bonillo, J. L. (dir.) (1991) Marseille ville et port, Marseille: Parenthèses.

Borruey, R, (1992) 'Réinventer une ville-port?', in Bonillo, J L and Donzel, A and Fabre, M (dir.) Métropoles portuaires en Europe: Barcelone-Gînes, Hambourg-Liverpool-Marseille-Rotterdam. Paris: Parenthèses ('Les Cahies de la Recherche Architecturale' no 30-31): pp. 127-147.

Borruey, R, & Chaline, C, 1992. 'Marseille, les nouvelles échelles de la ville portuaire', Les Annales de la Recherche Urbaine, no 55-56 'Grandes villes et ports de mer': pp. 53-62.

Broner, K (1986) New York face à son Patrimoine. Présevation du Patrimoine Architectural Urbain à New York: Analyse de la méthodologie. Etude de cas le secteur historique de SoHo, Bruxelles: Pierre Mardaga éditeur.

Brunier, J, 1993. Les ports maritimes et fluviaux, le place dans l'économie française et leur rôle dans l'aménagement du territoire. Paris, Conseil Économique et Social (texte du rapport présenté dans le cadre des séances des 27 et 28 avril 1993).

Cockcroft, W R (1994) The Albert Dock and Liverpool's Historic Waterfront, Rainworth: Print Origination Formby and Books Unlimited.

Colquhoun, I (1995) Urban Regeneration. An International Perspective, London: B.T. Batsford Ltd.

Cousins, L et al., 1980. Merseyside in Crisis. Birkenhead, Merseyside Socialist Research Group.

Crane, D (1987) The Transformation of the Avant-Guarde, The New York ArtWorld, 1940-1985, Chicago and London: Chicago University press.

De Roo, P, 1994. 'Marseille: de l'aire portuaire à l'aire métropolitaine' in Collin, Michèle (dir.), Ville et Port. XVIIIe-XXe siècles. Paris, L'Harmattan: pp. 107-126.

Donzel, A (1992) 'Marseille, la métropole éclatée', in Bonnillo, JL & Donzel, A & Fabre, M (dir.), Métropoles portuaires en Europe: Barcelone-Gênes, Hambourg-Liverpool-Marseille-Rotterdam Paris: Parenthèses ('Les Cahiers de la Recherche Architecturale' no. 30-31): pp. 113-126.

Felshin, N (ed.), (1995) But is it Art? The Spirit of Art as Activism, Seattle: Bay Press.

Hughes, Q (1993) Seaport: Architecture and Townscape in Liverpool, Liverpool: The Bluecoat Press and Merseyside Civic Society.

Hyde, F. E., (1971) Liverpool and the Mersey. An Economic History of a Port 1700-1970, Newton Abbot: David & Charles Publishers Ltd.

Jones, S (1995) Survey of Group Studio Provision. Stage 1. London: National Artists Association.

Landry, C and Bianchini, F (1995) The Creative City, London: Demos.

Landry, C and Creene, L (1995) *Revitalising Cities and Towns Through Cultural Development.* Bourners Green: Comedia.

Langsted, J (ed.) (1990) *Strategies. Studies in Modern Cultural Policy,* Aarhus: Aarhus University Press.

Lorente, J. P (1995) 'The city's beating art', *Museums Journal,* vol 95 n. 10: pp. 29-30.

Newell, E, (n.d.) *Albert Dock Liverpool.* Liverpool, author's edition.

O'Connor, F (1986) *Liverpool, It all Came Tumbling Down,* Liverpool: Brunswick Printing & Publishing Co. Ltd.

Paire, A (1991) *La Vieille Charité de Marseille,* Aix-en-Provence: Édisud.

Parkinson, M and Evans, R (1988) *Urban Regeneration and Development Corporations: Liverpool Style,* Liverpool: European Institute for Urban Affairs, working paper no 2.

Parkinson, M and Evans, R (1992) 'Liverpool, la restructuration urbaine d'un port en déclin', *Les Annales de la Recherche Urbaine* no 55-56 'Grandes villes et ports de mer': pp. 45-52.

Remesar, A (ed.) (1997) *Urban Regeneration. A Challenge for Public Art,* Barcelona: Univ. de Barcelona.

Ritchie-Noakes, N (1984) *Liverpool's Historic Waterfront. The World's First Mercantile Dock System,* London: H.M.S.O.

Roncayolo, M (1990) *L'imaginaire de Marseille: Port, ville, pôle.* Marseille, Chambre de Commerce et d'Industrie 'Historie du commerce et de l'industrie de Marseille XIX-XX siècles', t. V.

Sanmarco, P and Morel, B (1988) *Marseille l'état du futur,* Aix-en-Provence: Edisud.

Simpson, C R (1981) *SoHo: The Artist in the City,* Chicago and London: University of Chicago Press.

Smith, W (1953) 'The urban structure of Liverpool' in Smith, Wilfred (ed.), *A Scientific Survey of Merseyside.* Liverpool: British Association & Liverpool University Press: pp. 188-199.

Veer, S (1994) *Des Lieux d'Exposition à Marseille, 1960-1969,* Marseille:Laboritoire d'Art et d'Histoire.

Williams, J et al (1993) *The Artists in the Changing City,* London: British American Arts Association.

Zukin, S (1992) *Loft Living: Culture and Capital in Urban Change,* Baltimore & London: The Johns Hopkins Univ. Press.

Zukin, S (1995) *The Culture of Cities,* Oxford: Blackwell.

Jane Trowell

The Snowflake in Hell and The Baked Alaska
Improbability, Intimacy and Change in the Public Realm

In 1993, on the very outskirts of Budapest, Hungary, the Statue Park Museum opened. It was born out of the idea of a literary historian who, four years earlier, had proposed that "all the various Lenin statues from all over Hungary be gathered in a 'Lenin Garden'" (Szoborpark, 1995: 1). Since 1989, heated public debate had raged over what to do with the statuary, memorials and monuments from the former 'socialist' period. In the case of Budapest, its elected Assembly resolved this by proposing a process in which the choice of statues to be removed or kept would be decided by each district of the city, individually by referendum. Citizens would have one of three choices for each monument: a) keep it in place; b) have it destroyed; c) contribute it to the Statue Park Museum.

To give an example, a 4.3 metre bronze statue, made in 1951, of a Ukrainian – Captain Osztapenko – of the Soviet Red Army, used to stand atop a 5-metre plinth on the Vienna-Budapest highway. Osztapenko had died there in 1944 from shrapnel wounds during a mortar attack, after having failed to negotiate German surrender to Soviet forces. The ultimate triumph of the Soviets over Germany and indeed Hungary, is embodied by the sculptor Kerenyi in his mighty representation of Osztapenko: he stands alert, muscles tensed, signalling distant comrades with a proud pennant. The guidebook explains that the original statue (along with many others) was "torn down during the 1956 revolution", but later, with the failure of that uprising, replaced. However, "over time this statue had matured into a symbol of farewell and welcome for travellers on the highway. In fact, it had become almost a friend. Young people hitching a lift to [Lake] Balaton would stand at 'the Osztapenko'" (SzoborPark, 1995: 31). However, the social and cultural arguments to leave it there failed to swing the referendum. Now it towers over several Lenins, a Marx and an Engels, and many memorials and tributes to Hungarian communism and its heroes in the Statue Park. The park was never completely finished, and has a distinctly eerie and unsettling air, whatever your politics. Many are the tourists who, for whatever reason, have bought the popular sealed tins labelled "The Last Breath of Communism".

The choice to attempt a democratic process in such a situation was, arguably, more complex, volcanic, and divisive than if the new-born state had simply erased all cultural traces of former Soviet and socialist connections, as has been the case in so many former 'socialist' countries of Eastern Europe. The process brought to the surface a lot of pain, hatred and anger, with unexpected allegiances and unforeseen senses of ownership, often for non-ideological reasons, as seen in the case of Osztapenko.

It is too soon to know whether this cultural process which was so deeply uncomfortable in the short term, has enabled the country to come to terms with its history more fully and profoundly than it might have done through overnight erasure.

Has this culturally triggered debate laid to rest some of Hungary's ghosts and deep wounds in a way not unrelated to what Archbishop Desmond Tutu's *Truth and Reconciliation Commission* has been tackling on a profound scale in South Africa? or Weimar's recreation in 1999 of *Hitler's Art?* Hungary is the only country in the former 'socialist' east that dared to investigate the popular significance of such symbols, and to do this through a street-by-street democratic process. Both these facts, I suggest, make the Statue Park Museum an extraordinarily potent realisation of the previously unimaginable. As Tutu himself said in 1995 about world support for the ANC government "People like us because we are improbable".

Such histories are vital to the life-blood of organisations or groups committed to investigating processes of change away from dominating, seemingly invulnerable and permanent monocultures, in whatever socio-economic context. In the England of a century ago, it would have been unimaginable to all but a few that Anglican churches would become so unattended that vast numbers of them would be turned into shopping centres, arts venues and flats in the last decades of the century. Yet these very facts – whatever our ideological position on them – show us that to imagine beyond the seemingly invulnerable and permanent is an entirely reasonable act. Furthermore, to place that proposition as common sense in the public realm can be a potent contribution to change. The 'Lenin Garden' proposal could have been perceived as an ironic joke, but, in this moment, led to a profound civic process. The improbable can happen, and within this, there is a role for "inspired pragmatists" (Vidal, 1997) who maintain the right to operate between the snowflake in hell and the baked alaska.

Along these lines, PLATFORM's current long-term work 90% Crude (1996 onwards) is, through a series of projects, investigating changes which can seem equally unlikely and unimaginable, especially with the alleged 'triumph' of capitalism after the fall of the Berlin Wall: the end of fossil fuel dependency; the reversal of climate change; the dissolution of globalised trade which distances consumers from producers; and the disintegration of transnational corporate culture – all of which we see as acts towards 'dismantling the master's house' and, perhaps, a fitting act for people critical of their country's former imperial status and its legacy. The scale of the issues does not suggest to us that a mass response is the only effective strategy – far from it. There are many organisations and groups campaigning and taking action that reflect mass and collective opposition to globalised capitalism, such as has been seen in Seattle, Washington, London, Geneva etc, and whose aims could be summed up by *Reclaim the Streets'* slogan "Our resistance is as global as capital".

Complementary to such mass activity are intimate acts of exchange and trust, proposal and re-imagining, where a belief in the integrity of such exchange and dialogue is paramount. This position refutes the 'them bad, us good' mantra that can result from certain ideologies of mass activity. It demands that individuals look into each others eyes and recognise each other as people and not as representatives, however hard that struggle. From such a point, genuine investigations of and critical engagement with how each other has come to 'represent' certain value systems can begin; that is, the political debate can arise with more sustainable profundity when its roots are in mutual recognition (but not necessarily endorsement) of the personal. I will return to this point later.

PLATFORM was founded in 1983, as a meeting place for imagination, discussion, contemplation and action. Involved in political theatre, peace campaigning, and left/green activism, the initial grouping attracted people from a diverse range of disciplines and experiences to create street-based interactive performance work which provoked debate and awareness on a variety of issues: from supporting striking cleaning staff at a local hospital whose services were to be privatised (*Addenbrookes Blues*, 1983); to working with activists lobbying against the privatisation of a local historic community resource (*Corny Exchanges*, 1984); to protesting against the abolition of student main-tenance grants (1983-5); to intimate performances exploring notions of personal locatedness, responsibility and belonging (*Transformation*, 1986/7).

Since that time PLATFORM has evolved a complex interdisciplinary practice, influenced variously by: artist and ecological thinker Joseph Beuys; 'live art' and 'performance' practices; feminist theory and practice; the writer John Berger; the engaged and critical pedagogical practices of bell hooks and Paulo Freire; critiques of global corporate culture; and the wave of ecological and social practice artists and activists of the past twenty years (Becker, 1994, Felshin, 1995, Lacy, 1995, Littoral, 1994, 1998, McKay, 1996, Miles, 1997, Kastner, 1998). The group is artist-led – although those artists would also define themselves as teacher, naturalist, trade unionist, ecologist, activist – and collaborates in its projects with people from a wide range of experiences and disciplines inside and outside the arts. This practice serves to challenge territorial notions of knowledge or understanding, and creates situations where recognition of common aims and desire for shared, although distinct languages is fostered. We believe this creates thought and activity which benefits from and honours specific expertise whilst broadening the sensibility and reach of the work and its participants.

The aims of the work are, through interdisciplinary creativity, to address and help reveal the interrelationship between urgent ecological issues and social justice, and to effect change through a fusion of the poetic and the pragmatic. Since 1986 the geographical location of the work has essentially been the metropolis of London – the city as medium, metaphor and actuality – but, just as London's social and ecological impact is felt very many miles from the Lower Thames Valley, so the ramifications of the work are applicable beyond its actual locus.

In its early projects, PLATFORM started out working mainly in open-air public spaces, with and for three kinds of people: i) passers-by; ii) invited participants; iii) self-selecting people who responded to listings and adverts. This agitprop root has a veracity to it, as the exchange of money does not enter the engagement. If we have not found a form which communicates, it is visibly obvious in such a context – the work is dismissed, or nobody stops or stays. If we have found a form, but the ideas are not thought through, it becomes equally obvious – aggression or ridicule is invoked, or nobody engages. If we have found a form, but it only communicates well with certain kinds or groupings of people – then another set of socio-cultural issues about the exclusivity or targeting of our aesthetics and language becomes apparent and open to debate.

Working with passers-by has many unique merits for ecological practice, the main one being that passers-by already have a reason of their own for being in that place, which gives an independent meaning to their interaction. The reasons for being there

may not always be pleasant to the person, indeed they may be afraid or disgusted; the visit may be a one-off; it may be chosen; the quickest way from A to B; somewhere to hang out; or somewhere to control, even intimidate. One person's alienation is another's pride; one person's disgust at, or contempt for, the state of the place is another's sense of grief at what once was; one person's cockiness is another's real or perceived fear of attack. Those who are not passing by is also at issue, and speaks volumes. Implicit in this analysis is the question of flora and fauna: what is the bio-diversity of this place? As passers-by we are all acutely aware of questions of ownership, feelings of belonging, and feelings of curiosity, affection or of fear. As passers-by we hold keys to the history and present of a place, and therein may lie indications as to its future.

To mark moving from a Brighton-based project back to London, PLATFORM's 1989 project Tree of Life, City of Life involved two artists first walking from the Channel to the Thames. They then lived in a tall, seven-sided tent for 24 hours a day, seven days a week for ten weeks, at five points on the south banks of the Thames from Wandsworth Town to Greenland Dock, recycling all their waste and noting the sources of their consumption as they went. This eye-catching exposure to the workings of the city, the nature that does or does not exist, the sounds and realities of traffic, led to hours of conversations, some brief, many in-depth, with random and invited people who were drawn to the tent and its inmates. Some people stayed with the tent, some came to the next 'camp-site' and for some it was just an odd encounter that may or may not have remained in their minds. The most memorable and disturbing conversations were with local rough sleepers, some of whom had deeply observed the 'normality' and 'absurdities' of the city over time, and had much to say about the life and ecology of the city in the broadest sense, as well as about the city as a place for celebration. The most memorable imprint of the inner city was the ceaseless explosions of the combustion engine, the twenty-four-hour-a-day arrival and departure of consumables and waste, and the equation of the metropolis with the permanent extraction and burning of coal and copper to create light – the city as a floodlit, relentless, ingesting and excreting giant organism. In the past five years, we have broadened the practice, and have come to re-frame the social aspects of the work and indeed ourselves through four interrelated notions of community: i) 'communities of interest'; ii) 'communities of place'; iii) 'communities of the dead'; and iv) 'communities of the unborn'. Embedded in each concept are the crucial effects of time – evolutions of interest and commitment, shifts in allegiance to, or ownership, of place. It is the last two – 'communities of the dead' and 'the unborn' – which have helped highlight specifically the experiences and interests of forerunners, and of future generations. Thinking 'generationally' in this way is not to privilege family, ethnic or national structures or indeed exclusive, historic senses of community which can so easily be the resort of racism, but to encourage a way of thinking over and through time, and how we are each acting within that 'life-cycle' continuum – a profoundly ecological and indeed empathetic process, perhaps especially in a major capital city of a deeply materialist society.

This framing process begins with what we have come to call 'listening' projects, where germs of ideas are tried in the public or semi-public realm, in order to initiate discussion, to generate exchanges of understanding, and to see what 'takes'. Such

Gaston Bachelard quote on 'Still Waters' leaflet 1992

listening takes time, an aspect of life in the 'affluent' world which has come to have a price on its head.

Investigating communities of place (which includes the passer-by) involves being with the place itself over time: of moving from the concept of 'site' (with its scientific or 'development' overtones) to 'place' (with its overtones of history). To walk repeatedly at different times of day and night, to sit, to watch, to smell, to hear what can be heard or not heard, to be open and sensitised, to want to know even if what you find is not what you wished. What would have been here? What has been tried here? What could happen here? Who loves this place, who thrives, and who or what suffers?; and crucially, how do my own assumptions, prejudices and previous experiences affect my interpretation, my feelings and thoughts here?

As interdisciplinary artist-activists, in order to develop a proposition, this kind of listening is vital to the long-term success of the work. After a period, it is useful to move from the purest receptive mode of listening, to an active mode, provoking reactions which can then be heard and discussed. This then can test your receptiveness and the ideas among diverse publics, and can act, when successful, as lightning rods down which public ideas pass. PLATFORM's projects often build on each other in this model – from receptive to active listening – and serve to build veracity and a sense of timing into the work. This twin listening keeps the work complex – sometimes bafflingly so – and rich. One could also say that the constant conversation between hopes, fears, and realities encourages a rooted balance between the improbable and the possible.

The 1992 project *Still Waters*, which proposed as common sense the recovery of London's buried and degraded rivers, combined a sculptor with a green economist, a writer with a teacher, a performance artist with a publicist, and a clinical psychologist with an interdisciplinary artist to create a constellation of work and events taking place

Q. What gets buried in The City ?

Map Image by Nick Stewart 1992, as part of PLATFORM project 'Still Waters'. This image was recreated as a research tool (1999) for '90% Crude'

in four river valleys over four weeks. The projects happened along the river-beds (now often roads) or river-banks, mostly in the open-air and all for free. A multiplicity of techniques and strategies were developed, each river project having its own distinct trajectory and emotion within the whole. This kind of work – involving walks, performances, installations, actions, mass water-dowsing, and discussions, from the financial centre at Bank, to Wandsworth Town, Herne Hill and King's Cross – acted as a giant barometer for how numerous Londoners felt about living in a dry city, or a city with neglected waters. It is about who makes such decisions, about public imagination, the desirability and possibility of a city whose rivers are flowing cleanly, and lastly about political will – "if they [sic] can add another lane to the M25, then they should be able to unearth a river", said one Farringdon Road passer-by.

In 1996, we received a call from the Planning Department of the Corporation of the City of London, who had heard a PLATFORM presentation about the democratic meaning of the unearthing of the river Fleet (London Rivers Association, 1995). This resulted in a meeting where a carefully prepared financial and transport argument was put before us, with an estimate, in writing, from the City Engineer that the costs of tunneling out the Fleet (which lies under Farringdon Road at Blackfriars), and re-organising the transport would cost in the order of £500 million. In the then active climate of anti-roads protests in the UK, the seemingly improbable notion of a campaign for the unearthing of the Fleet had apparently become possible enough to come to the attention of one of the most tightly controlled and policed zones in the entire city.

The active mode of listening in the public realm seems for us to fall into five broad and overlapping strategies, buried within each of which is the notion of useful oddity and the interruption of norms :

i) Seduction

In 1997, as part of *90% Crude*, we worked with design students from Southwark College and an ecological architect to build the 'Agitpod' – a solar-powered, quadricycle-propelled, video and slide projection vehicle, which can take sustainable sound and vision to where it's needed, without dependence on the national grid or a generator. The Agitpod has the archetypal attraction of the 'go-cart' ('Smiles per hour, not Miles per hour'), with issues of energy consumption and a challenge to mass-production inherent within it. Sleekly constructed from aluminium and marine-ply, the aesthetic is hard to attribute : this vehicle has done its work in the context of the Royal College of Art, the annual Hackney Show, Kingston Green Fair, or Sustainable London Trust's *Gathering for Change*. Quite simply it is both fun and deadly serious at the same time – the fun draws people in, and organically from this arises a debate about values.

ii) Ritual

In the metropolis, one knows and (especially after a period of receptive listening), one sees that there are many people engaged in ritual or devotional acts in public on a regular basis, which are not done for public reaction, but as an end in themselves. Often done individually, occasionally in groups, these acts contribute to the fabric of the public city, and in more religious times and places, are much more commonplace and

recognised. There is a strange power in realising that someone is engaged in such an act: firstly, it is beyond the commercial, and secondly, there is no requirement for an onlooker's interaction or response (unless you feel sorely provoked). For PLATFORM, this archetypal act has an important place in making a discursive intervention in the public realm. Not only can these acts behave as metaphors for a possible future, but they can, if they work, leave vivid images in the minds and hearts of the viewer. This is unquantifiable – no audience analysis will be available from the passer-by on the bus. However, to plant such images is to suggest meaning beyond publicity and marketing, and yet acknowledges the gaze of others, and contributes to the visual culture. Sometimes it may result in discursive engagement, but this is not the point.

Every lunchtime for two weeks a smartly suited clinical psychologist cycled over from the hospital where he worked and ran from Liverpool Street Station to the mouth of the river Walbrook in the heart of the financial City at Cannon Street, wearing a cycle mask, balancing a briefcase on his head, stopping dead every so often, staring into space. When very occasionally he was approached, he would hand out a business card with "Listen, You are Walking on the Walbrook" written on it. His distracted 'normality' cut like a knife through the crowds of business workers. He required nothing of them, but his ritual highlighted their ritual. Discreetly following him, others of us occasionally got into conversation with people. Some were disturbed, shaking their heads. Some thought it was hilarious. Some did the City thing of blocking out all disturbance or abnormality from their sight and memory. (*Walking on the Walbrook*, 1992) Eight years later, a bargeman at Walbrook Wharf surprised us by recalling the daily performance "I thought he was going mad! They are under a lot of pressure you know".

iii) The double-take or 'trompe-l'œil'

The function of this is well known from the visual subverting or spoofing of existing material such as the *detournement* of the Situationists in the 1960s to the slick exactitude of organs such as 'Adbusters' from the 1990s onwards. This strategy has its dangers – chiefly the danger of the forgettable one-liner – but can be usefully provocative. *The Effra Redevelopment Agency* (1992) aped the design aesthetics and language of regeneration agencies that attempt retrospective public consultation. ERA, housed in a parade of shops in Herne Hill, informed its public that the local river Effra was to be dug up in its entirety, and the surrounding area (a mix of suburban villas and public housing) redesigned by 2020. Press conferences, public debates and more theoretical discussions were held which achieved the aim of making the word and river Effra vibrantly live in people's minds and hearts. The project was extremely successful in these ways, if deeply ethically problematic. People really believed that it was to happen. The project revealed a lot about the state of our democracy, with only one person out of the eight hundred visitors asking for substantive details on funding, timescales. Most people wanted to know about the re-routing of roads and how it would affect their homes. Some were delighted, and inspired, and wanted to get involved. Others were furious, and demanded to know how they were to be rehoused. Upon the closure and disappearance of ERA, the long-term validity and indeed integrity of this surrogacy strategy was closely examined, and led to heated internal debate.

The imitation commuter newspaper *Ignite* (1996-7) on the other hand, (parodying the former London freebie *Tonight*), was avidly taken up by 14,000 travellers keen for something different to break the routine of their journeys. The fact that its subject matter was about the impact of Londoners' oil consumption on Human Rights and on Climate Change was only later to dawn on them. This project had a viral quality, slipping a proposition into the blood-stream under the guise of a safe publication.

iv) Revelatory Absurdity

This is best illustrated by the long-term project *Delta* (1993 onwards) which is based on the River Wandle in Wandsworth, and which grew from the proposal that this once fast-flowing and important milling river could again generate power and inspiration for its locale. The Intermediate Technology Development Group, (who more usually work in Tibet, Nepal, and Peru), were invited to assess whether the much reduced river could turn the propellers of a micro-hydro turbine – a small-scale electricity generating 'mill'. They found it could – enough to generate about 3 kilowatts of electricity to the user, which is enough to boil three conventional modern electric kettles.

This amount of power, however, usually brings sufficient clean electricity to a whole village in rural areas of the 'developing' world. In London, the sculpturally-installed Wandle turbine would bring water-power to the music room of a local re-built eco-designed school, powering low energy light bulbs and *Delta TV* – a video installation (using a 12 volt TV and VCR) devised and created by the St Joseph's Primary School children during the accompanying education project.

The turbine and its output is absurd in London, but a sustainable life-line in Nepal. Its absurdity is its power, in that it potently reveals the very issue that it seems so pathetically to address. What we take as 'normal' in the 'affluent' world and what is being pedalled as 'desirable' in the developing world are dependent on the ravaging of finite resources, the scarring of the earth's crust, the polluting of waters and air, displacing and exploitation of peoples, and the creation of mountainous toxic waste, encouraging rampant consumerism and profit-driven built-in obsolescence.

This interdisciplinary project drew together an unlikely grouping of funders, from the then 'Tory Flagship' borough council of Wandsworth, the national and regional arts boards, and from the then Department of the Environment *Urban Programme*. It has spawned many further projects including RENUE – a £1.8 million renewable energy and arts initiative to encourage and inspire people along the Wandle Valley to re-imagine and re-design their relation to energy. It has generated enormous interest from diverse quarters locally and nationally, and has elicited enquiries from as far afield as Nigeria, San Francisco and India. The project has had an effect far beyond its scale, partly due to the proposition that one sluggish river in inner London retains its motive and emotive power.

v) Longevity

In these days of short-termism and quick fixes, where three-year funding has come to be seen as 'long-term', we believe that a key part of the work is to mean it, to stick with it, and to do it anyway, even on the tightest of budgets. To think long-term, to act long-term, even with insecurity. To be funding-driven, to set time-scales on the basis of

money, is a danger, even if at times it becomes an absolute necessity. We need to earn a living, but the original activist root has a stubborn grip. Between 1983 and 1992, PLATFORM worked voluntarily, doing other jobs to support the work. Between 1992 and the present, waging has been patchy, if improved. This is not so sustainable as life goes on, but the motivation remains the key. Short-term financial underpinning can lead to short-term thinking in the work. If the aims are to think and act ecologically, 'over time and in place', then this tendency must be combatted at all costs.

Taking long-term responsibility for the work affects working in the public realm, and gives off a different energy – the acts described above are not part of a consultation or 'focus-group' mentality. From such work have come not only insights and exchanges, but also long-term friends, collaborators and allies. The issues are not going away, and neither therefore is the work. We are still engaged in the question and metaphor of water in the city nine years on. The current project *90% Crude* is easily a ten to fifteen year project.

PLATFORM is at present beginning a new research project about transnational corporate culture within *90% Crude* entitled *Killing Us Softly*, which is investigating how such organisms foster ethical detachment and compartmentalisation in its workers, much as public boarding schools in England trained boys (and girls) to betray no emotion when administering the Empire and its progeny. *Killing Us Softly* juxtaposes such corporate compartmentalisation with that of the bureaucrats who administrated the genocidal actions of the Third Reich, and is engaging participants in this challenging material in a meditative, durational way. Such work is slow work, such work is not appropriate to the passer-by context. This particular work has moved away from the streets, away from the open air public realm, into an intimate performance space which demands an 8-hour period of time from participants. Future locations for this work are being explored: how would an eight-hour group meditation on such a subject feel and look if located in public view, at the meeting of Cornhill and Threadneedle Street, at Bank?

From the incidental meeting or vision on a street to an eight-hour commitment, stretches a continuum of meaning and influence which, we hope, is helping contribute to the democratic and ecological re-imagining of our city and region.

We are The City. We are the Passers-by, the Invited, the Responders to a Sign. We are the Community of Place, of Interest, of the Dead, and of the Unborn. We are the Ignored and the Loved, the Alienated and the Included. We are with Voice and Mute. We are Them and Us.

However we – the three of us at present in the core group – are also from the dominant class of Anglo-Britons; we are committed to exercising the responsibility and the right to try to shift such values embedded within our culture from the patriarchal, the imperial, the disdainful, the erasive and the extractive to the co-operative, the consensual, the vigourously debated, and the maintained.

The snowflake in hell is fleeting but powerfully vivid in its impossibility – it is hope against hope. The power of the Baked Alaska is that the ice survives that burning, at least for a period. The end of the snowflake may result in a trace of steam, but the end of the Baked Alaska is a confection that both deliciously defies and fully acknowledges the burning.

> There is a joy in the absence of book-burning. The design was drafted with this thought in mind: it aimed to break through the mine-field of objections, to achieve an accurate,

objective presentation of the statues, free from any sense of barely concealed mockery. This is not a 'joke-park', it is absolutely not that — and it desired to formulate a critique of the ideology that acted as the midwife for these creations, through the totality of the park's atmosphere.... This park is about dictatorship. And at the same time, because it can be talked about, described and built, this park is about democracy. After all, only democracy is able to give the opportunity to let us think freely about dictatorship. Or about democracy come to that. Or about anything. (SzoborPark, 1995: 3)

References

Becker, C (1994) *The Subversive Imagination*, New York: Routledge.

Felshin, N (ed.) (1995) *But is it Art?* Seattle: Bay Press.

Kastner, J (1998) *Land and Environmental Art*, London: Phaidon.

Lacy, S (ed) (1995) *Mapping the Terrain*, Seattle: Bay Press.

Littoral (1994 and 1998) International symposia (Salford and Dublin) for Critical Arts Practitioners, organised by Projects Environment, UK.

McKay, G (1996) *Senseless Acts of Beauty: Cultures of Resistance Since the Sixties*, London: Verso.

Miles, M (1997) *Art, Space and the City*, London: Routledge.

Jaijee, R and Thomas, K (eds) (1995) *Rivers of Meaning, Getting in Touch with the Thames*, London: London Rivers Association.

SzoborPark Museum, (1995) catalogue, Budapest: Akos Rethly.

Vidal, John, (1997) *'Eco-Soundings'* in The Guardian, October 1st.

PLATFORM Projects mentioned in text

 Addenbrookes Blues 1983

 Corny Exchanges 1984

 Transformation 1986

 Tree of Life, City of Life 1989

 Still Waters 1992

 Listening to the Fleet

 Walking on the Walbrook

 Unearthing the Effra : Effra Redevelopment Agency

 Delta 1993 –

 90% Crude 1996 –

 Ignite 1996, 1997

 Agitpod 1997

 Killing Us Softly 1999 –

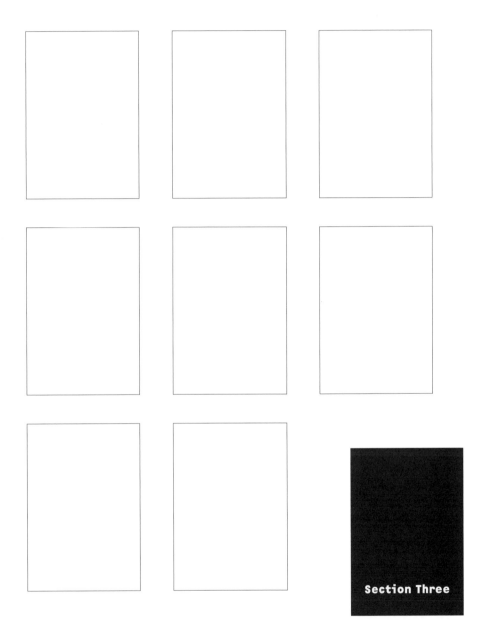

Section Three

On the Ground

Sarah Bennett & Gill Melling

■ Window Sills: Art of Locality

Introduction

Window Sills is a research project initiated by staff from the University of Plymouth, School of Art and Design. It takes the form of a collaborative art project which began in June 1999 and has taken place between residents of Exeter; commissioned artists Rebecca Eriksson, Edwina Fitzpatrick, Brendan Byrne and Neil Musson; and the University *Window Sills* team Sarah Bennett, John Butler and Gill Melling. *Window Sills* aims to examine the role of contemporary art practices in sustainable urban regeneration within non-metropolitan cities such as Exeter. The project culminates in July 2000 with a programme of mixed and multi-media artworks/performances located within participants' homes, residential streets and public spaces in the St Thomas and Exwick areas of the city. These are the result of a series of collaborations with residents that, over the past year, have explored the potential for creating artwork in a locality with people from diverse backgrounds.

Window Sills is based on an interest in the interface between activities within the private sphere of the home and the public domain of the street, exemplified by the window. This space is partly metaphorical, partly actual; through it individual, social and cultural identities are constructed and become mutually informing. In the early stages of the project the idea of the window space as an interface between public and private was extended, to explore it as a threshold in a broader sense, through examining the way that people's personal memories and present day activities build a picture of public history and private identity. The research set out to investigate how collaborative art practices could act as tools to explore and interpret this interface and to ascertain the value of this process in empowering citizens at a local level. This text aims to highlight some of the questions that arose during the project and to explore some of the work of theorists who have influenced our thinking and our strategies.

A Question of Locality

To initiate our project we needed to develop links and partnerships with people who would elect to participate in a project about experiences of their locality. We consulted others already working within the public realm and this allowed us to highlight strategies we wished to develop, and enabled us to avoid the pitfalls of an overly curated approach that would have transposed the museum zone into the streets of the city. Through this initial research, an important question emerged: which locality in the city of Exeter was the project to take place within? If the project was to be a collaboration between artists contracted to the University and residents with whom the University had had no previous contact, how were these residents to be found and approached? This issue exposed a dilemma: how to be inclusive in the first instance,

and secondly whether it is appropriate for non-resident artists and educators to propose to create a project about a place which is not theirs, i.e. whether this type of action could be viewed as cultural imperialism. The first issue, that of inclusivity, has been a key aspect of the project, and is concerned with the inclusion of citizens in decision making processes about art which is to be located within the public realm. Who should be included, in which way and with what intention, is complex and demands a recognition of the diverse ways people interact with each other and with the spaces in which they live their lives. In working at a local level we have had to recognise the dynamic histories and practices which inscribe place, manifested through its citizens and, therefore, understand that an engagement with locality in an inclusive manner must embrace diversity and the specificity of interactions.

In considering both this issue and the latter, that of 'belonging', we also needed to guard against basing our concerns on a binary division of inside from outside that assumes that there is a group called 'residents' who belong, to which a 'non-resident' does not. This assumption would reinforce such notions of sameness, whereby a group of people, defined by their geographical territory, share a common identity in a constituency of place which never changes. How could we (the research team and the commissioned artists) engage the residents of a locality with(in) the project without recourse to such mythical perceptions of community?

Conventional opinion holds that some parts of the city have greater needs than others but, identifying 'neediness', proposes an agenda, and agendas are formulated by those in a position of power. To equate financial wealth with richness of life is to deny the impoverishment that permeates all income brackets through the commodification of lives. It also ignores the deterioration of imaginative and communal activity characteristic of some kinds of modern urban existence, particularly suburban. Richard Sennett writes: "[There is] a deep and convoluted sickness in the community life of city dwellers who are not poor. This is an emotional poverty rather than material poverty, and it is voluntary. In that fact lie both a reason and a hope for change" (Sennett 1971: 91). Through *Window Sills* we wanted to provide an opportunity for residents, from a range of socio-economic backgrounds, to have access to creative and collaborative processes.

The districts where the *Window Sills* project has taken place, St Thomas and Exwick, share a geographical location west of the River Exe; the rest of the city lies on high ground to the east. Over the years West Exe (as these districts are called) has been looked down upon by the rest of the city; anecdotes from elderly participants indicate the past difficulties of gaining employment in the city because they lived west of the river. Extensive liaison work with other arts and non-arts organisations/individuals was undertaken early on to discover common ground and to establish the feasibility of the project taking place in West Exe. The positive response from those whom we contacted and the potential of support from agencies such as the Family Education Development Trust and Buddle Lane Family Centre, already working in the area, lead us to establish the project in this district. West Exe is made up of mixed housing: terraced streets built for railway workers; two large housing estates with few facilities; shopping precincts; 1930's suburban dwellings; and some fine Edwardian residencies. Rather than targeting any one socio-economic group the project has recognised the diversity

of the population. Participation has occurred both through approaches to g?
the establishment of shared concerns and activities, and to individuals
particular local knowledge or who self-selected. Throughout the proje
maintained and developed our partnerships with other organisations
including schools, day centres, youth clubs and nursing homes and this has resulteu in
opportunities for a range of individuals and groups to contribute, through creative
exchange, to the processes of bringing about sustainable change in their locality
through the project.

The Question of Community

Making work in and about a locality raises further questions about the construction of
the concepts of locality and collective identity and the representations of both. In a non-
metropolitan city like Exeter, conservatism and tradition tend to be prevalent. In such a
climate the links made between community, locality and social interaction within that
locality lead to a nostalgic perception (by observers or residents) of the notion of
'community'. Early on in the *Window Sills* project what became evident is how pervasive
the uncritical use of the term 'community' is within the English language and the
prevalence of the 'myth' of community. To examine social groupings and the
communications between people requires awareness of the construction of discourse in
order to avoid recourse to familiarity. Our research has shown the complexities of
communication with and between groups and individuals, and to this end community,
in its very performance; for as Raymond Williams suggests "the process of
communication is in fact the process of community" (Williams cited by Kelly, 1984: 50).

In *Community Art and the State*, Owen Kelly calls for activities "concerned with the
nature of community that a group is working towards; that is, what community a
group is participating bringing into being" (Kelly 1984: 50). Kelly's exploration of
community as a concept highlights a contingency "not an entity, nor even an
abstraction, but a set of shared social meanings which are constantly created and
mutated through the actions and interactions of its members" (Kelly 1984). Today,
however, sociological studies of neighbourhoods indicate that the cultural and
geographical networks in which residents participate are diverse, and may not
constitute a basis for conventional notions of community based in locality (Eade, 1997).
It has been important for those of us on the project team to interrogate the processes of
the project within broader theoretical terms and to understand the inherent
complexities of recognising and working with diversity.

As Sennett suggests in *The Uses of Disorder*, communal life is a conflictual process that,
in his examples of suburban affluence in the USA, becomes suppressed by an imagined
cohesion. This cohesion becomes evident when the community is challenged by a
perceived 'other' i.e. an outsider. Rather than a confrontation with difference, a
'purification' takes place creating a protective shield. The impression of sameness
conceals, Sennett claims, evidence of abuse, alcoholism, crime and difference within
the suburb and as a consequence is an act of "projecting an image of 'who we are', as a
collective personality, on a wholly different plane from, and in advance of, the
character of what they shared" (Sennett, 1971: 36).

Where sameness in the guise of community is perceived to have been lost, a comparison occurs between the disjunctions within a group as it stands, and mythical constructions of the existence of community elsewhere. To recognise this cohesion as an imagined construct based on traditions within the language of 'us and them', 'inside and outside' opens up the possibility to understand community in terms of a non-cohesive diversity of people actively constructing a contingent picture of themselves as the same, to serve as a protective mechanism. Rather than bringing people closer together in social action, Sennett argues that the construction of this myth provides people with an excuse for not interacting. "By an act of will, a lie if you like, the myth of community solidarity gave these modern people the chance to be cowards and hide from one another" (Sennett, 1971: 38).

The experience of *Window Sills* has been the repeated encounter with the desire for 'community' by both participants and other 'professionals', which led us to negotiate our positions as both academics and as project facilitators. However, it became clear that the concept of an homogenous entity, and the desire to belong to it, needed to be addressed at least by ourselves in order for the project to maintain a critical perspective.

A non-metropolitan city, such as Exeter, set in an agricultural region, may conjure up to 'outsiders' a vision of intimacy, an 'ideal community' based on everyone knowing everyone else, and the prevalence of face-to-face relations. Iris Marion Young questions the privileging of face-to-face relations in the ideal community by theorists such as Christian Bay and Roberto Unger (Young, 1990). She argues that such views presuppose the nature of communities as comprising small groups of people who know each other, who relate easily without mediation and self-operate a decentralised democracy. The idea that ideal communities are built upon relationships that require being in the same place at the same time is denied by the complexities of contemporary urban life and the need to extend outside of small independent units. Social relations take place over time, space and distance and require the processes of mediation and the recognition of difference. To live in a city of any size, metropolitan or non-metropolitan, is to encounter diversity and conflict as well as commonality. Where small social groupings do exist they need to relate beyond themselves and to engage in processes of exchange, i.e. of resources, goods and culture with other city dwellers whom they do not know and with whom they may remain strangers.

> City life thus embodies difference as the contrary of the face-to-face ideal expressed by most assertions of community. City life is the 'being-together' of strangers. Strangers encounter one another, either face to face or through media, often remaining strangers and yet acknowledging their contiguity in living and the contributions each makes to the others. (Young cited in Massey, 1990: 83)

Recognition of difference and sameness within the *Window Sills* collaborations resulted from initially 'being with strangers' and provided a diversity that was central to the dynamics and richness of the project. Most of the initial approaches were to established groups, themselves in a constant state of change, with members living in different areas, coming together to form fluctuating communities based on common

need. These groups were themselves constructed through the meeting of strangers and negotiated relationships to which we as strangers contributed.

The Question of Collaboration

An important concern for the project was to mediate the gaps between art and the 'everyday' by taking art out of the traditional spaces of the gallery and art institution. As an alternative to public art which is often imposed onto a place by commissioning bodies, the premise of *Window Sills* was for the project artists to work directly with local residents, initially through outreach workshops and then through collaborations, to make artworks that reflected the interests, lives and histories of the local participants. In order to be inclusive and involve people in creating a project about themselves and their place, it was important to avoid impositional models. We wanted to avoid being patronising or speaking a language of cultural benevolence, whilst wishing to address imbalances of power which create alienation in order to extend access to contemporary art to those who are socially excluded. The collaborations aimed to break down some of the perceived hierarchies related to the production of art, by enabling exchange between artists and residents in order to develop imaginative, creative and challenging activities.

Window Sills takes its lead from many of the practices developed in the USA within new genre public art (Lacy, 1995) and is based upon processes of exchange and reciprocity. Within the traditions of public art practices prevalent during the last two decades the processes of mediation often take place between artists and commissioning bodies, thereby excluding the public from engagement in decision making. The alienation produced by imposing art in other people's spaces is shown in the case of Richard Serra's *Tilted Arc* in New York. However, visits to many other cities can unearth equal hostility to sited works such as the recent controversy reported in the national press over Ray Smith's sculpture in the entrance to the Haymarket shopping mall, Newcastle. The piece is so disliked by some residents that they have requested its removal and have criticised the lack of a consultative process in its commissioning (Stokes, 2000). At the other end of the spectrum 'community arts', although working directly with people on a local level, do not traditionally include the process of critical reflection. This is not to say the tradition of community arts has no value to the people who take part, for it clearly can be challenging for people to try a new skill. However, on an ideological level, providing what is familiar and safe, in other words replicating "stereotypes" (Barthes, 1982), promotes sameness. This approach is often based upon a desire for unification and the celebration of traditional values and, unwittingly, the patriarchal, conservative institutions which define them.

As an alternative to both pre-determined, imposed public art and community arts, the *Window Sills* team has focused on developing strategies for interaction between the artists and residents that are transparent and begin with a process of dialogue, liaison and organic growth. This takes time and it was crucial to build the process into the early stages of the project. *Window Sills* explores place as space and time where people meet through constantly fluctuating negotiation. The process of exchange, of asking and discussing rather than telling is uppermost in our strategies. This process is one of uncertainty and

Pollination – *Artist,* **Edwina Fitzpatrick,** *has been working collaboratively with individuals to research the history of the many plant nurseries that used to be located in the area of St Thomas since the eighteenth century, through memories and photographic collections belonging to the families of local growers. This collaborative research led to scent dispensers, re-introducing the invisible scents of the plants grown in nurseries being located in the terraced streets built when the nurseries sold off their land to make way for housing for railway workers. The dispensers, showing one of the archive photographs, contain different scents: geranium; lavender; strawberry; pine; orchid; rose; night-scented stock; freesia; pinks; cucumber. Smell is a strong trigger to memory and in a world in which we have banished many smells, good and bad, we often try to re-introduce them through the artificial aromas contained in household cleaning products. The residents in the streets where the dispensers are located were invited to have a window box planted with the corresponding species sited at the front of their homes to bring the 'real smells' to the area, and to photograph their back garden and display the photo on the box. In terraced housing the boundaries between public and private are often blurred and the back garden or yard is a more private space so by making it public in this way intimate boundaries are being crossed. An important by-product of this project were the new friendships that were nurtured along with the plants by those who were involved.*

Installing 150 window boxes in St Thomas – photo: Alex Tymków

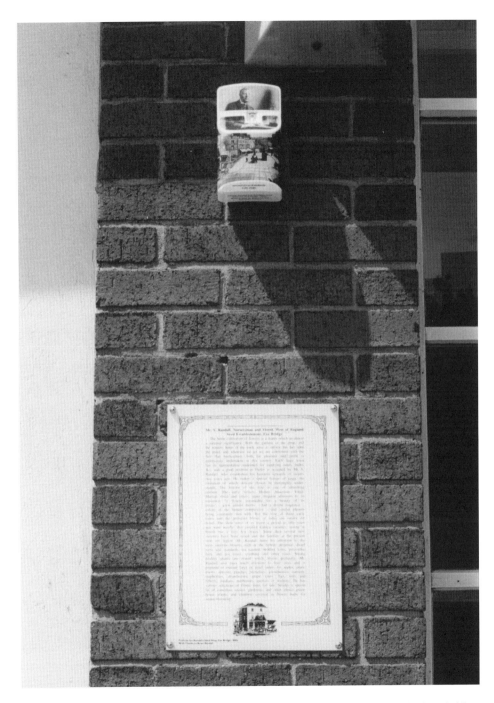

Rose scent dispenser sited at 'Hidden Hearing', Cowick Street showing photograph of Exebridge late 19th century (courtesy of Mavis Piller) and plaque below showing Randall's Seed Shop on Exebridge – photo: Jo Stevens

Mapping Home — started out as an exploration of notions of 'home' through local children's most frequently travelled routes around the area. The children, who worked with project artist **Neil Musson** used video and sound recordings to mark out their 'territories', and the resulting maps and recordings were shown at the **St Thomas Event**, an occasion early in the project when the outcomes of the outreach and the workshops were shared. This created much interest from the older residents some of whom had detailed knowledge about the changes that had taken place in the locality. A dialogue began between the different age groups about the spaces they frequented and a fascination developed about the diverse perceptions that existed of familiar surroundings. Differences and similarities between these perceptions began to form into a new kind of map — a vocal map comparing the generations. The elderly residents' recollections of the past and the children's more immediate responses to their environment together with the sounds of the place itself were layered onto tapes representing past and present perceptions of a place. During the **Window Sills Event** the recordings, triggered by sensors, were located at significant personal 'boundary' points chosen by the participants and an electronic text board relaying conversations about the area was visible to those on the other 'city' side of the river Exe.

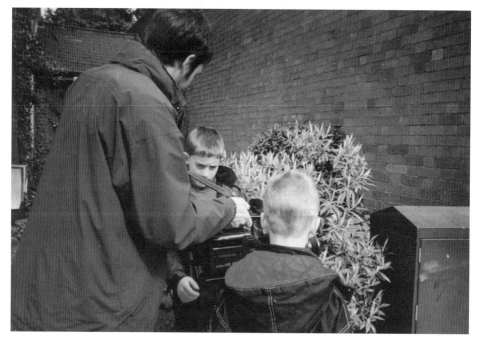

Neil Musson and participants filming 'Mapping Home' – photo: Lois Musson

Photographs taken by participants in 'Mapping Home'

Evident – involved elderly clients at the Hatherleigh Road Day Centre working in collaboration with project artist **Brendan Byrne**. Over the extended period of both stages of the **Window Sills** project Brendan and the participants made visits to the local museum to look for artefacts from the area and to the pub and spent time discussing what it is like to live in St Thomas and Exwick. Many themes surfaced that related to the employment of people in the area in the past, such as what they did during the war and about the work in the foundries. Other concepts such as issues relating to personal security, changing attitudes to money, keeping in touch with family and friends also came to light and influenced the outcome of the collaboration. Through the discussions it became apparent that certain materials such as iron, steel, copper and brass should be used in the collaborative work. One idea that emerged from these dialogues was to create a series of commemorative man-hole covers relating to the work of husbands, fathers and the participants themselves who used to make them (one of the 'bread and butter jobs' along with the bells for which the foundries were better known). The man-hole covers, sited during the **Window Sills Event** will, unlike the other collaborative artworks which are temporary, become a permanent aspect of the streets of St Thomas and Exwick.

'Wisteria Synensis Tunnel', site of sound installation relating to issues of security raised by Hatherleigh Road Day Centre clients – photo: Gill Melling

Manhole cover installed on Exeter Quay, relating to participant's story – photo: Gill Melling

Moments – *a series of 'moments', captured by residents around the theme of their windows using drawing, collage, text, photography, sound and film were displayed in public sites around the area. These fragments of time, snippets removed from the relentless flow of moments that connect together and form peoples lives, represent not only how residents observe the passing world outside their windows but also, how they present a view of their personal spaces to those in the street. The particpants chose to display their collections of images as small posters on local city buses, as postcards through outlets across the city, as images on TV screens in the local television and video retail shop and on large posters at St Thomas Station. These sites provided new contexts in which to view them; to see them as individual images or as part of a larger collection; to create the possibility that the images on the postcards might find their way into the living rooms of residents in other towns and cities. This collaboration took place between project artist* **Rebecca Eriksson***, University of Plymouth Fine Art student* **Kathy Woolner** *and the individual residents of St Thomas and Exwick whose ages ranged from 11 to 90 years old.*

'Lonely Bus Stop' by Tonya Howell

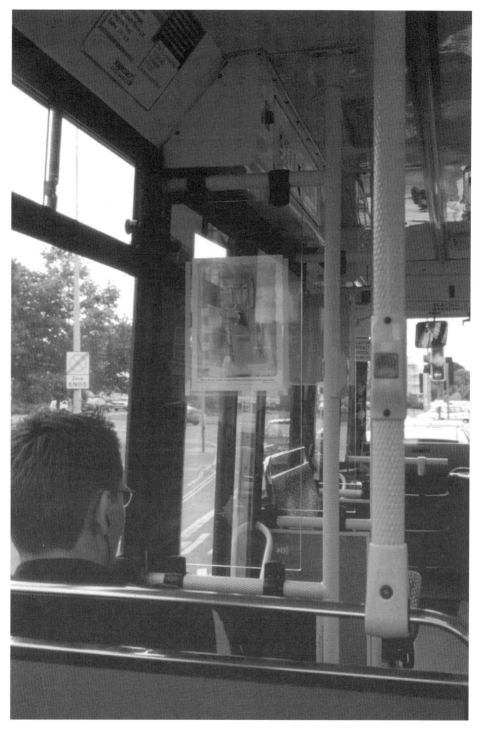

'Moments' poster by Margaret Johnson on a city bus – photo: Gill Melling

insecurity in terms of both interpersonal or communal practice and in terms of outcome. By shifting the focus from a state of binary opposition, other, in-between spaces are opened up. Edward Soja has developed the concept of "thirdspace", and the ideas offered by his "thirding-as-othering" introduce a "critical 'other-than' that speaks through its otherness" and allows for new approaches to be developed. He writes:

> The choice of an-Other alternative is strategically, not presuppositionally, privileged as a means of resisting binary closures. It is thirding that invites further expansion and extension, beyond not just the binary but beyond the third term as well.
> (Soja, 1996: 65)

The project has attempted to create alternative approaches to working within localities that are not merely dependent on the additive combination of oppositions but try to establish distinctly different ways of understanding places; a process of opening up rather than closure. By applying Soja's ideas we can escape from the either/or limitations of binaries and begin a process of expansion in our thinking as well as questioning previously held certainties. We can creatively explore the spaces between the art institution and the City; the City and West Exe; the past and present; the public and private; inside, outside. We can enter into the process of collaboration which is based upon a desire for outcomes not determined by conventional expectations. We have frequently encountered the view that collaborative practice inevitably leads to the 'watering down' of the results rather than their enrichment. Throughout *Window Sills* the processes of the collaborations have been part and parcel of the 'product' as well as the tangible: the artefacts; publications; events. Over 250 people have made a direct contribution to the project and, through qualitative evaluation, the feedback has shown that participants have valued their involvement; have been challenged by it; have gained esteem and self confidence; have realised a creative potential; have valued being listened to; have met new people with whom they share an interest or have found out about the different interests of others; have gained access to contemporary art, and so on. It has become evident that in-between spaces, are productive and dynamic spaces to explore with unending possibilities.

Contingent Possibilities

Third spaces are contingent spaces always under reconstruction. To examine the contingency of these interfaces requires an understanding of the contingency of the process of making meaning itself. Meanings are constructed through language. In *Contingency, Irony and Solidarity* Rorty reminds us that it is no longer possible to detach truth from the language from which it is constructed. He suggests that the development of new languages occurs through the creation of new metaphors, which happen to find favour at a particular moment "small mutations finding niches". The poet is someone who plays with vocabularies, dissatisfied with the ability of what is familiar or inherited to describe her world, and attempts "the invention of new tools to take the place of the old tools" (Rorty, 1982: 12 and 16). Comparing vocabularies, borrowing alternative vocabularies to our own we can mutate our descriptions of ourselves and the world

around us. This Rorty states is a process of recognising ones own contingency. "If...we drop the notion of language as fitting the world, we can see the point of Bloom's and Nietzche's claim that the strong maker, the person who uses words as they have never before been used, is best able to appreciate her own contingency" (Rorty, 1982: 28). Reflecting on our own contingency means we refuse to naturalise our identity and the languages used to construct it. However, as new metaphors become literalised through repetition, a new vocabulary becomes sedimented; the 'stereotype' is created. This 'progression' is not logical and linear but occurs through chance and experiment, and at the same time is not singular and homogenised but part of a network of change, a simultaneity. Can we apply this poetic process to a project such as *Window Sills* which seeks to bring something new into being?

The process of dialogue within each artist's collaboration in the project began gently with an initial stage of making acquaintance and building trust. Through a gradual process of discussion and exchange of opinion, ideas emerged to transform an everyday anecdote into a new language. For example the interface where some of the older participants' memories of employment in the foundries of St Thomas met project artist Brendan Byrne's interpretation through his own language as an artist and academic, gave rise to a third language; the transformation of an ordinary manhole cover referred to by the participants into a poetic object (a new metaphor) through the splicing of a utilitarian language with biographical imagery and information drawn from the reminiscences.

To recognise and play with the contingency of language in this way is to confront the unknown. It is also to search for the rifts where new metaphors can be created. The stereotype as Barthes describes it "is the word repeated without magic, any enthusiasm, as though it were natural...Nietzsche has observed that 'truth' is only the solidification of old metaphors" (Barthes, 1982: 42). Confronting this repetition and sedimentation of tradition is uppermost in our work as contemporary artists. Reflecting on language and becoming poets in the way Rorty advocates might be considered a crucial aspect of life.

The project has brought about a collision of diverse languages which fluctuate between a desire for closure and its inherent impossibility. As a project initiated by a mainstream academic institution we are caught between the rules laid down by that institution, which adhere to values of productivity, and their deconstruction through the strategies emerging from a rejection of these values. Throughout the project contingent conflicting languages have coexisted. We are caught in a contradictory dynamic of both desiring the utopian ideal whereby conflict is eradicated, and recognition that our otherness returns to point out the inherent rupture within this desire.

By intentionally beginning a process of collaborative art practice the project team has explored a process of mediation occurring through language, confronting mythical perceptions of community and highlighting the possibilities of change through inclusive art practices. The development of collaboration requires both establishing common ground, and the fracturing of this familiarity in order to create 'new metaphors'. A subtle process of mediation, whereby one does not make assumptions but remain responsive to the specificity of each situation, can produce an exchange of power, control and creativity which opens up a space for transformation. *Window Sills* in

this way has facilitated a network of specific exchanges, inherent within which is the possibility for power to shift and for diversity to be expressed. These strategies have created a project, which does not seek to bring together quantities of people in a fleeting spectacle, but involves people over time in diverse ways so that they do not feel alienated from a product but have been active in creating new languages and developed an awareness that new languages are possible. This specificity and contingency within the strategies has enabled people to make their own decisions about their inclusion so that not everyone is expected to 'own' the project in the same way; this would advocate a homogeneity. But through setting up process orientated activities, which are grounded in context, people develop an awareness of themselves as social beings, part of constructed and resonating histories and as subjects actively constructing histories.

When common ground exists between individuals at a particular moment, then possibilities arise for working together to bring about inclusive, democratic and creative change. In other words networking, sustaining and building on fruitful relationships can create a dynamic where individuals can make a difference within the city in which they live.

References

Barthes, R (1990), *The Pleasure of the Text*, Oxford: Blackwell.

Eade, J (ed.) (1997) *Living the Global City*, London: Routledge.

Kelly, O (1984) *Community Art and the State*, London: Comedia.

Lacy, S (1995) *Mapping the Terrain: New Genre Public Art*, Washington: Bay Press.

Massey, D (1990) 'The Conceptualization of Place', in Massey, D and Jess, P (eds) *A Place in the World*, Oxford: Oxford university Press.

Young, I M (1990) ' The Ideal of Community and the politics of Difference' in Nicholson, L (ed.) *Feminism/Postmoderism*, London: Routledge.

Rorty, Richard (1989), *Contingency, Irony, and Solidarity*. Cambridge, USA: Cambridge University Press.

Sennett, R (1971) *The Uses of Disorder Personal: Identity and City Life*, Harmondsworth: Penguin.

Soja, E (1989) 'History: Geography: Modernity' in During, S (ed.) *The Cultural Studies Reader*, London: Routledge.

Soja, E (1996), *Thirdspace: Journeys to Los Angeles and Other Real-and-Imagined Places*, Cambridge, USA: Blackwell.

Stokes, P (2000) 'Ridicule drives Lego Men out of town', *The Daily Telegraph*, 2 March.

*Consultants to the **Window Sills** Project were artists Alison Marchant, Sally Morgan and Louise Short, and Catherine Bailes, Exeter City Arts Officer, Maggie Bolt, Director of Public Art South West and Nigel Hillier.*

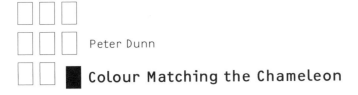

Peter Dunn

Colour Matching the Chameleon

Introduction

> In a world of uncontrolled, confusing change, people tend to regroup around primary
> identities: religious, ethnic, territorial, national. In a world of global flows of wealth, power,
> and images, the search for identity, collective or individual, ascribed or constructed, becomes
> a fundamental source of social meaning. Identity is becoming the main, and sometimes
> only, source of meaning in a historical period characterised by widespread destructuring of
> organisations, delimitation of institutions, fading away of major social movements, and
> ephemeral cultural expressions. Meanwhile...global networks of instrumental exchanges
> selectively switch on and off individuals, groups, religions, and even countries, according to
> their relevance in fulfilling the goals processed in the network, in a relentless flow of
> strategic decisions. (Castells, 1996: 3)

The construction of identities uses building materials from history, geography,
biology, productive and reproductive institutions, the apparatus of power and religious
revelations, from collective memory and personal fantasies. We rearrange these
building materials according to social influences and cultural projects rooted in the
social structures and time/space co-ordinates we occupy. The crucial issue is how these
identities are constructed, by whom and for what purpose.

Castells distinguishes three main areas of collective identity building:

> 1. Legitimising identity – by dominant institutions or power bases to extend and
> rationalise their domain vis à vis social actors (e.g. Nationalism).
> 2. Resistance Identity – grounded in opposition to the rationalisations of domination – in
> positions/conditions that are perceived as marginal, devalued or stigmatised by the
> dominant legitimising means. Identity built on principles defined as a polarisation from,
> but in relation to, the dominant forms of legitimisation.
> 3. Project identity – often grows out of resistance identity, building a new identity that
> redefines a position (e.g. 'I'm black and I'm proud', 'glad to be gay') and by doing so, seeks
> to transform the whole structure of society or an institution. (Castells, 1997)

In relation to our own practice, firstly as the *Docklands Poster Project* back in the 80s – as
part of a campaign – we were primarily involved in Resistance Identity, though at times
beginning to move towards Project Identity by constructing alternatives. As *The Art of
Change* however, our emphasis has shifted to the transition from Resistance Identity to
Project Identity, to try where possible to create new models.

Issues of personal identity may be complex enough, but any social practice is about negotiating spaces for the interface of a range of identities: personal, group, and variegated supra-groupings. In order to understand the complex relationships that might emerge from this it is necessary to have a sense of the bigger picture, especially at this moment when these identities are undergoing rapid transformations due to many factors, local and global.

In most industrial societies Project Identity was constructed from, or in relation to, civil society (and its Legitimising Identity) – e.g. Socialism was founded on the Resistance Identity of the labour movement, on roles and functions inscribed within the capitalist structure. In the transition to the globalised network society, the construction of subjects at the heart of social change takes a different route. Subjects are constructed less and less around roles defined in relation to contemporary 'civil societies' (using the fiction of the nation state as its Legitimising Identity because the societies and roles defined by them are themselves in the process of dis-articulation and disintegration.

What we seem to be witnessing during this transition is a prolongation of Resistance Identities. Meanwhile the mainstream Legitimising Identities are being redefined, deconstructed and continuously transformed as a result of globalisation. If Resistance Identity does not have a global dimension, then it will become stranded and tossed in the turbulent eddies of globalisation as it rushes by. With the possible exception of a small elite of geopoliticians and transnational economists, many people across the globe resent the loss of control over their lives, their jobs, economies, governments, countries, environment, and ultimately over the fate of the planet. It is essential therefore that the local is linked to the global. The old adage – 'Think global, act local' – still holds true, but with the addition of – 'and communicate globally'.

We have so far painted a somewhat gloomy picture of the effects of technology and globalisation upon identity. However, history shows that resistance does eventually confront domination, empowerment acts against powerlessness, and alternative projects challenge the legitimation of dominion. People around the planet increasingly see the 'new global order' as global disorder; even the powerful find themselves powerless.

Anyone who knows anything about our work at *The Art of Change*, or our previous incarnation as the *Docklands Poster Project*, will know that we don't have a rosy view of a future dominated by the increasing globalisation of capital. However it might be useful to look at some of the positive effects of technology and globalisation for a moment. For the first time (at least since industrialisation), culture – as the symbolic processing of meaning and communication – is integral to the creation of a new social and economic infrastructure. To quote Castells again,

> There is a specially close linkage between culture and the productive forces in the informational mode of development... (and) modes of development shape the entire realm of social behaviour... it follows that we should expect the emergence of historically new forms of social interaction, social control and social change. (Castells, 1996: 18)

In short, culture will be the main arena where the forces which shape our culture will interact in conflict or collaboration. And we – as shapers of cultural forms – like it or not, will be implicated.

There are opportunities as society moves out of the fetters of industrialisation. It should no longer be necessary to occupy the narrow boxes of time and space organised and encultured around industrial production processes; to work from 9 to 5, to travel *en-masse* into large overcrowded conurbations on overloaded transport systems, where these tightly packed physical spaces leave enormous ecological footprints which are ultimately unsustainable.

Artists in the post-industrial culture can leave behind the constraints of Modernism – industrialisation's cultural child – dispense with the narrow boxes of style and hierarchies which squeezed out diversity, downgraded crafts and skills, pictorial narrative forms, anything non-western or related to popular culture (unless reprocessed and repackaged in a very particular way). We can of course retain what we perceive to be the useful things that emerged from Modernism.

To some extent this is already happening: our culture is being revitalised not only by the forms, but the processes and concepts of other cultures. We are witnessing a beginning in the growth of diversity, new fusions of the craft based, hand made, and emerging technologies. A crossover between older technologies, including the photographic, with new digital forms. This may well create a huge increase in post-gallery art. We do not mean galleries as spaces will disappear, although what goes in them will diversify quite considerably. The dominance of an institutionalised system with its focus on the gallery as marketplace will however be shaken. Those historically specific modes of art transaction, meritocracy, and economy, will become even more specialised and less significant to the mainstream of culture. Post-gallery work is already beginning to create new relationships between the local and the global, and – along with a new wave of cultural theorists – are beginning to recognise that new forms of communication will radically shape the development of our culture.

Issues of audience, identity, engagement – the interface between public and private – are not fixed and cannot be addressed by simple formulas. They are problematised, complex and changing – particularly with the effects of globalisation and new communications technology to name just two factors.

It is vital for us at *The Art of Change* to regard each project afresh while constantly re-assessing our experience and over-arching principles, through both theory and practice. As we have said, a critical practice is not simply about a critique of what is, the point is to construct new models, to begin to create stepping stones in the pathway to a different future. Or, as a very famous old philosopher once said, it's not enough to describe the world, the point is to change it!

Strands of Practice

I will outline a number of projects as an example how this approach may become manifest in practice, not so much as a description of the projects themselves but more to give a sense of how the specificity of practice may shape strands of exploration within a continuum of change.

The first strand began a shift from a 'Resistance' to 'Project' Identity approach, from billboards to cyberspace. The project, *Changing Places* (1995-6), became a nexus point in this shift. It came out of a series of billboard projects, displayed in East London during

a period that was particularly fraught with racial tension, laying the ground for exploring identities in a critical but not a didactic or 'Resistance' approach which characterised a lot of anti-racist work at that time. It was a collaboration between ourselves, a secondary school on the Isle of Dogs in London's Docklands, and the Tate Gallery. We had worked with this school before. It is in a tough area with a high proportion of minority cultures who, at the time, were under a sustained attack from the British National Party. The Tate approached us to do some work based on their collection, involving young people from 'our community'. We decided quite early that, if we were going to make this project work, we would have to get the young people – some of whom had never been to a gallery in their lives – to 'change places' with the artists whose work they were looking at, to find a way to make it their own.

Our initial thoughts about working with the Tate Gallery collection revolved around the fact that it is Euro-centric through its historic focus on British Art and its more recent Modernist collection. While Modernism in its various forms borrowed heavily from the aesthetics of the cultural 'other' – Cubism being a classic example – the critical emphasis on Formalism maintained a "correct distance" (Dunn) from the social, economic or political context of that other which is not allowed to contaminate the purity of the (artistic) field. Our main concern was how the young people we were working with – with backgrounds rooted in diverse cultures, many non-western – might relate to the work in the Tate in a way that was meaningful and empowering. With them we explored issues of 'place', Britishness, the cultural meanings of death and regeneration. We push-pulled the pictorial conventions of the western tradition, both during the process of *Changing Places* and in the resulting image *Awakenings* which used digital imaging technology.

This project offered the possibility of bringing together a number of elements central to our practice. The first was the use of the creative process as a vehicle to allow people to move from present circumstances to future possibilities – to use the Tate Gallery's collection not so much as works of art to be appreciated but as a rich source of material to feed the imaginations of participants. By putting themselves in the shoes of the creators, the collection became the material through which to 'dream', to visualise and concretise possible futures. Much of our work starts with a process that can involve people in a variety of ways – a drawing together of issues and experiences that is wider than the knowledge of any one individual and roots the work firmly in the communities from which it stems. For us it is important that this process culminates in the production of an artwork – the visual power of the product is an important part of the empowering process – for participants see and have confirmed that they have contributed something they can feel proud of. Digital imaging is an ideal medium for this. It enables us to combine a range of disparate material, whether two-dimensional or three-dimensional, either by direct scanning or photographs. We can work with whatever scale and media are appropriate for the situation and, most importantly, draw on particular skills and interests in a range of participants.

Students visited the gallery and initially chose a work that they had a gut response to. After identifying elements that signified social and historical position, including race, culture and gender, the images were copied using traditional media but

'Awakenings', after Stanly Spencer's 'The Resurrection, Cookham',
by Peter Dunn & Loraine Leeson 1995/6.

a single significant item was changed to reflect their own identity. They started this process individually then divided into small groups to work on a larger scale using a variety of media, this time keeping only the formal structure of the work and re-casting all of the iconography in terms of themselves, their cultures and their environment. This allowed the students to situate themselves more clearly in relation to the historical and social framework within which the paintings were made.

Awakenings

Stanley Spencer's monumental 18ft x 9ft *Resurrection, Cookham* was chosen for the final phase. There were a number of reasons for this. From the beginning we had wanted to make a large-scale work involving the whole group in a way that would allow each individual a clearly identified role. Physically and compositionally Spencer's *Resurrection, Cookham* contains a 'jig saw' of discrete elements, and the numbers of people represented meant that all those involved in the project – pupils, teachers, artists, and Tate personnel – could be included. Secondly, the artistic tradition of the resurrection, as a 'moment of rebirth' set in some unspecified future, is frequently used to explore contemporary values, both as critique and an embodiment of aspiration. It is of course also a celebration. *Awakenings* was chosen as the title for the final work, not only to remove it from a purely Christian interpretation but to root it in the personal experience of the young people involved, who were poised at the beginning of their new life as adults.

Spencer's work revolves around a celebration of *place* – Cookham – and the 'local narratives' of that place. (Most of Spencer's paintings of this period were depicted in specific and recognisable places in or around Cookham and he believed in a parallel, spiritual Cookham, uncorrupted by time which was for him the 'embodiment' of place.) Much of our work explores how local narratives provide specificity to broader and more general themes and issues that affect our lives. Brecht has said that all the

great issues of human experience are enacted upon local stages. This idea tied in perfectly with the initial aims of our project and reflected very much the distinctive sense of place that the Isle of Dogs seems to generate for those living there. There were also interesting correspondences between Spencer's 'place' and ours. Both are joined by the Thames, a river of time from the early part of the Century to its latter period, and from West to East. Spencer's Cookham, to the West of London, is an island created by irrigation and navigation channels during the agrarian revolution; an island of rural English village life threatened by encroaching industrialisation and the changes following in the wake of the First World War. The Isle of Dogs, in East London, became an island through industrialisation and the building of the docks. Its urban communities are threatened by a post-industrial climate of unemployment combined with the physical and social dislocation of a major redevelopment.

Spencer's work also celebrates the pictorial values developed during the early Italian Renaissance but also incorporates 'precious gifts' from Africa. The centre section of the painting depicts African figures rising out of baked earth, in what looks like a boat, bearing mysterious objects. Spencer's brother in law, also featured in the painting close by, was an anthropologist and mounted one of the first exhibitions of African Art in Britain. We interpreted this as important cultural influences from 'afar'. We asked pupils about such influences in their own lives – some knowledge or wisdom passed through their families bringing information and insight from elsewhere, whether from the past or another place – if there were objects associated with this. For this group, these influences were not African but Bengali, Chinese, Irish and Greek. For all those involved, Awakenings became a celebration of another fusion: a remaking of 'Englishness' that is not a muddy multiculturalism but the variegated richness of cultural difference.

Students were taken through a process of imaginatively rethinking different aspects of the painting in their own terms. For example we asked what their families or relatives might do with their body if they died. How might they commemorate their life? What images would they choose to be remembered by? If they awoke from the dead, what would be the first thing they would do? Where would they like to come back to? Where would they feel most 'at home'? They each took a section to re-make as their 'own space' as well as contributing to shared parts of the work. Clay was chosen as the medium for re-making the 'tombs' and commemorative plaques, while batik was used for some of the foliage, textures and 'soft' materials. Photographs were taken in a temporary photographic studio set up in the school. Participants were asked to take up a pose in keeping with the 'space' they had created for themselves and what they imagined they would be doing there. We used synchronised flash and a medium format camera with a Polaroid back so they could check if the pose was right before taking the final shot to film. They took this themselves using a squeeze-ball trigger. The final work was compiled on computer. Image construction was complex both on a technical and compositional level. The basic structure of Spencer's composition is retained but pushed and pulled so that the different colours and icons, the photographic imagery, proportions, tones and textures still maintain the overall balance of the composition. The work represented a fusion of elements of high art and

'Momentos', 1999, by Peter Dunn & Loraine Leeson, image from 'Central Tech, Toronto'

popular culture, new technology and more traditional representations of space and volume that are part of the western tradition, together with the forms and signifiers of other traditions. The young people, through practice, deconstructed and reconstructed many diverse identity signifiers, not only in relation to what they were producing but in the works they had engaged with. Awakenings was displayed as a 13ft x 7ft Cibachrome print at the Tate Gallery, together with examples of work in progress and some of Spencer's working drawings, from 9th May 95 – February 96. It has since been purchased by the London Borough of Tower Hamlets to hang in the Town Hall, near the entrance to the Isle of Dogs.

The approach developed in this project evolved through a series of other works, the most recent being *Momentos* (1999), commissioned by the Art Gallery of Ontario to create a website project for teenagers in four high schools in Toronto. The project took as its point of departure a major exhibition of the paintings of Cornelius Krieghoff, a nineteenth century artist who was instrumental in creating the visual signifiers of Canadian identity at that time. Forged as it was from mainly European immigration, many of these signifiers still remain powerful in the cultural psyche of Nationhood today, despite the many culturally diverse communities of non-European origin that form the population today. Kieghoff was also a key figure in the formation of 'Native American' (mis)representations. The work which explored current Canadian identities, resulted in a set of virtual postcards which can be used to send 'messages' across the

'Momentos', 1999, by Peter Dunn & Loraine Leeson, image from 'Western Tech, Toronto'

globe. The project was also designed to create transferable materials for Ontario's new national curriculum. While both these projects were commissioned by galleries, those between were not, resulting in billboards, websites and three-dimensional works in public environments. One strand of this approach is being developed and broadened out for the creation of content for the National Grid for Learning in Britain under the title of *Unlocking the Grid* – unlocking the potential of ICT using the arts and a cross curricular approach.

Another strand has developed out of the *Wymering Public Arts Project*, Portsmouth: a series of seven related artworks using the focus of Agenda 21 – which came out of the Rio Earth Summit – to create an environment that projects the history, identity, desires and aspirations of the people of Wymering. This project has been described in detail elsewhere (Dunn, 1999: 8; 2000: 14-15; 2000: 4-11; 1999), suffice it to say that the model of involvement developed in working with a community to create a physical and cultural space for themselves has led to our thinking about a new approach to exploring the use of public space within the context of a network society – the 'Global Town Square'.

The ancient Roman forum was a place of debate, of interaction; a crucible of 'citizenship'. It was also a beautiful physical space. The 'Global Town Square' takes this concept into the twenty-first century, combining the physical and the virtual, the local and the global. The development of this initiative involves a co-ordinated programme of work that will build on the success of the Futuretown initiative nation-wide and

draw upon the government's new proposals about the introduction of 'citizenship' into the school curriculum. (Futuretown is a nation-wide scheme to raise awareness among young people of the importance of our towns and cities.) The programme will create a significant arts/creativity focus delivered through ICT and, crucially, extend participation to a broader age range and a wider spread of communities.

In short, 'Futuretown' will be expanded to encompass a 'life-long learning' dimension, will be linked to the HEFCE Widening Participation schemes, and create pathways to developing 'distance learning' programmes. Participating groups would be involved in research and prototype development, glimpsing possible futures for themselves and creating a vision for the development of public spaces, physical and virtual, for their town. A holistic approach, combining both material and virtual design with global links, extends the space, its use, and its aesthetic potential. Local identity becomes the key to locating the space within the global 'space of flows' and for users feel 'at home' using it.

Over the last decade public spaces have been increasingly 'invaded' by new technology. Most of this has developed piecemeal, driven by developments in public display systems. These tend to be additive to, or replacement of, existing systems: continuous information flow for transport terminals and commercial advertising are the most common examples. They proliferate as public space 'accessories' justified by functional or commercial expediency. By their very nature such systems are designed to be competitive, to 'outshine' other visual elements within the spaces they occupy. This is creating an insidious form of visual pollution in our public spaces: LED poisoning.

Much of this technology is still in its infancy and is often regarded as too 'fragile' for outdoor use. Consequently when it is used in public contexts it is not designed 'into' the space but simply placed into the space as an 'off the shelf' piece of technology, often clad in ugly steel armouring as a functional security measure. This problem does not reside in the technology itself but it its application. New forms of public communication, interactivity, and exciting new aesthetic possibilities could be combined with imagination and flair. The technology can be designed into spaces as part of either refurbishment or new build. A range of technologies can be incorporated, from simple pressure pads or infra-red beams built into walls, floors, decorative elements, to more sophisticated activation devices using peripherals. Convergence of technologies such as mobile phones, personal audio systems, palm top computing, with home entertainment and commercial systems means that these technologies will become increasingly interchangeable and capable of transmutation into many forms. Screens and display systems are also becoming more flexible and variable in scale, shape etc, through new plasma, LED and laser technology. We are reaching a point where 'the screen' as the usual glass rectangle will just be one of many forms that image display and transmission will take.

We believe it is important for artists, designers, architects, technologists and planners, and community organisations, to explore the concept of the 'Global Town Square' as both a practical means and the metaphor for the future development of public space across the physical/virtual divide. The 'Global Town Square' can provide public place for, and a democratic space within, the development of new technologies.

And this within a context of sustainable development, using renewable energy systems. The first of these initiatives is beginning in Gravesend in the early summer of 2000.

> The potential integration of images, text, and sounds in the same system, interacting from multiple points, in chosen time (real or delayed) along a global network, in conditions of open and affordable access, does fundamentally change the character of communication. And communication decisively shapes culture. As Postman writes, 'Our metaphors create the content of our culture. Because culture is mediated and enacted through communication, cultures themselves – that is our historically produced systems of beliefs and codes – become fundamentally transformed, and will do more so over time, by the new technological system...Its global reach, its integration of all communication media, and its potential interactivity is changing and will change forever our culture'.
> (Castells, 1996: 328)

References

Castells, M (1996) *The Information Age: Economy, Society and Culture Volume 1*: The Rise of the network Society, Massachusetts: Blackwell.

Castells, M (1997) *The Information Age:Volume 2:The Power of Identity*, Massachusets: Blackwell.

Castells, M (1998) *The Information Age: Economy, Society and Culture Volume 3: The End of the Millenium*, Massachusets: Blackwell.

Dunn, P (1999) 'Currents', Artist's Newsletter (UK): Dec p. 8.

Dunn, P (2000) 'Flavours of the Month', Mailout (UK): April pp. 14-15.

Dunn, P (2000) 'Afterlife', Public Art Journal (UK): April pp. 4-11.

Dunn, P (1999) 'Wymering Public Art Project', Portsmouth City Council.

Dunn, P 'Incorrect Distance', on: www.Artofchange.com

Eley, G and Suny, R (eds) (1996) *Becoming National:A Reader*, Oxford: Oxford University Press.

Foster, H (1993) 'Postmodernism in parallax', October, No 63, MIT Press USA.

Lyotard, J F (1984) *The Postmodern Condition*, Manchester: Manchester University Press.

Mcluhan, M, (1996) *The Making of Typographic Man*, Toronto: University of Toronto Press.

Postman, N (1985) *Amusing Ourselves to Death: Public Discourse in the Age of Show Business*, New York: Penguin Books.

Thompson, E (1967) 'Time, Work-discipline, and Industrial Capitalism',Past and Present, No 38, pp. 56-97.

Williams, R (1958) *Culture and Society* , London: Chatto and Windus.

The practice described in the above text was developed by Peter Dunn and Loraine Leeson, artists and co-directors of **The Art of Change.**

John Gingell

The Barry Job: Art, Sentiment and Commercialism

The city has always been an embodiment of hope and a source of festering guilt: a dream pursued, and found vain, wanting and destructive: Our current mood of revulsion against cities is not new; we have grown used to looking for Utopia only to discover that we have created Hell. (Raban, 1988: 17)

Introduction

This paper is concerned with the problem of the artist working in the public realm. Art agencies, private and public, set up to support this business are engaged in a complex operation. They have emerged from the history of the last 30 years to become part of the framework by which art is commissioned for the city spaces, and they have increasingly provided possibilities for projects at all levels, from the humble public park bench to the monumental sculpture. Numerous examples of works and projects exist now in every major city in Britain and the agencies have grown in sophistication to become offices employing project managers, backed by reference indexes. Public bodies, local authorities and private developers engage with these agencies and enable the process by which artists and crafts people take their place in what now seems to be *de rigeur* in re-development – the provision of art as part of the overall scheme. It is now a sophisticated business operation.

However, the artist essentially works alone, facing the reality of setting him or herself to the task in a solitary fashion. This may relate as always to the development of singular ideas in the studio and the delivery of the unique object to the site. More often now, questions of site, public consultation and engagement with a committee form part of the development process by which the idea 'grows up' in response to the unique factors of a particular space or place. So the artist acts as a director, a shaper and a unique voice in a joint venture.

Art in the Western world is largely generated for the wealthy, who have the means to buy images and objects which convey their status and command of taste. The state, too, retains the role of patron, through the Arts Councils. Their advocacy produced a new focus on art in public spaces in the 1980s; this continues, and offers artists a renewed relation to site and social context.

The Artist

As an artist, I have moved from the gallery sector – art for art's sake – into the real world of the city scene. I have been commissioned over the last ten years to provide monumental art objects within the reformed spaces of Cardiff and more recently Reading. Last summer *Artworks Wales* asked me to undertake a three day visit to Barry, a

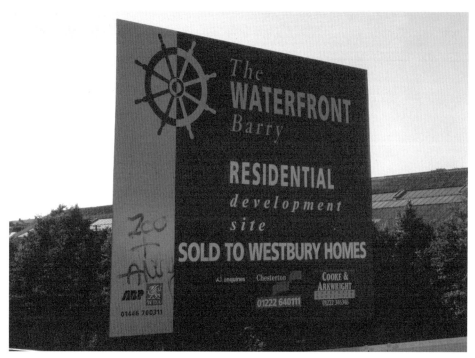

Barry Dock 1999 – photo: John Gingell

small town adjacent to Cardiff. My task was to come up with ideas and concepts as a counter measure to the official art strategy being put together by the art agency and the local authority working with its development corporation. My resulting work was to be exhibited in the town to excite public reaction to the possibilities emerging as Barry Waterfront developed. As an academic teaching in a University I undertake research as part of a European funded project, the Public Art Observatory, to study cities and in particular the role of public art within their development. This study compares Barcelona, Helsinki, Rotterdam, Birmingham and Exeter as 'Waterfront Cities'. Our collective consideration of public art as fact and then more recently the discourse and politics of the artist as part of a number of interventions by social, economic and 'future' agencies, has begun to throw up the need for wholesale re-vision of strategic development of which public art is often only a placebo or a cosmetic mask for commercial exploitation.

There is the problem of salving the conscience of the private developers. The artist faces, as a public city artist, the accusation of playing when the world suffers.

Cities are in the hands of such developers who are there to make money. The cities constitute a market and no obfuscation can hide this. An artist has to confront this reality. In Britain, development is largely piecemeal, at best encapsulated in a 'developed cityscape', wrapped in sanitisation currently termed 'gentrification'. The English longing for a sentimental past. There is scant reading of site in relation to the whole and little account for society or community.

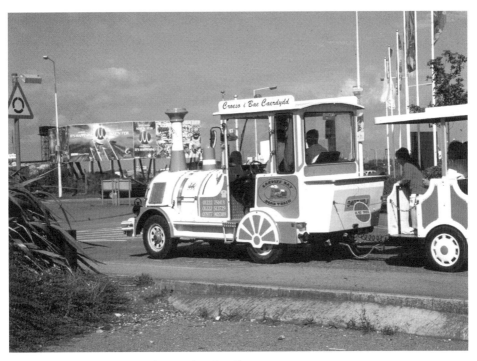

Tourist Buggy, Cardiff Bay – photo: John Gingell

Critics and political theorists such as Gramsci, reminds us that artists are complicit in historical processes, such as hegemony. They also carry a cultural memory, a store of traces and fragments, which is a point of departure for a search for meaning which is brought back into the present. Through this, artists see the world in its complex state, and from it they can imagine its transformation, which may be innovative or restorative.

Following the homogenisation which occurred in all fields of cultural, social and economic activity during the twentieth century, there has been a reduction of diversity in language, local custom and culture. There is a loss of structural difference accelerated by faster than light computing technology and the expanding network. This has left in its wake a cultural residue as 'heritage' and at large a hidden fashion of economic and politically expedient efficiency. Our commonality within this (at least in the developed countries) unifies us as universal consumers of supermarket products. We are therefore displaced into 'hyper' space, suspended from the primary world, its rivers, valleys, climates and localities that once formed peculiarity, identity and thus culture.

We are in a maelstrom of growth and the loss of the individual. Names disappear, acronyms and bar codes replace them. So there is a sense of the ocean; but what of the goldfish bowl, our city places? Anthoni Remesar, founder of the Public Art Observatory, University of Barcelona, lists the following themes for the future of the interacting artist, and thus questions:

- *the set of values that have sustained artistic work...*
- *the value of diversity...*
- *the value of innovation...*
- *the value of social pleasure...*
- *the value of art in the environment...* (Remesar, 1997: 8)

The 'city' purports to the ideal. That is to say within its official structure, deposited by history into legislation and institutions, the ideals of an ordered democratic society are supposedly inherent in the mechanisms of good order and the provision of uplifting repositories of learning, care and the welfare of the human spirit: libraries, galleries, hospitals, theatres, places for music, song and dance; parks, recreation and pleasure domes; sewers, good water, schools and the safety of the citizens as they walk, work and sleep.

The Job

In the middle of a busy period as a public artist, these thoughts of the responsibility I undertake are posed as a question for all that undertake commissions in this field. I was recently asked to 'look at the whole scene', in a small town in South Wales – free of any constraints. It was a rush, but it was a gift to be so free to think out loud. However, my notes of this adventure leave suspended the essential questions and identify the enormity of the problem.

I was phoned up suddenly. It felt as if I was a private eye taking on a rush job. "Go to Barry to investigate" – and come up with 'ideas' for the public art strategy to be launched soon.

Barry is a small late Victorian town, huddled on a low hill surrounding a near dead dock (hardly a Port) a few miles from Cardiff. This place is about to be redeveloped – or at least the central dock area, by the same Development Group who have with much fanfare, completed or nearly so, the world famous Cardiff Bay Development. For over 10 years this has transformed the old coal dockyards into a 'blue lagoon' harbour around which condominiums and private dwellings jostle with commercial office blocks and a new Assembly House for the devolved Welsh Government. Barry is smaller but of a scale to provoke the question of the role of the 'artist' acting alone like a Don Quixote jousting at the windmills of possibility. In completing my appointed task, I felt a deep pessimism. In a tactical sense it was great to be asked at so early a stage to participate provocatively – to be free to propose, independent of budgets and planning inhibitions. To be free to muse and surmise, to suggest. My immediate pleasure in the task was rapidly ambushed by the thoughts which come upon all artists and others who 'intervene' or 'participate' in the 'space of the public' – what am I doing and for whom?

The role of the artist – to be employed – quickly surfaces through all the rhetoric and grand conference statements. The question of what can an artist do collapses before the need to be recognised as a maker, a thinker within the mechanism of possibility. The city is the organism, swarming, heaving, pushing and pulled under the skeins of power working through the ordinances of order, planning, power supply, roads and designations of division, licensing and the forbidden.

Paul Jukes talks of that other more famous Docklands development Canary Wharf – and makes reference to a similar interaction of powers and forces acting in every contemporary development – the 'past' in the future.

> It was Docklands and its red brick road that really started me thinking that there was an intrinsic link between rapid development and the glamour of backwardness. Like the Yellow Brick Road in the Wizard of Oz, the red brick road promises a future, a new start. But unlike that imaginary highway, built on a green field site, the red brick road is built on the rubble of what preceded it. So the newcomers moving in dwell imaginatively in that past they no longer have to live with. In the dock, a wind surfer slides past a refurbished Thames barge…Even the 'Docklands' style of post-modern architecture, with its stick on Dayglo pediments, cornices and flutes, alludes to an antique style…It's not just new building you can smell here, but the new designs, new industries, new lift styles of a global culture…the only thing making it recognisable is its nostalgia for a vanished identity: the relics it smashes into manageable fragments, pawns and parodies and makes interchangeable with any other past. (Jukes, 1990: 56)

What is identified here is the dynamic that affects all cities. It is the singular event like a Dock redevelopment which stands out and raises the problem of 'whose cities and for whom?' Time outstrips our comprehension as projects emerge in the public realm and overwhelm by their complexity the artist's ability to enter other than as a complicit actor. A dilemma is thus presented. Do we acquiesce? Or do we resist? But most development proceeds by incremental steps, so that even acquiescence may be by default.

Most towns and cities in Britain – and my recent foray into Barry serves as a specific local reminder – are developed on an ad hoc basis, with no sense of purpose. Local authorities are largely rendered powerless to enact a purposeful considered project. They are cashless-paupers in local power – like aristocrats with no funds. They are there and go to the developers in order to be in operation. In Cardiff, some semblance of 'planned' and accountable reconstruction is encompassed. The Bay Corporation, licensed to develop the old docklands, has worked to a scheme mitigated by a sense of design and consideration. But this is at the limit of a conglomerate of direct commercial interest acting at best benignly. Inevitably, the beneficiary of this conspiracy of the public and private sectors is a standard clientele of middle-class salary earning professionals able to afford the life-style which condominiums on the waterfront provide. In living cities all kinds and conditions of human status are accommodated in the shifting flux of the rise and fall of property, locale and scene.

In the Bay, a 'kit' has been assembled, shot through with jolly seaside nostalgia typified in the pseudo repro of lighting standards and railings. Assembled at the front lie the anodyne business parks around the to-be-built Assembly building. In all, a sense of sanitised gentrification and lack-lustre conformity fills the nostrils of those who promenade its empty walks. Is this really what the people need? Does this mark the new Jerusalem of all that the assembled hearts and minds of the good and the great at the end of the twentieth century can make of it – pro bono publico. I think not. The British wallow in sentiment – and suspect all professional promulgation as improper. At heart,

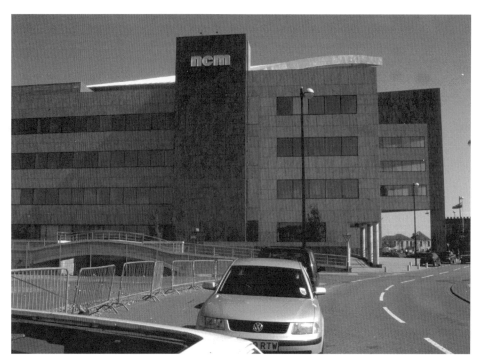

Cardiff Bay – photo: John Gingell

the managers of big commercial enterprises who now operate in the city and who swarm to the abandoned waterfronts are suburban wannabe 'garden village' philistines who drive their bargains with paralysed civic authorities. From their sweaty desperate embrace comes a sugary effluent of sentimental gentrification in the name of 'sensitive development'. This piecemeal selling of the local family silver has prevented any real, imaginative and socially appropriate thinking at the level of the innovation and care that can be seen in Rotterdam, as a new city unfurls, or in Paris with the imagination and daring of the *Paris 5* project.

Who represents the city as the place of melodrama? A realm where citizens of all standings and circumstance can enact the ordinary dramas of their collective reverie and passions and live in the privacy of their individual psyches? What of the poor and lowly, the dispossessed, lives outside the contract of family and recognition? How are the single, the transient, and the non-conformist to be accommodated? The current norm is one of sweeping clear and clean – and the development of the new within an unchallenged plan which brooks no delay, no redemption of the reusable, no adaptation or imaginative rededication. The customer is seen in too narrow a sense, drawn from a single species of plastic card owning, mobile phone connected passenger.

Absent from all the current action (in Cardiff or Barry), is long-term intelligent comprehension by those whom we have elected to understand and manage the complex notion of what can be a reasonable, imaginative and dynamic solution to the great task of moving forward the city as an assemblage of a thousand constituencies of lives to be lived.

Road connecting Barry Waterfront to City Centre – photo: John Gingell

The *Barry Job* took me on a journey from the Bay, along the three or four miles which separates the City of Cardiff from its small cousin to the West. Already machines were tearing up the land; tarmac and roundabouts were in place to connect the old town huddled on the hill to its new centre around the Waterfront Dock across the inlet to Barry Island. There, around the deserted dock pool, were the new grass swards which mark British renewal and the nostalgic reproduction lamp-posts eerily plucked from an Edwardian catalogue and plonked in the smart grass edges of the near twenty-first century. And 'o'er the lea' jostling in brittle semblance of 'my home is my castle' were the shiny machine exact replicas of Barrett houses, dumped there on sold-off lots in strategic sites like curds encrusting the sink after the washing up is done. Without any sense of place or scale, and in the patent absence of new or purposeful thinking about the role of this dramatic possibility in a virtually undesignated site, came the depressing pattern-book tide of unconnected hutches with badges of significance attached to them. Little Homebase 'old-time' lamps by the front doors. Bath stone lintels to upgrade window apertures and thin brick garden-walls marching round the assembled plots. What can the artist, an ant staring at this idiocy, do? I started with a statement of the obvious: artists, if they survive the uniformity prevalent within current education and manage to find commissions, are glad to have work.

So, with the *Barry Job*, I found myself in the middle of a dilemma. I was relieved that this commission was different from how I normally relate professionally to a job. It identified in my mind the true crisis which exists in the absence of a overall strategy enabling a

View of Waterfront from Old Barry – photo: John Gingell

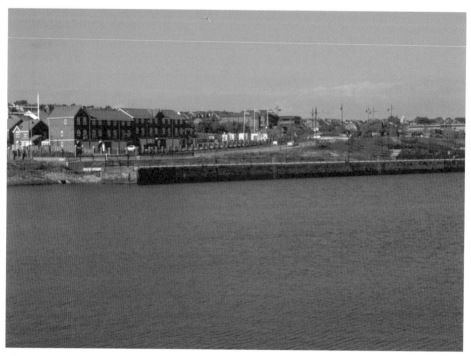

View of Waterfront from Barry Island – photo: John Gingell

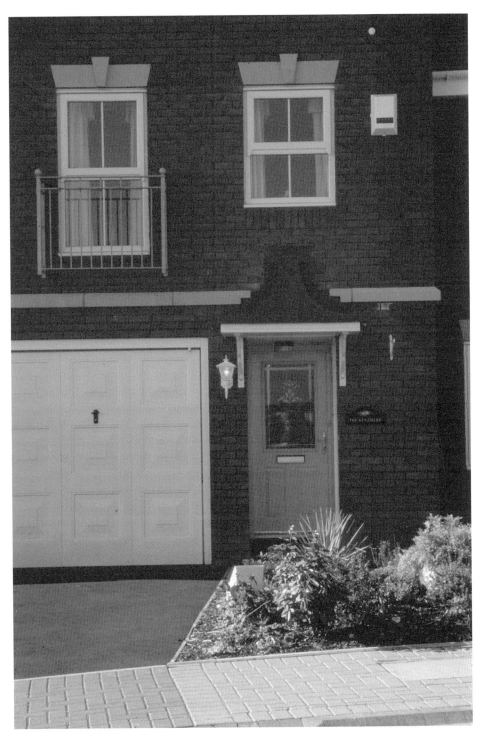

New Houses at Barry Waterfront (detail) – photo:John Gingell

unique plan to emerge based on real contact. I realised the real questions were ones of radical thinking applied to the redevelopment. Public art is to be seen as part of an imaginative over-arching and on-going plan to address the future public use of the new space. The need for lighting, communication and transport, and changes to the infrastructure, including the use of the water itself. I found myself acting free of the need to consider a single work in a specific site. I produced a work called *The Barry Waterfront* consisting of all the ideas and concepts that occurred to me. I was acting as part of the public intellect and it proposed to me a possible new way of working. The work in itself reads like a bulletin, a personal and evocative call to action, if you like, a new form of drawing. I extract relevant parts of this to show the form:

Art can be less about objects and more about a way of viewing complexity and claiming a period free to consider change – to provide a poetic within the fabric of the given towards courage for the possible.
Art as intervention in the decision making process.

Barry : City of the Future

Eventually Barry, or Greater Barry, will form part of Severnside – a city complex surrounding the Severn Estuary incorporating Weston Super-Mare, Bristol, Gloucester, Newport, Cardiff and Barry. It will be home to 10 million people and be serviced by an electricity providing barrage road link.

It would be tragic if Barry were to assume that all of society's needs are to be catered for by the means of '2 up and 3 down' plus 2/3 kids. The Barrett Home mentality does not include the single, the old, the impoverished, the outsider both rich and poor.

The new City centre – Barry Waterfront must be a microcosm of the latest thinking from Paris to Rotterdam – that to make a work of art – i.e. a working development on an urban site takes time, imagination and insight and takes time to be seen.

Barry must assume its new role to provide a wide mix of living accommodation and new focuses of interest for those who come and those who go.

A living democracy built of the absence of 'performed gentrification'.

A unique small-scale site possessing all the potential that water, harbour, jetties and strands offer.

A virtually clear site capable of supporting a mix of uses – similar to Cardiff Bay but more intimately.

City Textures

Post Modern *ad hoc* philosophy of reclamation of the symbolically significant:

Historic	Dock House
	Tank Buildings
	Dock Fronts
	Tower Chimney Building
Everyday	Nissen-hut Complex
	Blue Factory
	Tank Wash House

Novel	Bus Refurbishment Housing
	Contractor Huts
	Ship Houses
	House Boats
	Barge Houses
New	Conference Centre
	High-rise Hotel Complex
	Innovation Park
	Hi-Tech Alternative Living Places
	Light Tower – Wind Generator
Mixing & Crossing	Bridge
	Walkway-North Dock
	Path/Walk & Cycle Way Route
	Water Buses/Taxis
	Light Rail

Hi-Tech/Low-Tech challenging the blanket of neatness.

Alternative Housing

To attract a whole range of dwellers, who will not tolerate high rise or '2 up/2 down', to provide for the full range of the community within 'neo-quarters'. To fill the sky-scape between Dow Corning and the Dock with the waters themselves and to create what occurs historically in water towns like Amsterdam. New 'estates' in miniature to be created from rehabilitated buses, boats, barges, sheds etc, offered as alternatives.

This will create a counterpoint to hi-tech, provide housing for the itinerant, young and single.

Innovations Park

This should be receptive to a range of low tech-high tech energy sufficient housing, set in a park acting as an idiosyncratic place to live in, walk in and relax.

Power to be visibly supplied by the promotion of a wind generator set on the coast adjacent to symbolise and yet function as part of 'innovations'.

This area will be lived in and yet donate a lung of green, verdant arboreal space to the south-east of the Dock, contrasting with the High Rise splendours of 'the Mole'. A 21st Century Welwyn Garden.

Water Buses Taxis & Light Rail

Communication plays a vital role in the organism of space. At present, the Dock acts as a basin around which the communities of Barry and the Island live. The Dock development will create the core inviting both elements of North and South Shores.

In addition to the proposed Bridge, a key element will be a new water bus service, with water taxis, linking key points of the Dock surroundings.

Apart from tourist use, the service will function to connect the proposed Ship City, Barge Village and Houseboat Location. Light rail connections via a new system should be planned for the future to link the new centre with the outlying areas (cf. Amsterdam, Rotterdam harbour and city transportation systems).

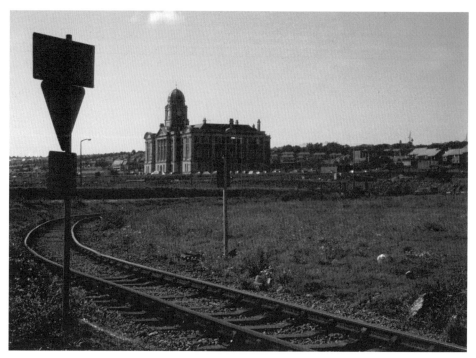

The Dockhouse, Barry – photo: John Gingell

It may be all over in Barry, or just begun, and my work may just have been a slingshot fired in love and anger in a battlefield of commercial prosaic development. But I end, postscript to the sense of defeat the 'Barry Job' brought on, with a note that our failure must be seen against innovative and practical new approaches to the evolution of cities as places for all to take on their lives and futures, thereby addressing the whole fabric of the social and the good of the people as well as commercial enterprises. But you have to travel by train or coach or via the web to view the alternatives: Helsinki and social housing along the water-edge; Rotterdam and the Kop van Zuid part of the master-plan of 50 years; Amsterdam and the creative industries project in the City Centre.

But beware, when you stay late in the office and a phone rings: "Hi, I've got a job for you..."

History cascades us with its models. As we live in the cacophony of what we have now – inevitably growing wired mega-scenes, we can see where it all came from as we search the crystal balls of what will be, terrified as we are before the gargantuan inevitability of our own endless commercial energy from coast to coast, from furthest promontory to garden city, the always forever onwards push.

History is littered with 'new' cities.

> *The very existence of the city, with its peculiar personal freedoms and possibilities, has*
> *acted as a licence for sermons and dreams. Here society might be arranged for man's*

greatest good; here, all too often, it has seemed a sink of vice and failure. Nor has this melodramatic, moralistic view of city life been the exclusive province of philosophers and theologians; political bosses, architects, town planners, even sociologists have happily connived at the idea of the City as a controllable option between heaven and hell. Bits and pieces of ideal cities have been incorporated into real ones; traffic projects and re-housing schemes are habitually introduced by their sponsors as steps to paradise. The ideal city gives us the authority to castigate the real one; while the sore itch of real cities goads us into creating ideal ones. (Raban, 1988: 19-20)

References

Jukes, P (1990) *A Shout in the Street*, London: Faber and Faber.

Raban, J (1988) *Soft City*, London: Collins Harrill.

Remesar, A (1997) 'Public Art an Ethical Approach' in Remesar, A (ed.) *Urban Regeneration, a Challenge for Public Art*, Barcelona: University of Barcelona Monografies.

Antoni Remesar & Enric Pol – CER POLIS.University of Barcelona

Civic Participation Workshops in Sant Adrià de Besòs:
A Creative Methodology

This paper outlines a process of civic participation in response to proposals to redevelop the district of Sant Adrià de Besòs, near Barcelona.

Sant Adrià de Besòs is a small town (35,000 inhabitants) bordering Barcelona. Historically it has been a territory without municipal entity, until, with the Regional Plan of 1952, Franco conferred municipal status on the territory. In the years of industrial development Sant Adrià de Besòs became a kind of residual zone through the establishment, along with polluting Industry, of metropolitan facilities such as heating and electrical plants, water treatment plants and so forth.

Sant Adrià de Besòs gets its name from the river Besòs, a strange and dangerous river like most of the Mediterranean rivers. The river divides the city into two areas which have become both territorial and social divisions of the city. Some of the degraded neighbourhoods in the metropolitan region of Barcelona are concentrated on the right riverbank. It is this territory that, at the moment, is being planned as the zone in which Barcelona can complete the urban development of its waterfront.

The urban office *Barcelona Regional* has proposed a plan for redevelopment of the area that, among other things, contemplates the regeneration of the whole Besòs river with the intention of transforming it into a great metropolitan river park. At first glance it seems a good idea, but is this project good for Sant Adrià's development? Is the proposed project the best one possible? Are the social needs of the population considered? These have been some of the questions that have recently led to a workshop for civic participation in urban design in Barcelona.

The workshop approaches the problem of the river, not only from the thematic outlook that is important for the city authorities in context of plans for regeneration of the whole of the river Besòs, but also from the perspective of rescuing the river as a central element and articulator of the possible urban, social and community development of the city. The central topic of the workshop, then is the social use of the river in context of its environmental regeneration.

Objectives of the workshop

We can state the following objectives for the workshop:

> **1 – Objective: participation** – The group's working process and organisation have as their first objective, to empower the participation of citizens in the planning process; to approach, from a local and personal perspective, the possible impacts of developments and action plans on this part of the city.

2 – Objective: information – Through the development of the workshop and given the characteristics of the work that we will analyse later, to seek a system of civic information based on the representability of the participants to set out and where possible to disseminate the information in their own networks (Neighbourhood groups, cultural associations, etc).

3 – Objective: education – Through the development of the activity, we seek to educate the participants in technical subjects and to be capable of territorial and regional analysis. Usually, this kind of training doesn't take place in the participative processes since the mediation of technicians prevents the citizens developing their own discursive capabilities. Participation in the workshop is also seen as a way of learning how to consider the real distance between the desire or the expectations and the viability of the conclusions of any scheme.

4 – Objective: extension to the community – Because of its diffusive characteristics, the process and the results of the workshop enable a good part of the population to 'participate' in the discussion and at the same time the workshop becomes an open process, by being open to new ideas and the opinions of the publics of Sant Adrià de Besòs.

Methodology

Usually, the processes of civic participation are outlined either within the disciplines of the social sciences or from a viewpoint of political praxis. In general, the process becomes one of problem detection and consultation is aimed at finding possible solutions to given problems so the participation of citizens is limited to reacting to a process of decision making which is carried out by the municipal authorities and professional 'experts'.

The workshop introduces, as a nucleus of its activity, a methodology which is more characteristic of disciplines such as Architecture, Design or Public Art, and more recently has been extended within management environments, as much in private companies as in public administrations.

The project methodology has three elements:

1 – The conceptualisation or design of scenarios

It is not possible to develop a project if it doesn't fit in a frame that warrants its meaning. This frame can be considered as a scenario. The study and identification of this scenario facilitates the creation of projects that are autonomous, of quality and, largely non-mimetical with regard to images from other possible solutions through the media, or other informative systems. This design of scenarios supposes at the same time, that local projects are approached from a wider perspective (dialectical locality – globality).

2 – Demarcation of the topic

In this phase, after the construction of the scenario, one proceeds to define and to delimit the topic on which the workshop will turn and how it will proceed in the following phases. In this phase it is important to rescue the memory, to reference in the historical, anthropological and cultural past. In parallel, an analysis of the present and current situation should be developed regarding the topic that is being defined. The process is developed in a dialectical way, detecting the problems and needs of the present and contrasting them with the data arising from memories. It is fundamental to discover that the data of the present are conditioned by the past, but at the same time to realise their solutions can be a replication of past problems. This procedure allows signifiers of identity to be generated, which will inform the development of the project.

3 – The points in favour and against the topic to be developed

Hierarchisation/territorialisation of the possible needs. Once defined, the topic should be developed so that we obtain a map of what can be in favour of, and against, it. The exploration in depth of the data of the present, making visible this data and the development of imaginative proposals, will allow the weaknesses of the situation to be identified.

When concluding this work we begin the exercise of organising contributions in relation to their social importance for the population.

Three sessions of the 'Workshop on Participation' took place and were guided so that the group analysed, in a non directive way, the needs and problems that face the municipality of Sant Adrià de Besòs at the present time.

Later on, these items were prioritised by the participants and, lastly, they made proposals for their resolution (locating them in a map of the city).

The form of the proposals. Project Phase

In a normal participation process, the workshop would have concluded its activity. In the previous phase it is possible to present a report that picks up the feasibility of the proposals. Later on these proposals can be re-read and re-interpreted by the technical and political apparatus of the town and translated into a formal project.

Our question was (and still is) "are the neighbours able to develop 'the form' the data would take and realities that are contributed?" Our methodology enables us to respond affirmatively to this question. If the Technician is our resource, a barrier will be lifted; a barrier that systematically operates between the citizens and the public administration. Obviously the mediation of this barrier responds to a structure and operating system that has derived from a kind of 'enlightened despotism' that frames the final solutions to the proposals or projects in such a way they cannot be contributed to by 'common humans' since they require an interface of technical character.

If we analyse the project methodology we can find this argument lacks foundation. The definition of the proposal's 'form' implies two different phases. In the first phase, these proposals, shaped in sentences like 'green areas', 'recreational areas', etc, must be re-conceptualized in relation to the content parameter and to some general formal parameters. A green area can be a green area of grass or a Mediterranean green area of vegetation.

Formally, these green areas can take diverse forms – those that the territory allows, or those that we design (round, square, etc). We argue that, in this first project phase, there are no technical impediments, only the possibility to formalise proposals endowing them with specific content and approaching certain formal solutions. This process can be carried out by citizens.

In essence this first phase allows us to establish 'managing directives' which radically differ from those used in the materialisation of the project. In the second phase the intervention of certain technicians is crucial, in order to evaluate the viability of the project proposal and to outline definitive solutions to the proposals contained in the projects. There is nothing new about the real gap between the masterplans and the contributed specific solutions.

The communication of the proposal

The normal procedure supposes a technical and political evaluation and appraisal of the civic participation processes. The methodology we propose establishes a way for the community to evaluate the workshop, since we understand that the project is not completed if it is not referred back to the citizens to whom it is directed.

It is necessary to develop a second phase for the workshop in which the participants outline, study and design communication acts with the rest of the citizens. We believe that the follow up process in Sant Adrià, is a good model that facilitates, with slight modifications in each case, the establishment of basic rules of the communication within the city, with the citizens. At the same time it is empowering the active participation of those who want to be involved in the final phase of the project.

The scheme of this development consists of:

The exhibition
An exhibition should be designed that picks up the contents, phases, processes, aspects and essential proposals of the workshop. This exhibition is supported in two different formats. One is the classic that allows the exhibition to be shown to the entirety of the city territory, bringing the proposals to all the citizens. This exhibition form should be accompanied by new supports that allow the use of the Information Technology: CD-ROM and web pages (when possible).

The participation can be boosted in a traditional ways through the exhibitions, for example through questionnaires that capture the opinion of the visitors. If these questionnaires can have an electronic format that will make it possible for other sector of the population to participate with their suggestions.

The explanation to the citizens

The exhibition can gather faithfully the development of the whole project but it is necessary that, to facilitate participation, the members of the workshop develop an intense contact with the rest of the associative 'fabric' that has not participated directly in the development. This can be through organising work sessions with these groups to explain the experience 'from the inside', that is to say, to present the experience as being centred more in the participative and work aspects than in the formal aspects of the results that the exhibition takes charge of developing. In these sessions it is very important to pick up the contributions, suggestions, comments and criticisms that the proposals of the workshop raised.

The visibility

Communication design also implies 'media management'. The workshop must be able to energise the local media (newspapers, magazines, bulletins, etc) so that they inform the public about the workshop, its results and the exhibition. This task is more complex if it should be applied to national media coverage and, in this case, the participation of the City council can be decisive in working to promote the visibility of the workshop.

The critical analysis of the proposal

The last methodological stage consists of a general evaluation of the process developed by the workshop. This evaluation has two differentiated aspects. On one hand it is important that the contributions of the citizens picked up through the tour are incorporated within the project; the electronic nature of the CD-ROM and the final publication of the experience providing a suitable means for this.

On the other hand, it is necessary that the workshop faces constructive criticism by technical and specialised 'agents' who can analyse, value and expose in a public way the advantages and weakness of the proposals presented. The itinerary can conclude in a forum session, in which a 'panel' of experts contribute their considerations. These considerations should be picked up in the final conclusions.

When does the workshop conclude?

Formally the workshop finishes when the elaboration of the conclusions end. It doesn't necessarily mean, always, that the work has concluded. The possibility exists that auto-organizing processes emerge that give the participants of the workshop the chance to continue their task in the context of other participative scenarios. The possibility also exists that the participants' interests and the political will of the City Council will lead to the prolongation of the process, in

another workshop that approaches, for example, the development of specific aspects of the proposal which require an itemised treatment, or those aspects that have been criticised or rejected. Anyway, the workshop concludes at the moment of the elaboration of conclusions. Starting from there a new workshop begins in which we repeat the presented cycle.

Impact of the workshop

Depending on whether the communication system has worked, the impact on the population can be considerable, especially if the City Council assumes a pro-active role oriented to incorporate the proposals or part of them in its political strategies and management.

However we would like to highlight the importance of another kind of impact. We refer to the fact that the experiences that are carried out can configure a kind of 'think tank' on participative processes and urban projects to be used, not just by the City Council, but to facilitate the use of these processes and projects on the part of other local Public Administrations, as much at regional, as at state or supra-state level.

In this sense the possibility of a global dissemination of the experiences (e.g. via Internet) is fundamental.